Passenger Seat

Creating a Photographic Project from Conception
through Execution in Adobe Photoshop Lightroom

JULIEANNE KOST

ADOBE
PRESS

Adobe

Passenger Seat
Creating a Photographic Project from Conception
through Execution in Adobe Photoshop Lightroom

Julieanne Kost

Adobe Press books are published by Peachpit,
a division of Pearson Education.

For the latest on Adobe Press books,
go to www.adobepress.com.
To report errors, please send a note to
errata@peachpit.com.

Acquisitions Editor: Victor Gavenda
Development Editor: Linda Laflamme
Production Editor: Tracey Croom
Technical Editor: Rocky Berlier
Copyeditor and Proofreader: Scout Festa
Compositor: Kim Scott, Bumpy Design
Indexer: Rebecca Plunkett
Cover Design: Mimi Heft
Cover Illustration: Julieanne Kost
Interior Design: Mimi Heft

Printed and bound in the United States of America

ISBN-13: 978-0-134-27820-9
ISBN-10: 0-134-27820-8

987654321

This book is dedicated to my best friend, Thomas Musheno.

Acknowledgments

With special thanks to:

My mother and father, Judy and Gary, who set this in motion long ago.

Jack Davis, for challenging me to make a photograph of something that I couldn't see.

Dean Collins, for giving me the courage to do things that I didn't think I could do.

John Warnock and Chuck Geschke, for changing the way that I see the world.

Russell Brown, Luanne Cohen, Katrin Eismann, Thomas Knoll, John Paul Caponigro, and Chris Cox, for being early pioneers and letting me play in their sandbox.

Bryan Lamkin, Kevin Connor, Maria Yap, and Winston Hendrickson, for bringing me aboard and making me want to stay.

Tom Hogarty, Sharad Mangalick, Jeff Tranberry, Eric Chan, John Nack, and Martin Evening, for explaining what I often think I already understand.

The entire Photoshop and Lightroom teams, whose brilliance continues to astonish me year after year.

Maggie Taylor, Jerry Uelsmann, Bert Monroy, Joe Glyda, Rob Carr, Greg Gorman, John Sexton, and Ryszard Horowitz, for their inspiration and support.

Laurie Klein, Chris Orwig, Jon Allyn, Noha Edell, Kathy Waite, Bryn Forbes, and Dane Sanders, for their enthusiasm and encouragement.

Tony Smith, Bob Rose, Fred Brady, Tony Corbell, and my entire CCA family, for sharing their experience and expertise.

Victor Gavenda, Linda Laflamme, Tracey Croom, Mimi Heft, Kim Scott, Rocky Berlier, Scout Festa, Rebecca Plunkett, and the entire Adobe Press/Peachpit team—without their help this book would never have happened.

And of course, to everyone that I've had the honor of meeting at industry events—you continually open my eyes to what's possible.

Contents

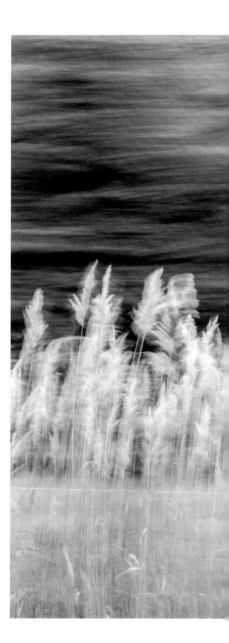

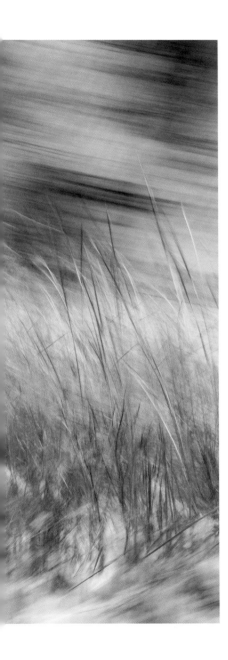

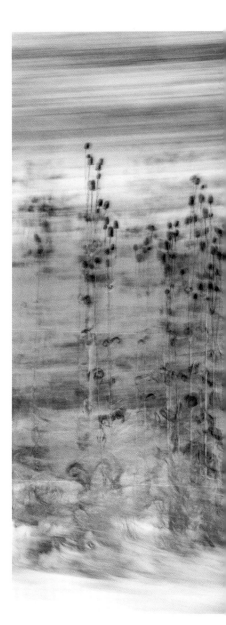

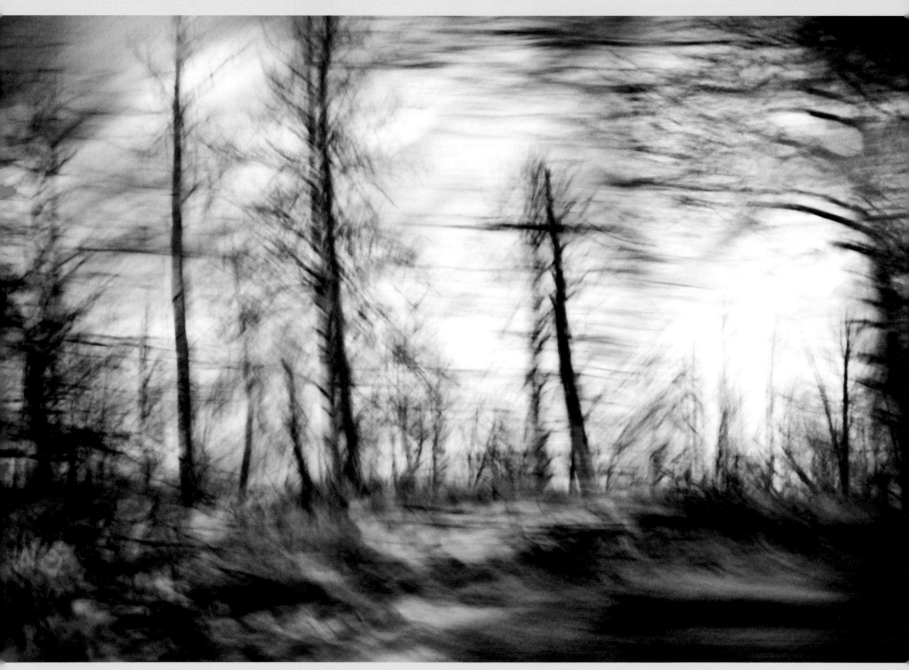

Montana, 2008

Introduction

Passenger Seat, the project, started as a purely personal one as I traveled through the northeastern United States to view the leaves in fall. We drove all day looking for iconic New England landscapes, and between the small towns, I started taking images out the window of the car. At the end of the day, the images that I had made "in between" were the images that resonated with me. I found myself capturing a distinct yet ephemeral moment that was not entirely apparent or observable when the image was made, yet these photographs conveyed the mood, colors, and transient notion of fall better than anything that I had mindfully composed.

I instantly decided that this project was worthy of additional investigation. The discovery of something unseen, the serendipity of art and science coming together as one, and the contrast between chaos and order within a single frame, fueled the creative embers inside of me. Knowing that photography is the unity of the "left and right brain," I tried to learn as much as I could about the technical process to increase the odds of capturing a successful image. At the same time, I needed to embrace and lose myself in the creative process. Planning, pre-visualization, and technique, combined with feeling, intuition, and perseverance, would be needed

to create this body of images. *Passenger Seat*, the book you hold in your hands, marks the completion of that personal project.

As photographers and artists, we can't underestimate the need for personal time and creative time; I consider this to be our most valuable time. If you can't find the space in your life for your projects, maybe it's time to re-prioritize. We live in an incredibly fast-paced, hustling, and ever-changing world, but a full schedule doesn't necessarily mean that you're being productive. Make sure that being *busy* isn't an excuse not to focus on what's important to you.

We need to constantly explore different techniques and subjects in order to stay healthy and not atrophy. This project allowed me to stop and take a second look at the world that I *thought* I knew, broadening my vision to include a world that can be seen only by the camera, not the naked eye. It helped me continue to look at things with a new perspective, learn how to make technology work for me, and "let go" and lose myself in the process of making images.

No matter what journey your personal project takes you on, I hope that riding along with mine in *Passenger Seat* will provide inspiration and guidance. I'll walk you through the conception and evolution of the project,

discuss capture and editing processes, provide toning and post-processing techniques, and examine delivery options for presenting and sharing projects. Along the way, we'll explore how to balance intuition with technical know-how, define (and limit) the scope of a project, stay motivated in order to overcome the inevitable "bumps in the road," discover the most efficient Lightroom and Photoshop workflow and image enhancement techniques, and realize the benefits of constructive criticism.

There is so much more to see, and an infinite number of ways to see what is there. As a photographer, it's your willingness to experiment—to try something new without the fear of failure—that will set you apart. "It hasn't all been done before," because you have yet to make your image through your eye, with your voice, telling your story. You have to realize that the possibilities are endless.

The soul always starts a thought with an image.

—ARISTOTLE

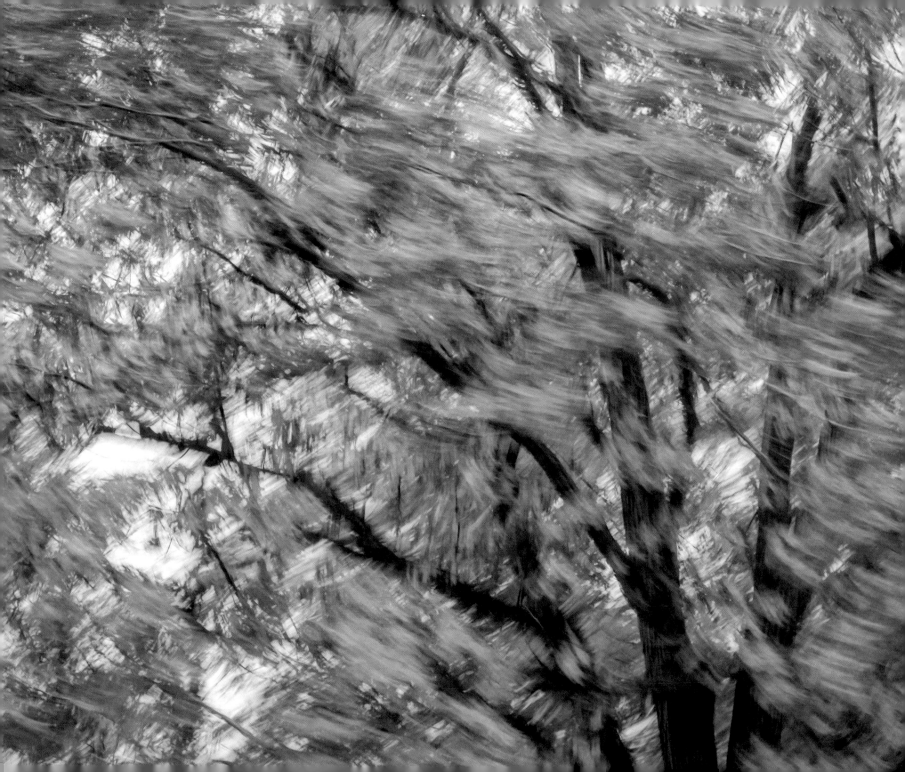

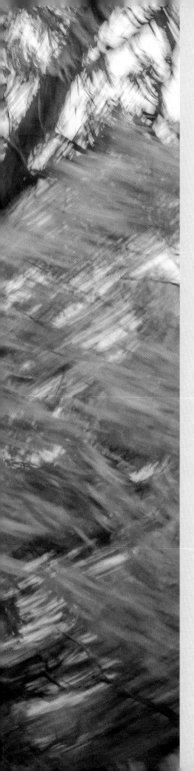

PHASE I

Telling Your Photographic Story

New York, 2009

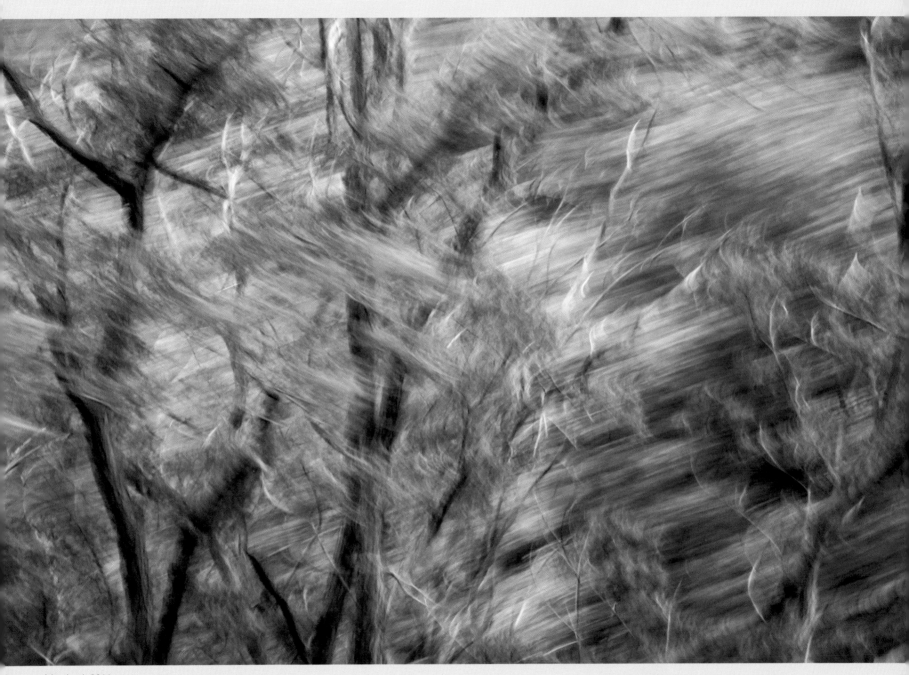

Maryland, 2011

CHAPTER 1 Personal Projects: A Necessity

Everything has its beauty, but not everyone sees it.

—CONFUCIUS

Do you remember the moment that you fell in love with photography? Maybe it was the first time that you saw the image come alive in the developer tray in the dark room. It was simply magical, the way that the image seemed to appear out of nowhere. Or perhaps you fell in love the first time you captured an image on your mobile device and could instantly send it to your friend or share it with your family back home. No matter how or when it happened, most likely it was a personal project that first brought photography into your life, as it was for many of us.

Whether photography is your primary source of income or an essential passion through which you share how and what you see in the world, please do not underestimate the value and importance of embarking on purely personal projects.

Time and time again, I have found that it's my personal projects that continue to keep me in love with and passionate about photography. These projects are an investment in my own work and allow me the opportunity to create meaningful collections of images and ideas to share with the world. They are the primary way for me to ensure that my photography continues to evolve, and they advance my ability to tell

a story. I want to make sure that I am constantly challenging myself and my work in order to improve. Because personal projects are self-assignments, I am able to take risks, experiment without any pressure, try new technologies, and pursue new ideas. Every time I commit to a body of work, I have the opportunity to practice my craft, improve my skills, and reach new levels of image making.

It's the personal projects that get me out of bed filled with excitement before the sun rises and keep me photographing after the sun goes down. These projects fuel my creativity. They allow me to explore new subjects and fall in love with photography over and over again. Personal projects allow me to be expressive. They give me the opportunity to explore new places, see new things, and feed my soul. They make me happy and bring me joy. They keep me grounded and connected with the physical world around me and fulfill my need/want/desire to be creative and communicate with the world.

Want to Do, Not Must Do

Because the aspect of "play" is critical to learning (both during the photographic process as well as after), we need to make sure to

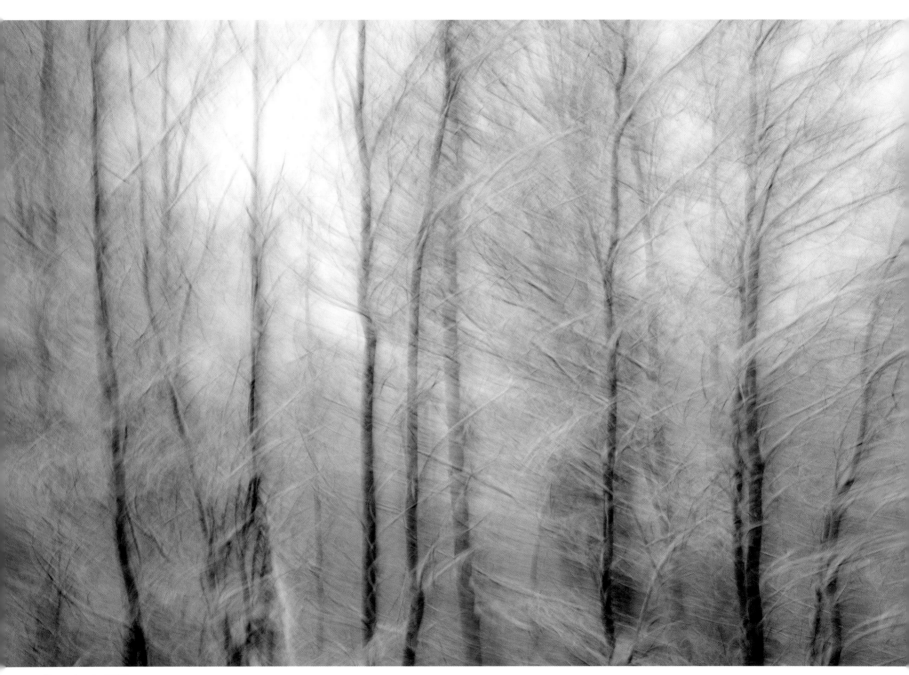

Pennsylvania, 2012

include it in every body of work that we take on as a personal project. When we introduce play into our projects, we lower the psychological risk of being wrong or failing—after all, we're just playing, right? Plus, I like to play, I want to play, and therefore I find that I *want* to make time to create the images—they're not obligations that I *have* to do.

I always have several personal projects going on at one time—most of which span several years. I didn't think that I was the type of person that would work on a project for a month, much less a year or a decade. But sometimes things turn out very differently than one expects. This has been especially true with my relationship with photography. In other aspects of my life, I tend to pursue things for a shorter amount of time and then move on. Because I enjoy making images for my personal projects, it never seems to be a chore to continue to pursue them. In fact, it's especially gratifying to see a project to completion knowing that I'm simultaneously improving my vision and enjoying the journey.

It has also been found that artists who make large quantities of work learn more quickly and try new techniques more readily than artists that attempt to make a limited number of pieces of "perfect" art, so I make sure that I produce a lot of different images from which I can cull—ultimately including only those images that support and add to the project.

Because these personal projects are not deadline-driven, we have the benefit of "living" with the images for an extended period of time. Don't underestimate the importance of giving ideas time to develop. Letting images rest, and revisiting them as the project moves forward, has enabled me to see the relationship between images that I would have otherwise missed. Over a project's lifetime, as I watch it evolve, I am able to make better judgments about the photographs than if I instantly share them. Some images withstand the test of time, continuing to catch and holding my attention, while others fade away. Time also helps remove the emotional attachment that I have when I first make the photograph. It can be difficult to separate whether or not the image is successful—because of my involvement in the making of the photograph—from the contents of the photograph itself.

Working on and editing multiple long-term projects at a time also gives you the luxury of shifting your focus from one body of work to another, depending on the time, location, and situation that you find yourself in. For example, some of my projects are based on subject matter such as clouds or textures and can be added to at any time. Others are based on concepts that require travel or collaboration and other constraints so that they can be worked on only at specific times or in specific locations. Because I am constantly involved in and juggling multiple

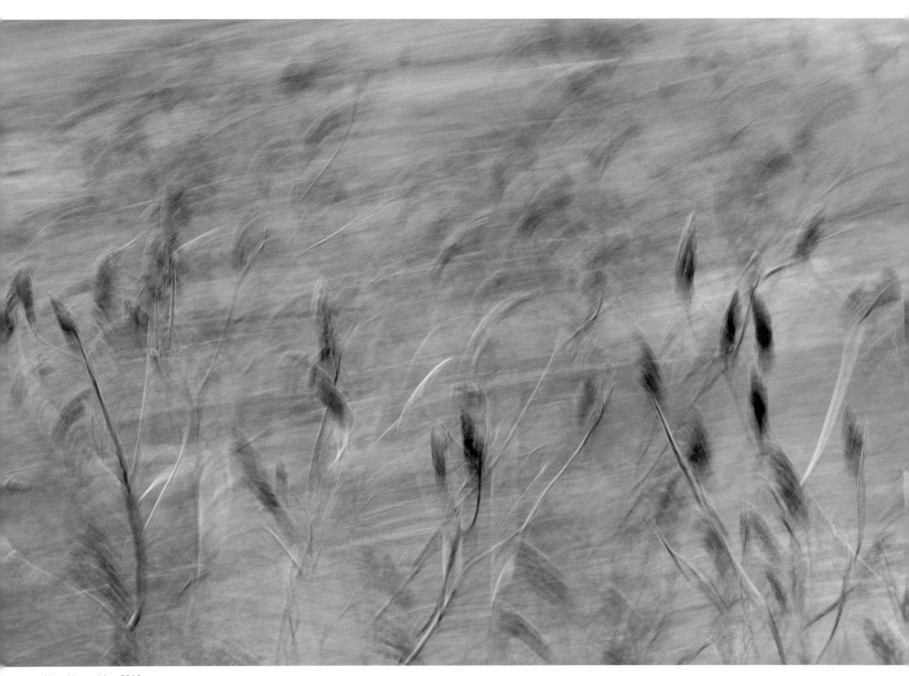

New Hampshire, 2010

People only see what they are prepared to see.

—RALPH WALDO EMERSON

projects, I never get bored; I always feel that I have bodies of work to nurture and grow.

Your Passion, Your Project

Do not concern yourself with other people's passion (or lack thereof) for your projects. We all hope, of course, that others will share our excitement for our projects, but don't choose a project based on whether or not you think it will be accepted and validated by the external world. The majority of my images will never be seen by anyone else on the planet, but that's not the point. The projects provide us with personal outlets for creative expression and the opportunity to improve our techniques and thoroughly immerse ourselves in the process of image making.

It's up to you to choose what you want to photograph—what story you want to tell. It makes my heart ache to hear stories of people abandoning personal projects because someone told them that the project didn't matter. While constructive criticism is extremely helpful (more on this in Chapter 33), I have never let it stop me from creating a body of work that I thought had personal significance. Just think, maybe you're living ahead of your time, perhaps you've found something that no one else has yet to discover, and it's your opportunity to share it with the world.

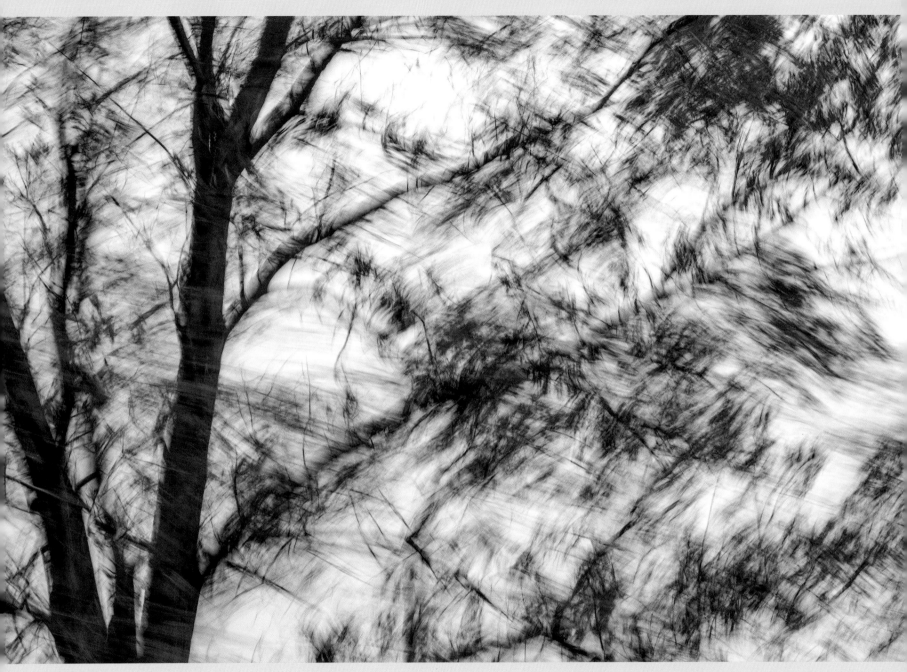

Maryland, 2012

CHAPTER 2 # Fear and Risk

Dance with fear, don't push it away.

—SETH GODIN

Telling your story with a new body of work involves risk. The work might fail, but you will never succeed if you don't even try. When we attempt something new, we have to let go of stability and find our own way. Imagine what it would be like to set aside your self-doubt and fears and simply create something because it would be personally rewarding.

I believe that we are all creative individuals and that we have a deep, inherent need to express ourselves and leave our mark in the world. When I embark on a personal project, I do so in hopes of making work that will improve my vision. I create personal projects to encourage myself to explore the unknown, venture outside my comfort zone, and discover something new that can be shared with others.

To remove fear and risk from the equation, give yourself permission to be the one that sets the requirements of the project as well as defines what the success of these projects looks like. As a result, you won't have to fear how other people will react to it. You won't need to look for external acceptance; the images do not have to resonate with anyone else. (You hope that they will, of course, but this gives you permission to take

more chances.) Instead of basing the success on whether or not other people accept it, the project's success can be based on whether you tried something new and, during that exploration, whether you learned something while telling the story. If I meet that goal, then I feel my project is a success.

Push Through Doubts

I think it's fair to say that we all experience self doubt at some point. We have that inner voice—that "heckler in your head" or "bully in your brain." Whatever you want to call it, when that little voice says you can't or you shouldn't: Ignore it. That voice is warm and comfortable and wants to stay that way. It doesn't want you to change, because it's afraid. But you're not. And *you* control that voice. Tell it you'll visit with it later when it has something more positive and encouraging to say.

It's hard to make a difference when you're trying to fit in. Instead, shift your goal to making work that will stand out. Photographs are an interpretation of the scene. Don't just document what's there; add your hand to it and make it yours. The reality is that others might not appreciate, understand,

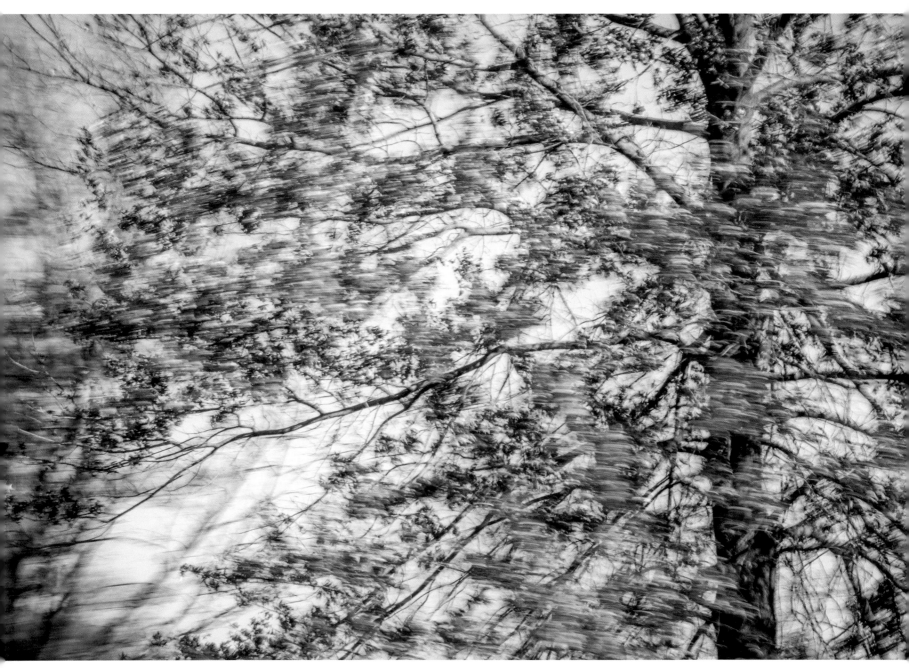

Maryland, 2011

Man cannot discover new oceans unless he has courage to lose sight of the shore.

—ANDRE GIDE

or accept your work. They might not be ready for your story. But that doesn't mean that you shouldn't tell it.

What if you could stop taking other people's feedback so personally? Wouldn't that be empowering? Are you willing to take that risk and stop limiting yourself by playing only in the shallow end of the pool?

I felt silly when I started the *Passenger Seat* project. I was sitting in the passenger seat of a car, panning a small point-and-shoot camera as we drove along the road. The camera had such a delay between the time I pushed the shutter button and the actual taking of the photograph that it wasn't even worth looking through the viewfinder. I had to try to anticipate when the shutter would open and what would be moving by the window at that time. I could only imagine what other people were thinking when they looked in the car.

But you know what? It didn't matter. Honestly, no one cares what you're doing. They really don't. And if they do, I would wager that they're really wishing that they were the ones that were trying something new, breaking out of the box that they've built around themselves, and seeing what you're seeing. Other people can make you feel silly, dumb, or weird only if you let them. Why give them that control over your life?

From Failed It to Nailed It

The first images that I captured were blurred beyond recognition. Complete failures. But I was determined not to stop until I made at least one image that worked for me. At first, I was panning the camera in the opposite direction of what was needed, *adding* motion to the image instead of trying to *freeze* the motion. By reversing the pan and slowing the camera to follow the landscape, I improved the images. To encourage myself (and take some of the seriousness out of it, because I had started to get discouraged), I started saying "Nailed it" every time I took a photo—even when I didn't. I laughed. I relaxed. And you know what happened? Eventually, I did "nail it." I still think some of the images that I took on that first trip are among my most interesting.

Your story is a gift to be created and shared—what are you waiting for? Our time on this planet is limited, and we all share the same fate. Dare to start your project without knowing the outcome. If you don't do it, you have already surrendered to fear, and the longer you put it off, the less likely it is to happen. Stop playing it safe, and give yourself permission to tell that story. If you don't, you're only hurting yourself by limiting your growth. At the end of the day, I want to say that I created something that was meaningful, don't you? You can. Just remember that the only person standing in the way of accomplishing your true potential is you.

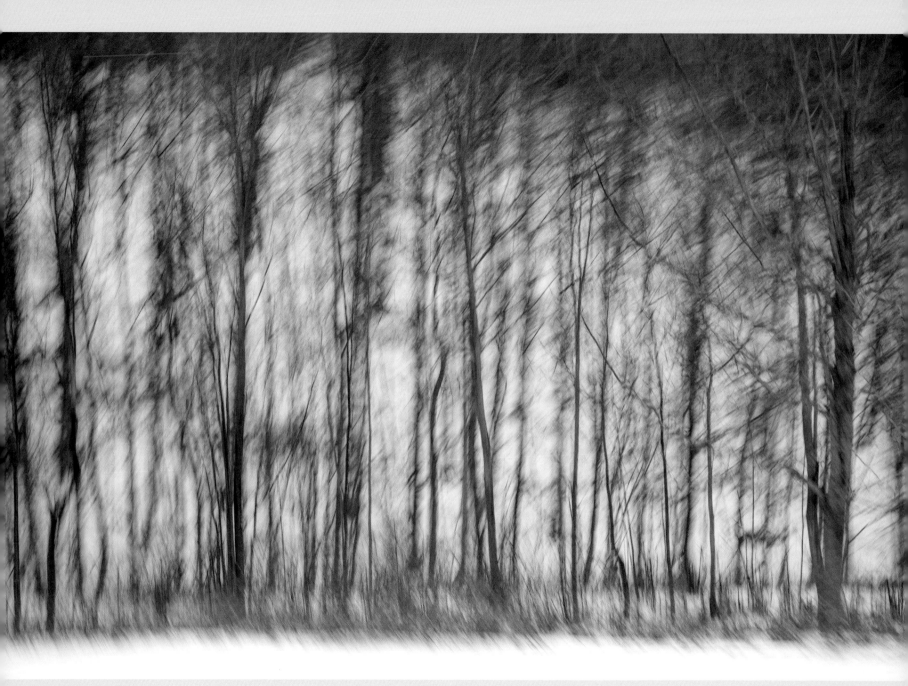
Vermont, 2010

CHAPTER 3 # Discovering Your Personal Project

> Do what you like to do. It'll probably turn out to be what you do best.
>
> —WALLACE STEGNER

Some photographers have multiple personal projects that they want to accomplish and actively work on them day after day, month after month, year after year. They know exactly what they want to do, and they are moving forward on their way to achieving their goals.

Other times, when I ask photographers about their personal projects, they shrug their shoulders, look defeated, and sigh. So I ask them what images they would be excited about making, but the most common response is "I don't know." At this point, I prod them a little and say, "I know that you don't *know*, but if you did, what would it look like?" When given permission that they don't have to "know" exactly what they want to photograph, they usually start describing a meaningful idea that they want to explore—at no risk, because after all, it's just an "idea."

What's Your Story

The important point is that we all have thoughts about stories that we want to tell; sometimes we just need a little help getting started!

As you begin to define your personal project, ask yourself:

- What is it that I would like to accomplish?
- What story do I want to tell?
- What event, location, or experience do I want to document, or create?
- What technique, skill, or concept do I want to explore?

In order to get what you want, you have to know what that is. Once you've defined a project, you'll be less likely to get distracted if you know what you want.

I had played with capturing camera blur before, but it wasn't until I took a road trip through New England, to see the turning of the leaves in the fall, that I decided to make it a project. Before that, just adding motion to an image was an interesting technique, but it didn't hold a deeper meaning in need of exploration. Once I realized that there was another reality that my eye was incapable of interpreting but that the camera was capable of capturing, I knew I needed to investigate. I wanted to use the camera to see what was invisible, to question my perception of reality, and to capture a moment in time that didn't resemble anything I was able to see with the naked eye.

I thought about how this desire to see

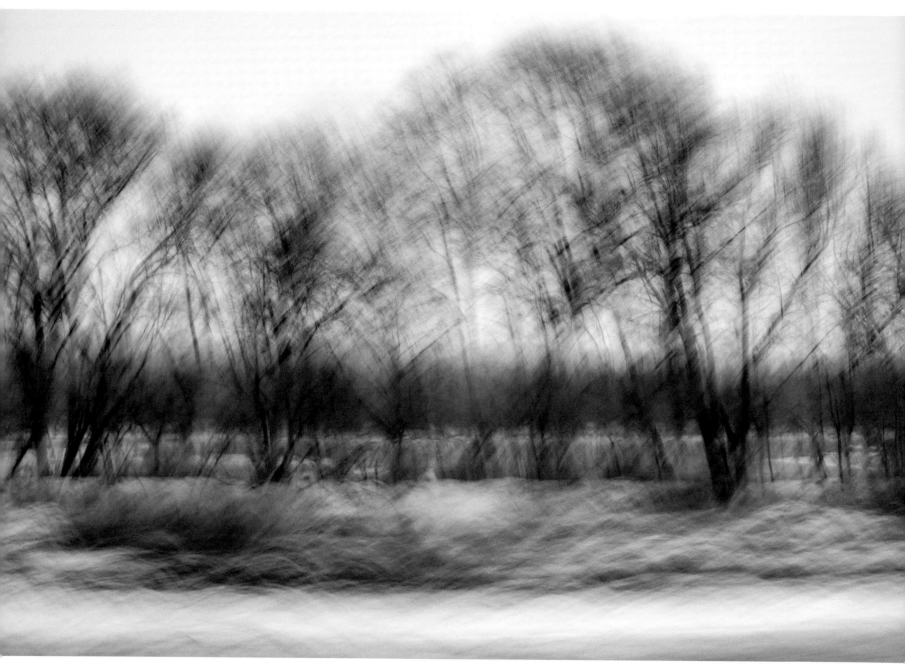

New York, 2010

the unseen paralleled other questions I have about life. What am I missing as I rush through my days, jumping from one project to another? Was I aware of and focusing on the things that really matter, or was I blind to things that were right in front of me? If I slowed down, would I be able to discover a new reality? Am I paying attention to the world, and if so, what in the world am I paying attention to? The ability of the camera to freeze a sliver of landscape in a fraction of a moment (a scene otherwise unable to be seen) allows me to look at the world with a fresh perspective.

I found a story that I wanted to tell, I identified an "event" that I wanted to document, and I chose a technique that I wanted to explore. These images, just like your stories, are simply waiting for us to slow down, take notice, and share them with others.

In addition, the *Passenger Seat* project was ideal for me because I don't always have a lot of free time to make photographs. By taking advantage of "idle" time in the car, I was able to create an entire body of work while getting from point A to point B.

If you don't have a specific project in mind, ask yourself:

- What do I enjoy doing?
- What are my interests, and how do I prefer to spend my time?
- Does this interest enable me to access someone or something that others might not have access to and that I would want to share?
- How can I use my knowledge, personal insights, and emotional attachment to the subject to help tell the story?

Things that seem common to you may be completely unique and fascinating to someone else. We tend to dismiss what is familiar to us, not realizing how "foreign" our lifestyles might appear to others. Photography can open doors and give you access to people, places, and things that you might not otherwise be brave enough to investigate. Just having a camera can give you the needed boost or permission to photograph a scene. For instance, I photographed out of the windows of commercial airlines for years while traveling from one location to another for my job, eventually publishing a book called *Window Seat*. While many other people travel as a part of their jobs, I was able to take advantage of having access to a unique perspective from which to make photographs and tell my story.

Find a concept that you want to explore, and follow that lead. A few years ago I started restoring an old house, replacing the "obsolete" technologies with more modern ones. At first, I was thrilled to be stripping out the knob-and-tube wiring and removing the coal furnace. As I removed them, however, I began to feel that I was stripping the house of its heart and soul—these very

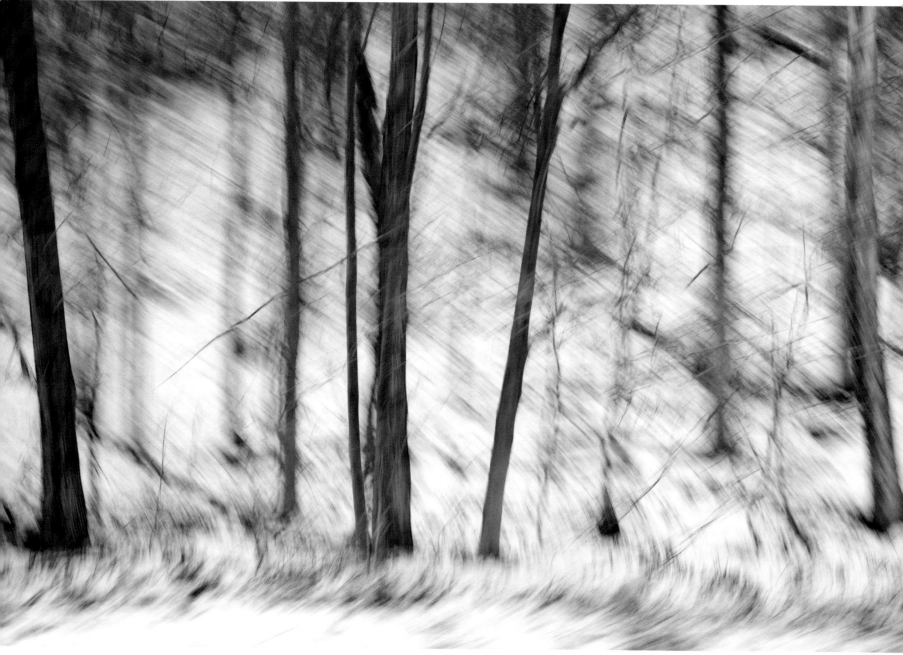

New Hampshire, 2010

A journey of a
thousand miles
begins with a
single step.

—LAO TZU

features, so cutting edge in their day, were now destined for the landfill. I quietly rescued many of the items from the all-consuming dumpster so that I could photograph those utilitarian objects with the dignity that they deserved—permanently documenting their place along the continuum of technology. There are so many stories to be told.

Instinct and Intent

If your next project isn't self evident, don't fret, just get out there with your camera and make photographs of what you are passionate about. Trust your instinct. You don't always have to have a specific direction in mind; sometimes we need to make photographs before we can discover their intent. I have photographed many subjects over the years (abstract landscapes, water in its different forms, even power lines), and only time has revealed which of those projects ended up being part of a significant body of work. I try not to limit myself when I go out

and photograph, because I never know what images might resonate at some point in the future. I might not understand the images that I make today, and it's only in hindsight that I can discover their meaning and their relationship to my life at the time that I made them.

If you need something more concrete to get you started, give yourself an assignment. Keep it simple. Give yourself a number of images to capture with in a specific time limit. For example, you can choose to photograph a specific shape (arrows or rectangles) or color (blue or magenta), a subject (fish or mountains), or an emotion (tranquility or joy). Or take a ten-minute walk with your camera and commit to making five images of different yet related subjects. The photographs may never win awards, but the exercise will enable you to practice your passion and exercise your creativity. The objective is to get out and start making images, which will, in turn, spark another idea and keep the momentum moving forward.

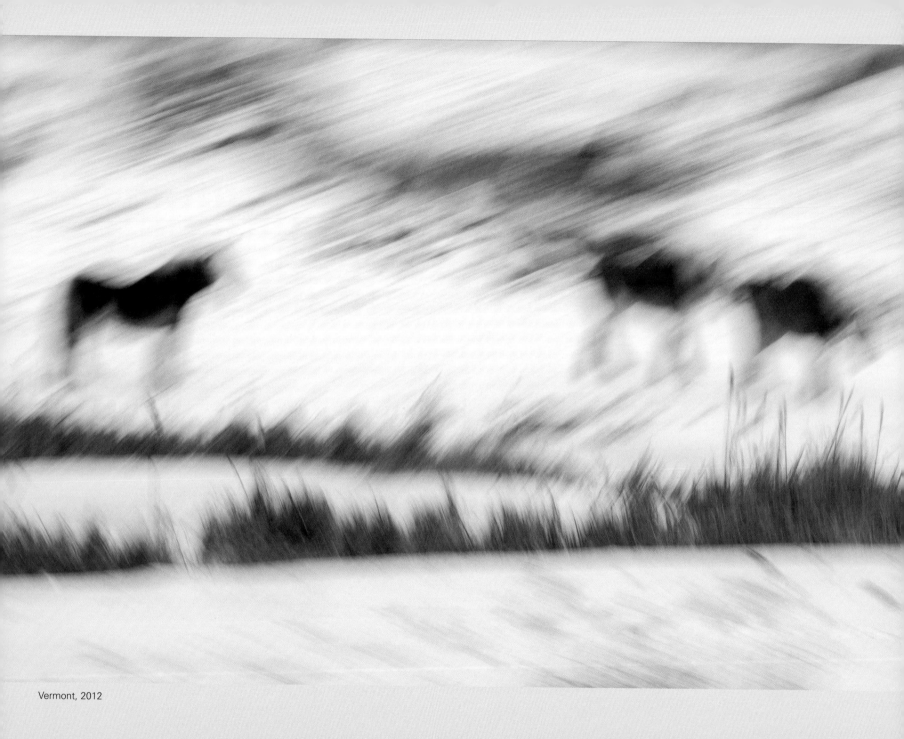

Vermont, 2012

CHAPTER 4 # Finding Inspiration

> If you can dream
> it, you can do it.
>
> —WALT DISNEY

I am a firm believer that inspiration can be found almost anywhere if you are open to new ideas. Because of this, I try to expose myself to as many different experiences as I can. And anything that I see that catches my attention, sparks my imagination, or triggers a visceral emotive experience, I record in an idea bank for later reference.

Ever since I can remember, I have kept a journal (in fact, several at one time) to collect and store ideas. I'm an avid reader and books are one of my favorite sources of inspiration. I jot down words that I don't know and look up their definitions, and I keep track of quotes, notes, descriptions of places and people, lyrics, anything that triggers a visual that I feel is worth remembering. I don't know when I might use it, but I don't want to lose it. I keep a pencil and paper next to the bed at night so that when I have that artistic insight I can write it down so that I will remember it in the morning. I relish knowing that I have diaries of inspiring references that I can return to at any time.

Don't Get Too Comfortable

To make work that tells a compelling story, we need to look closely at the things that surround us, which can be very difficult to do when we're merely going through the motions of our lives. Habits in and of themselves are not bad, but we need to avoiding the mind-numbing routines that form when we set our lives on auto-pilot. I try to constantly push myself to break out of the comfortable cocoon that I find I am predisposed to spin around myself. If I'm not paying attention, I will drive to work by the same roads, eat the same foods, and solve problems in the same way, time after time. Instead, open yourself to new experiences— explore a new neighborhood, try a new food, play a new sport. Try to do something new every day. Challenge yourself to constantly evolve.

Learn how to do something unique every year. Be a beginner and ask questions. Flip on your "learning switch" to expand your mind in new directions. Keep your brain exercised. Take an active part in the world. Be a creator as often as possible; don't be satisfied with merely being a bystander. Do interesting things, and chances are you will become a more interesting person. It's far more gratifying to generate your own content and tell your own stories than it is to simply watch and consume other people's take on life.

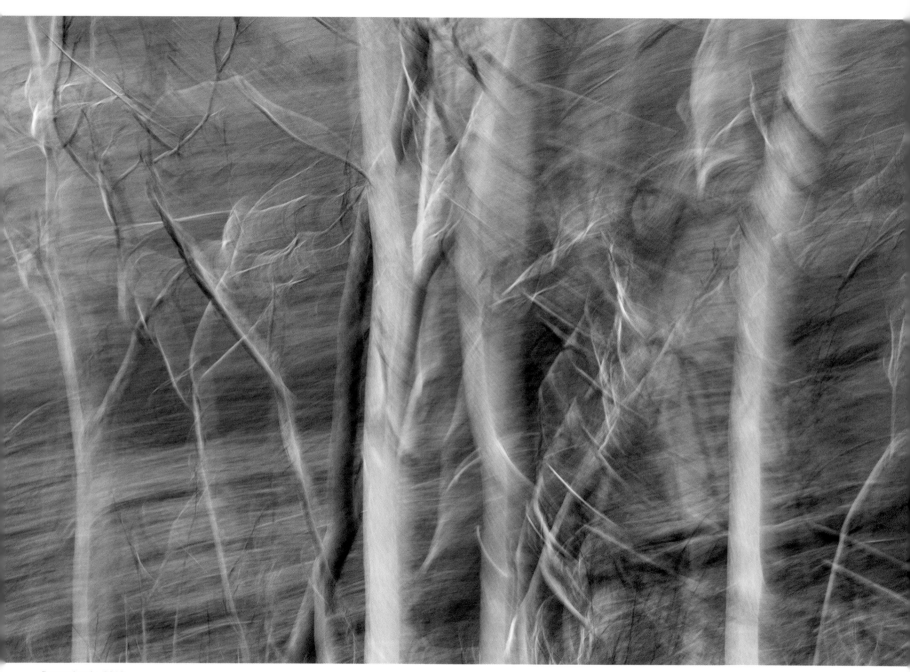

Pennsylvania, 2012

Visit other places; seek out other cultures. Traveling is one of the easiest ways to alter your consciousness. Changing your environment can instantly expose you to different customs, divergent architecture, distinctive fashion, and diverse behaviors. As Arthur Schopenhauer said, "Every man takes the limits of his own field of vision for the limits of the world." These predetermined views prevent us from exploring things. Trying to understand other people's point of view and seeing the world through their eyes can help us overcome some of our own fears. Don't fight it. Open yourself up to others' ideas and ways of life. Don't judge; just be a part of it. Be in the moment and experience the situation, and see where it takes you.

Look, Then Look Deeper

Of course, we don't have to travel to change perspective. The key is to make sure that you continuously view the world around you with fresh eyes. Try looking from a different point of view. Get down low or climb up high. Get close to a subject, then back away. Look at the quality and quantity of light and study the shadows. Look for reflections; notice where lights converge and subjects overlap. Pay attention to negative and positive space. Scrutinize your surroundings and take note of the details. The more "present" you are, the more you will see.

Try staying at one location for one hour and make ten photographs of different things. Then make ten different photographs of the same thing. Forcing ourselves to slow down and analyze the world around us provides new insights and opens new doors.

I have a habit of walking around my neighborhood in the morning. I collect things that I see on my journey—interesting twigs, seedpods, even metal coat hangers (I'm astonished at how many of the twisted hanger tops I have found over the years). I don't typically know exactly how I will use them when I find them, but over the years I've photographed many of the objects, incorporated others in my encaustic paintings, and even decorated the planting beds in my gardens with them.

Sometimes I give myself assignments for the morning walk. I'll look in my journal for ideas, and then try to find examples of those concepts when I walk. I might choose a word, like "resilient," and then try to find examples of how resilient nature can be and photograph them—weeds growing up through the sidewalks, trees overtaking a side-yard, and insects building their homes within an abandoned structure. When I encourage myself to look at things more closely as I walk by an empty lot, I find myself wondering what world is contained in that space that I walk by every day and don't even notice. If I really look, how much life would I find in a

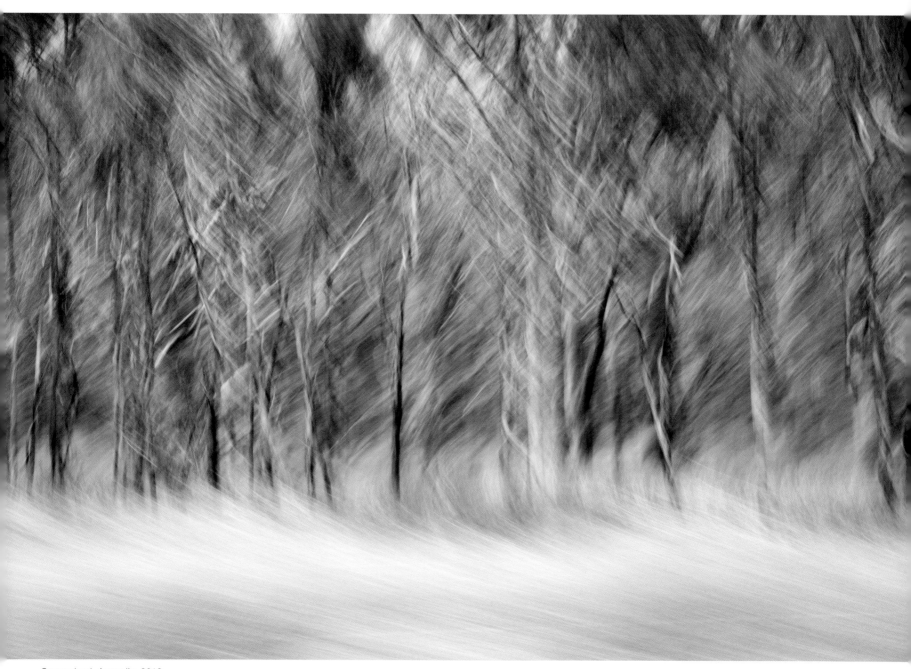

Queensland, Australia, 2012

The more one looks, the more one sees. And the more one sees, the better one knows where to look.

—TEILHARD DE CHARDIN

shovelful of earth or the branch of a tree? Nature is a source of infinite variation and inspiration. Make the time to study and take in its beauty.

I constantly observe the way other people capture the world around them, as well. I look at photographs anywhere I can—in books, online, in museums and galleries. By studying other photographers' work, I have learned a great deal about what I feel makes a successful image, from content to composition to lighting. I look at other sources of imaging, such as alternative light sources (infra-red and ultraviolet), chemical-based processes, scanning microscopy, and molecular science. They all have the potential to influence my photography and generate new ideas.

I try to stay well rounded by looking at other mediums of art—sculpture, painting, fiber, installation—from different cultures around the world, today and throughout history. Inspiration can come from anything—a piece of music that kindles the imagination, the beauty of a well-built piece of furniture that brings us joy, or a simple, thoughtfully prepared home-cooked meal that comforts our soul.

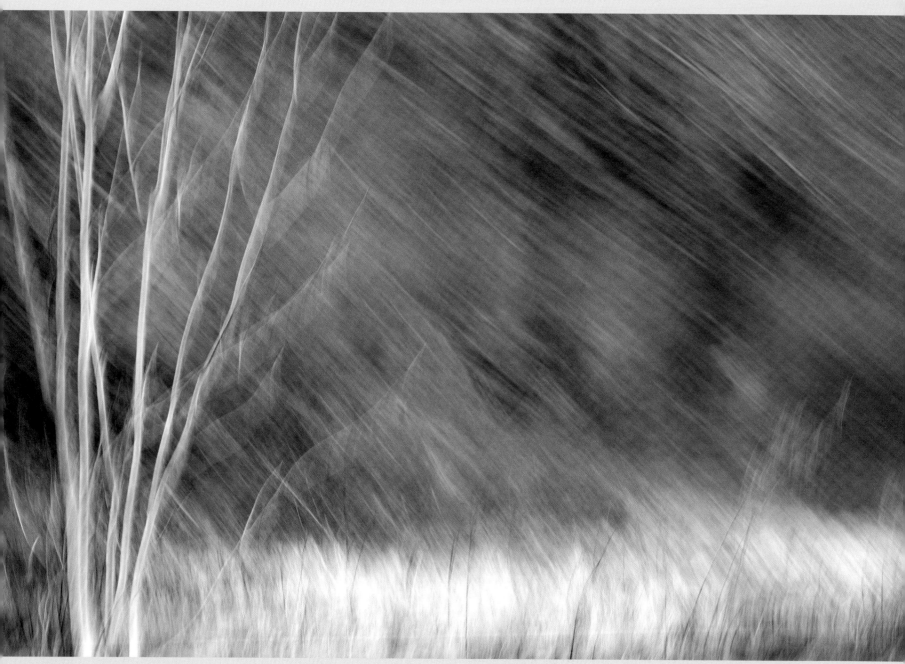

Maine, 2014

CHAPTER 5 # Limiting the Scope of a Project

An idea can
only become a
reality once it
is broken down
into organized,
actionable
elements.

— SCOTT BELSKY

After letting your creativity run free to find the inspiration and topic for your personal project, you need to rein it in a bit and establish boundaries. I find that the more I can narrow down the scope of a project, the more likely that I am to accomplish what it is that I set out to do. That might sound counterintuitive, but for me, when there are endless possibilities, paralysis sets in and I find it very difficult to begin. If you tell me that I can make images of anything in the world, I will hesitate because I don't know where to focus my efforts. If you tell me instead that I need to make images of San Francisco or the neighbor's dog, I can immediately begin to imagine what the story and related images might look like. Limiting the subject matter can also make the body of work more cohesive and make it easier to lead the viewer from one image to the next when sharing your story.

Certainly there is wisdom in letting a project evolve as you work through it, but the odds are better that you will actually finish the project if you create a plan, draw a map, and then move forward in order to make it happen. Sure, you can get to the same destination without a map, but maps (as well as goals, plans, and lists) help you get from point A to point B in a more direct manner. Limiting the scope of the project enables you be *more* creative by staying mentally focused and avoiding distracting detours. Sometimes limiting the chaos by determining what not to include will help form what is included.

Work Backwards

Thinking ahead to your destination and working backwards to your starting point can be equally effective ways of defining the scope of your project. Once I have the beginnings of a collection of images that I believe will tell a meaningful story, for example, I previsualize the finished project and figure out what needs to be done in order for me to accomplish it. To be sure that I think through the project, as well as reinforce these thoughts, I write them down (or enter them into the computer). This is not to say that every image I make has to be part of a predefined project, only that as I start constructing a substantial body of work I find it helpful to set expectations for the final result.

With the body of images in this book, for example, I knew that I wanted to publish a book, have a gallery exhibition, and post the images online to my social media properties.

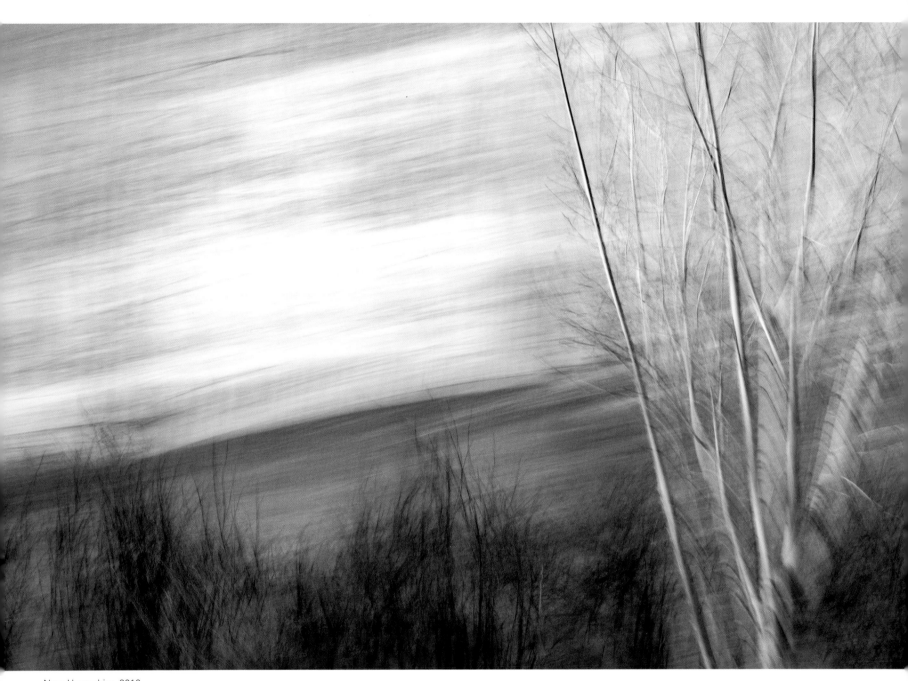

New Hampshire, 2010

In order to do this most successfully, I needed to have control over how the images were displayed as well as the sequence in which they were shown. A curated experience can help viewers interpret the work, and as the creator of your project, you are that curator. A well-told narrative can help viewers understand a subject that they don't know a lot about. And isn't that what you're doing? When telling your story, you are helping others to see something in the world that they may have overlooked. What a gift to be able to expand someone's curiosity and provide them a portal to a world that is uniquely yours.

Questions to Ask

Whether you work forwards or backwards, a few additional questions that can help you limit the scope of a project are:

- **How will the images be displayed?** Knowing how you will be sharing your images can potentially have a tremendous impact on how and what you shoot. Different presentations (books, galleries, electronically, onscreen, projected) will have different requirements for file size, which may determine what camera you need to use to capture the image. For this project, once I decided that my project required an exhibition, I chose to photograph with the Canon 5D Mark II

because it captures the largest file size (21MP) and highest image quality (RAW) of any of the cameras that I own.

- **How many images does the final project call for?** Are you looking to create a single image, 25 images for a gallery exhibition, or 200+ for a book? Will each image need to stand on its own, or do you need a mix of primary and secondary (supporting) images?

- **What format do the images lend themselves to?** Does the subject matter lend itself to vertical, horizontal, square, or panoramic format, or to an assortment of different orientations and aspect ratios?

- **Would the visual narrative be more compelling if processed with a specific style or look?** Will color or black and white be a better choice? What about using a camera converted to infrared, film, or a different alternative process altogether?

- **What is the thread that will stitch all the images together to tell a cohesive story?** How will you sequence the images? Do you need to have images from specific locations or that span multiple categories (the four seasons or day versus night)? Will they be sequenced chronologically or by some other factor (subject, concept, mood)? Will you include wide shots for context and close-ups for detail? How will you vary the images to

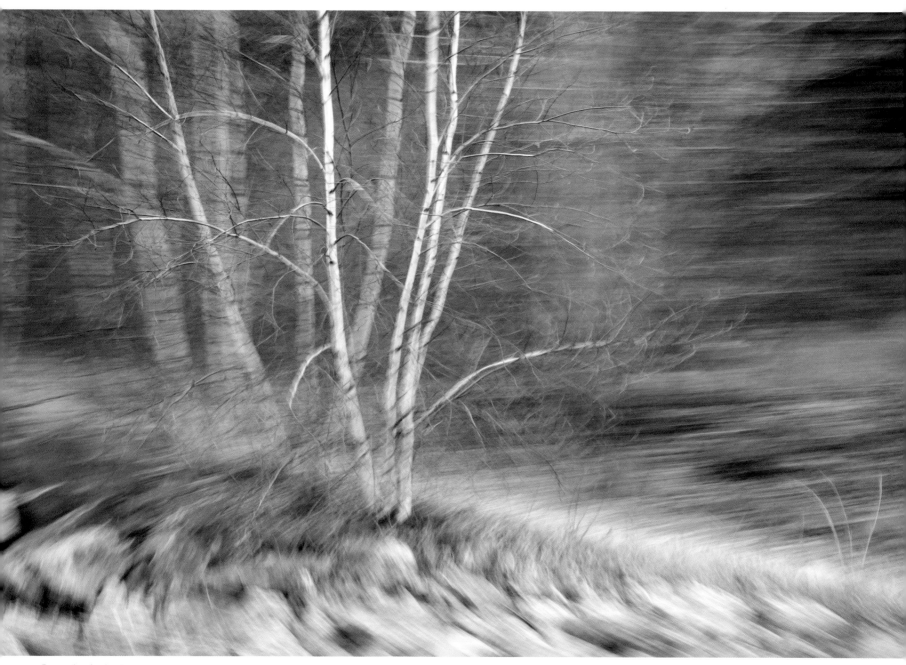

Pennsylvania, 2012

Art, in itself,
is an attempt
to bring order
out of chaos.

—STEPHEN SONDHEIM

keep them unique while remaining united so that the viewer can easily progress from one image to the next?

- **How will you know when the project is complete?** When do you draw the line in the sand and say, "This is it—this is what I've created, and at this moment in time the project is finished" and set it free to the world?

This last question can be very difficult to answer, because I am not sure that anything is really ever complete, just as nothing is ever perfect or permanent. Giving yourself boundaries and constraints, however, can help.

For the *Passenger Seat* project, I added another constraint to keep the aspect of "play" in the project. I determined that there would be no "go-backs." Even if I missed what I thought might have been the most incredible image, I wouldn't ask the driver to turn around and drive by it a second time. I felt that going back and trying to photograph what I thought would make a good image for this project, based on what I saw, would have gone against the very nature of the "unseen" element that I was trying to capture.

In addition, I used this constraint to help me avoid one of my biggest obstacles to being creative, which was my desire to achieve the unachievable: perfection. When you're taking on a personal project, it might be helpful to think about your biggest stumbling blocks and what constraints you can add to avoid them. If you know that you procrastinate, would setting a timeline help keep you on track? If you know that you're easily distracted or take on too much, how could you define the scope of the project to avoid project creep?

Regardless of all your preparing, even if you have the best of intentions, life isn't perfect. It's messy and chaotic and it rarely turns out exactly as planned. My projects emerge, unfold, and advance over time, but limiting the scope of the project allows me to do fewer things better.

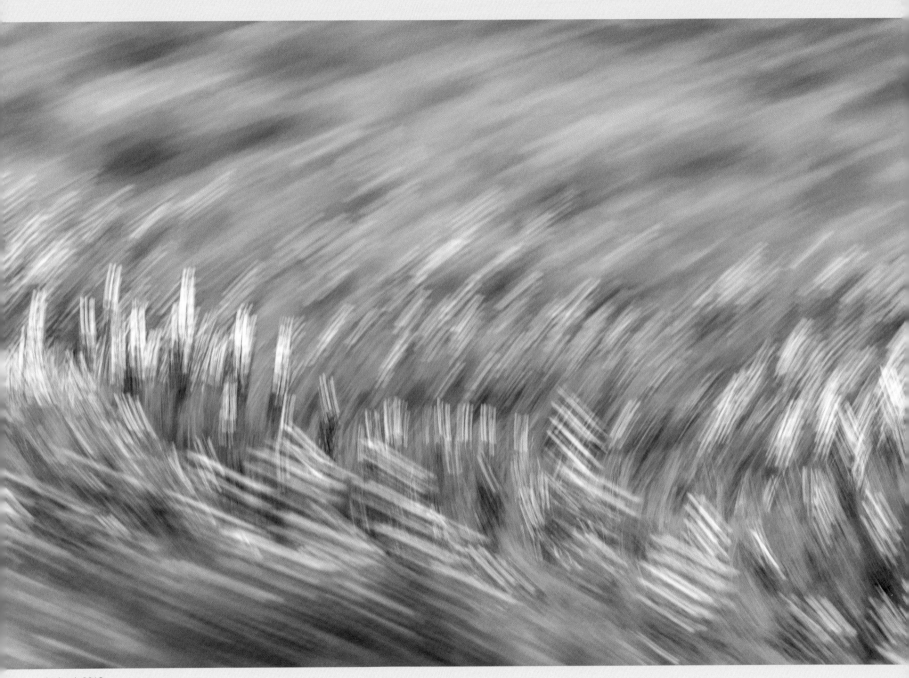

Iceland, 2012

CHAPTER 6 # Moving the Project Forward

What counts is not the hours you put in, but how much you put in the hours.

—SAM EWING

Planning a pragmatic course of action will help make sure that your personal project (and all of your creative endeavors) continues to move forward. Look at your behaviors, figure out how you get things done best, and use those strategies, tactics, and habits to your project's advantage. For example, I know that I work best in the mornings, when I'm more alert and observant. Therefore, I make sure to put time on my calendar early in the day for tasks that I find difficult, such as selecting the best images from a shoot, making sure that they work well together, and finding the most compelling way to sequence them.

I know that I need a tidy and organized environment to do my best work. A clear space can help clear the mind of distractions and open the flow of creativity. In my house, I try to make sure that everything has a place and that those things are put in their places. As a result, I rarely waste time looking for something. And when I leave the house, a quick glance at my desk is all it takes to make sure that I have everything I need. I used to have a fair amount of clutter, but I am always working toward finding the balance between the want for things and the freedom achieved from not having things.

If you like to photograph alone, then schedule time when you know that you won't be interrupted. If you prefer to work with others, surround yourself with positive people to help feed your soul nourishing content. Like ripples in a pond, everything we do influences who we are and the work that we create. Collaborate with other people and inspire one another. If music helps you process your images on the computer, then be sure to have it accessible when you're in your studio. The better you know yourself, the easier it is to figure out what you need to do to realize your goals.

Write It Down

The single best method to keep me on track, for instance, is organizing my projects into written lists. Making a list helps me clarify my thoughts, focus on my vision, and be more productive, by freeing up my mind from the logistical tasks so that I can then be more creative (or present) when I'm making the images. I keep more than 50 lists at any given time, including lists for all my projects so that I can quickly move between them as time allows. I could never recall all the goals, steps, notes, details, appointments,

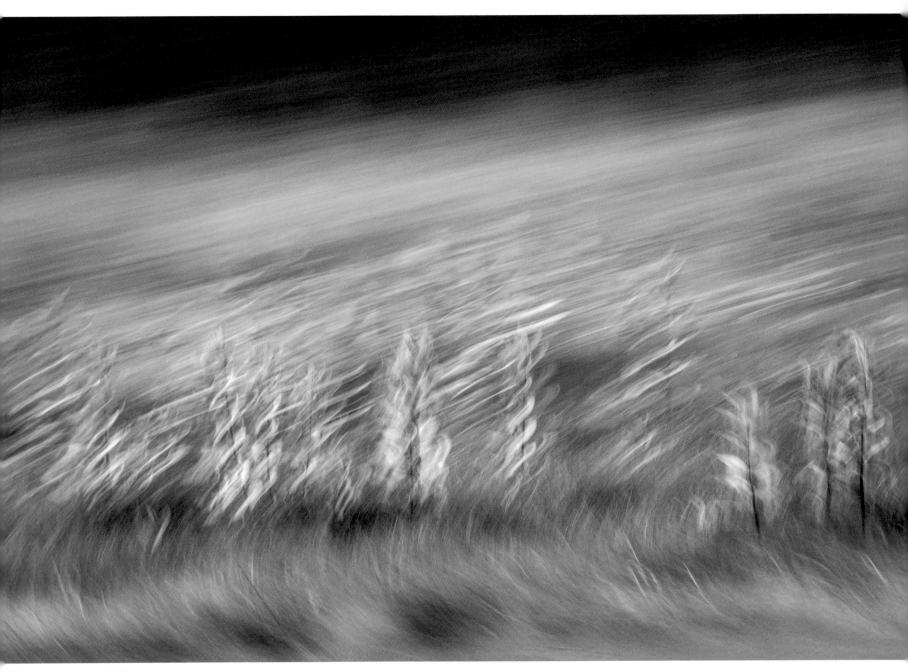

Pennsylvania, 2013

reminders, and other information on all of my current project lists, but knowing that I can reference them at any time puts my mind at ease. I no longer have to rely on my memory. What you know often isn't as important as whether you can find what you need to know. I keep my lists close at hand so I can refer to them and keep myself on track. (Currently, I use Evernote, a cloud-based solution, to make and store my lists so that I can access them across all my devices.)

Writing things down also helps you set the framework, priorities, and goals for the things you need to do. It forces you to slow down and evaluate what is really important, and what you can let go of. Lists can help you estimate the time necessary to complete a task, prevent you from overbooking your schedule, and help you track your time. Lists enable you to work out the practical aspects of a project and determine scale and costs. They help you stay focused on the current state of the project and enjoy the journey instead of focusing only on the final goal. This organization with a bias toward action (and the efficiency that it brings to a project) is a competitive advantage—even when you're only competing with yourself.

Break each list down into objective, quantitative, and realistic tasks that you can clearly "check off" when finished. One accomplishment motivates the next and encourages forward momentum, while simultaneously keeping the project from being overwhelming and causing anxiety and a breakdown in the creative flow. Try making the tasks small. As those boxes start to get checked off, you'll begin to think there are an unlimited number of projects that you can do!

Because I work best under deadline (which is really another way to limit the scope of a project), I also include a timeline in my list. This helps me guide the project along while making sure that I don't forget any important steps. For example, I block out specific days for making photographs, for post-processing, and for meeting with others (such as publishers, printers, galleries, and the like). Each project has different requirements. If you can anticipate what you will need to do along the way, it will most likely expedite the entire process. If you work best under time constraints, then put one on each step. If you know that you aren't going to be able to get to the work this month, document where you are so that you know where to pick up from. And if you know that you typically underestimate the time that it will take you to complete a task, add in some buffers so that you aren't putting yourself under unnecessary stress.

Be Accountable

Enlist your friends, family, trusted circle, or community to hold you accountable and keep your creative body of work on track. If

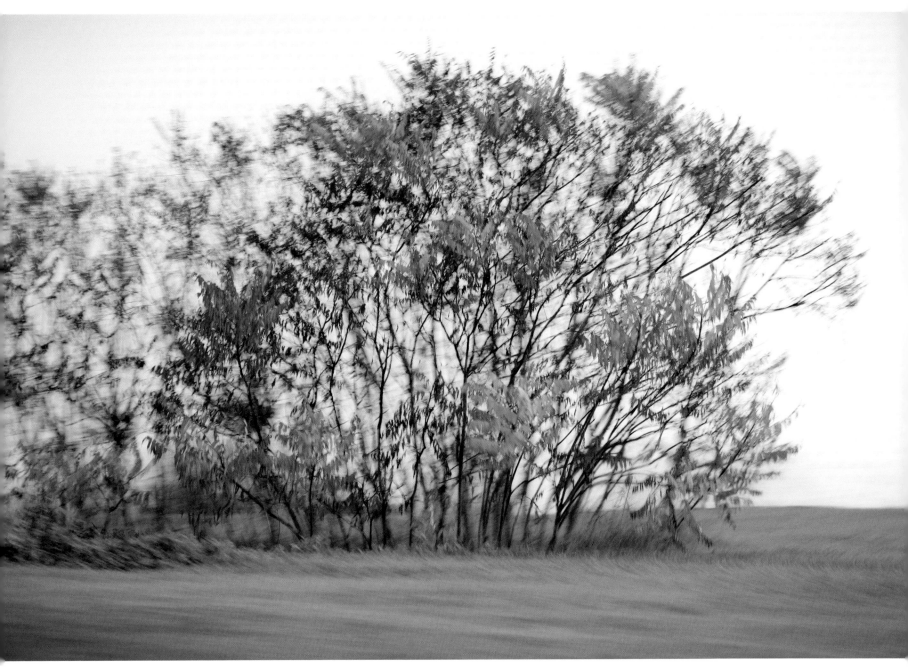

Pennsylvania, 2009

Photography is 90% sheer brutal drudgery and 10% inspiration!

—BRETT WESTON

you announce your plans and make them public—even if it's just to one other person— you are much more likely to accomplish them. I wanted to write this book for a long while, but it took signing an agreement with a publisher to make me make a definitive commitment to keep typing. If you can't self-motivate, choose a supportive colleague, one that will also help you move forward when you're stuck standing still. I always try to choose someone that knows more than me and will push me—like a coach. Athletes and musicians have coaches throughout their lives, so why shouldn't we, as photographers and artists?

Most importantly, you simply have to do the work. Seriously. You have to show up on a regular basis and put in the hours. There are days when I might not *feel* like making photographs, but that's when I know that I have to step up and take action. I know that might sound a little harsh, but sometimes we need to stop making excuses and start making images. Don't lose sight of your long-term goals. If you want to make that meaningful body of work, separate your emotions from the task at hand and do it.

Even if it's just a small step today, move the project forward. Don't just talk about it—actions speak louder than words. You are in control of the outcome—and you have already established that you want to tell the story—so instead of waiting for the perfect moment or the perfect trip or the perfect subject, just get out there and push it for-ward, one step at a time. You can do this!

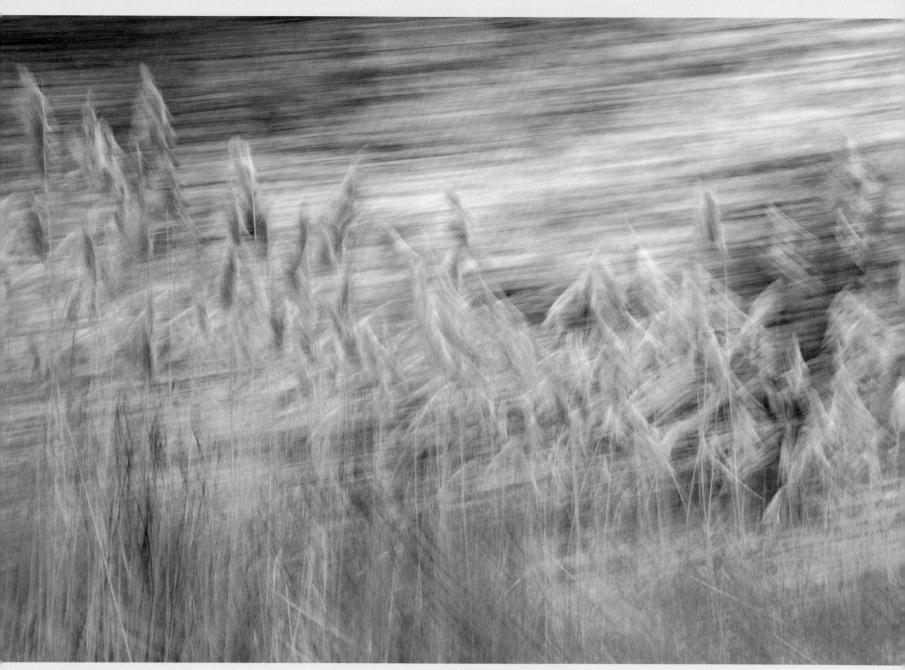

New York, 2010

CHAPTER 7 # Perseverance

> The only place success comes before work is in the dictionary.
>
> —VINCE LOMBARDI

We all have days where we just can't seem to execute the images that we can visualize in our minds—and it's frustrating. Of course we can blame it on the weather, the light, the subject, or a million other things, but sometimes we have to realize that we might be getting in our own way. So what do we do then?

When I'm not successful the first time around, the first thing I do is see if I'm really present. Ask yourself, "Am I in the moment or distracted by other thoughts—something that happened yesterday or something that's going to happen tomorrow?" If you're not focused on what you're doing *now*, don't be surprised at the end of the day when you realize you didn't make the images that you wanted.

Look In to See Out

If those distracting thoughts persist and you can't stay in the moment, then you can't reach your creative potential. I find that looking inward to see what is causing the disruption is the quickest way to change my behavior as well as my mood. Most of the time, a small change can make a huge difference. The better you know yourself, the quicker you can do what you need to do in order to get in your "zone."

Figure out what you need to do to give yourself a jump-start on an "off" day. Because we are influenced by that which surrounds us, I find that the fastest way to realign my mood and get in the correct frame of mind is to change the environment. Sometimes it's really helpful to put the camera down for a moment and take a deep breath or a 15-minute break to regain your balance (or find your quiet place). Try listening to some music or taking a walk around the block. Sometimes you have to step away in order to step back with a clear mind.

Ultimately, I know that what I really need to do is simply begin. Once I'm able to focus on what's in front of me, my incessantly chattering monkey brain switches off and I can lose myself in the process. Making photographs can be frustrating, but not making photographs is even more frustrating. You need to do the best work that you can in the moment that you're in. Making images can be cathartic. You might be surprised when you look back at a body of work to discover that it represents something much more cerebral (and self-revealing) than you thought at the time.

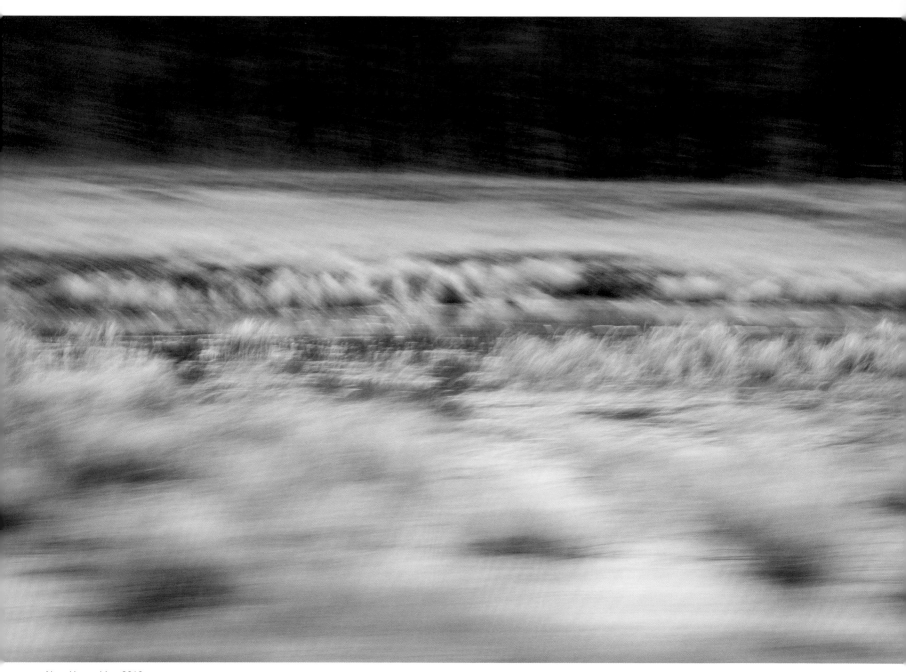

New Hampshire, 2010

If I know that I'm present and focusing on the here and now and the creativity still isn't flowing, I check to make sure that I'm not so intent on getting the image that I was "expecting" to make that I am missing all the other ones that are revealing themselves to me. If things aren't going the way you want them to, just roll with it and don't get frustrated—something else will come along. I try to view these days as a chance for discovery and experimentation.

Pause, Don't Stop

You might need to switch to a different project for the day, knowing that you can return at a later date. Everything in our lives is cyclical. We aren't always at the top of our game. If you hit the wall, take a break. Athletes take days off to rest, recover, and rebuild their strength. Sometimes we need to do the same for our creative muscles. Make it a priority to take care of yourself. Be well rested, exercise, eat well. Accept that some days will be more successful than others and we can't always be creative on demand, but it's nearly impossible to move forward if you just sit there like a bump on a log and do nothing but make excuses for why you don't want to take photos. (I know, tough love.)

If you're in the middle of the project and you're frustrated, you might need to postpone it, even step away from it, but don't quit. It's almost impossible to make a qualitative judgment as to whether the body of work you're absorbed in is going to be successful while you're in the middle of it. A frustrating moment is most likely just that—a temporary setback, relatively minor and quickly forgotten when the project is finished. Your work can, should, and will grow and mature. If you need to place it on the back burner for a while, fine, but if the project has meaning, I strongly encourage you to finish it. Only when the project is complete will you be able to decide if it is the story that you wanted to tell.

Train Your Vision

The success of an image depends on you, your eye, and what you decide to bring to the table. Cameras can't come up with ideas—they don't decide when to click the shutter, nor can they compose the image. Those decisions are all up to you—and that's why, even if "it's been done before," you will always do it differently from everyone around you. So go for it! You will benefit from the project in more ways than you think.

The *Passenger Seat* project enabled me to become quicker with my camera and anticipate what's coming next, and in turn, this practice has also helped my other photographic projects. Your photographic vision is just as important as any other muscle. Certainly if you train your body, you can

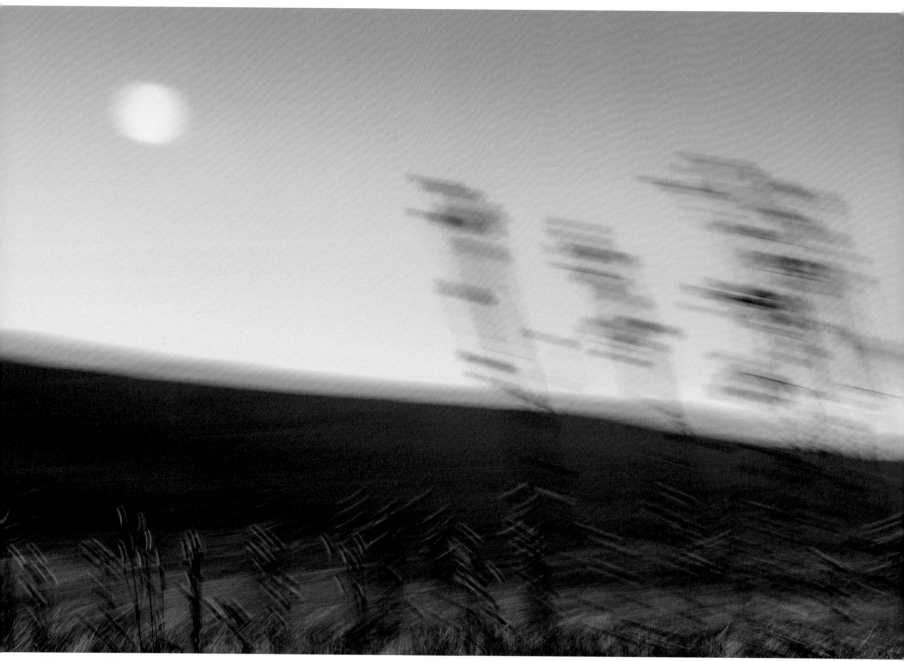

Pennsylvania, 2010

Art is making the invisible, visible.

—PAUL KLEE

run a marathon, but if you don't work out, you're going to lose that ability. Your vision is the same—you have to exercise it in order to stay creative. And athletes don't just work out their legs or their arms, they work out their entire bodies, and if they want an added edge, they're going to eat well and get the rest they need. We owe that to ourselves as creative human beings who make and share stories with others, enabling people to see things from different points of view.

I have shot a *lot* of images over the life of this project (probably around 30,000), and most of them are junk. Trash. Garbage. They never even had a chance. I deleted image after image because the blur was too much or too little, too soft or too wild, too little was in focus or too much was in focus. I have kept less than half the images I shot, and maybe only 1500 of those will ever see the light of day. But I never got discouraged when less than a dozen images turned out after shooting for hours, because I was enjoying the journey.

I promised myself early on, and you should do the same, that I would pursue my project as long as it was enjoyable and continued to push me to grow and learn. If it was meant to happen, and I was able to make prints and a book and have a show, then so be it. If not, I didn't need another stressful project in my life. I believe that because of my relaxed attitude, I actually became more involved and attached to it, making it an even greater challenge and opportunity for me to see it to completion.

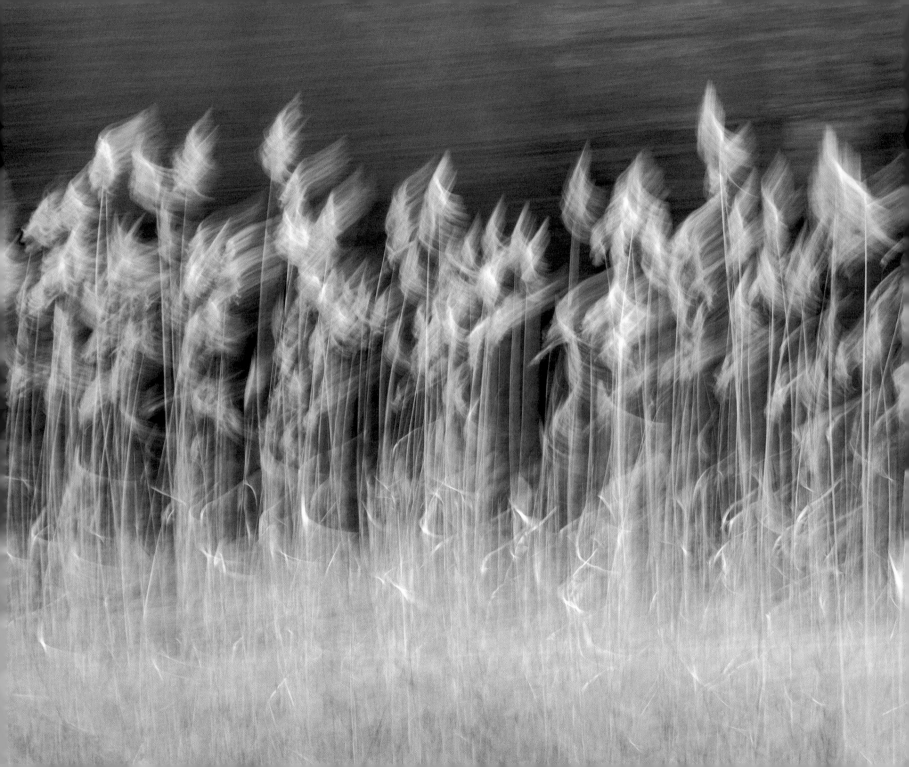

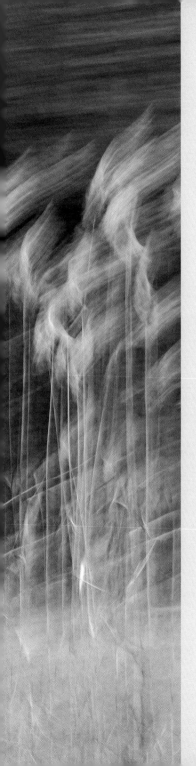

PHASE II

Making Photographs

New York, 2014

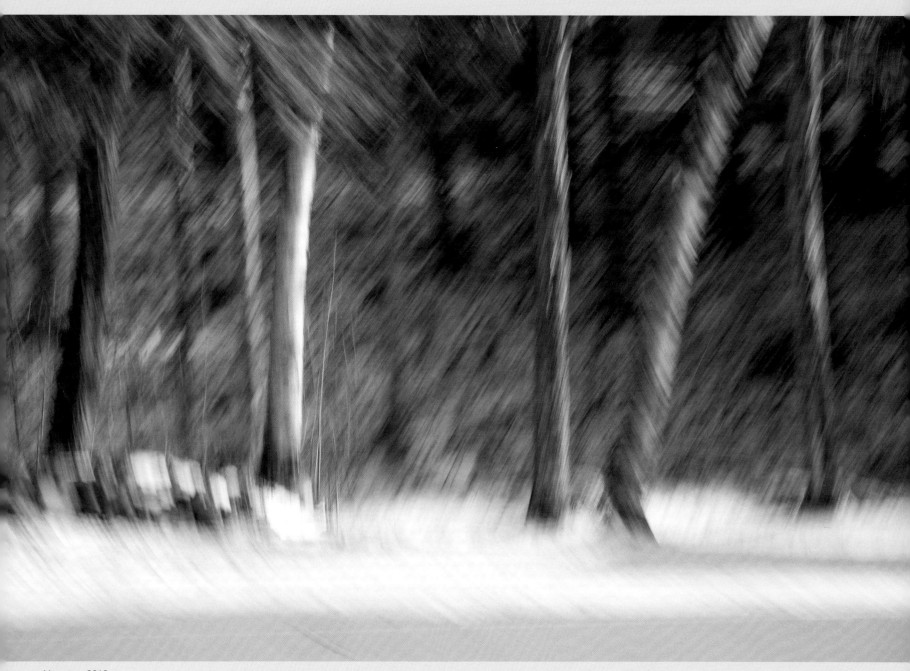

Vermont, 2012

CHAPTER 8 **Being Prepared**

> To be prepared is
> half the victory.
>
> —MIGUEL DE CERVANTES

I'm sure that most of us can recall at least one instance when we didn't have the equipment we needed and missed the shot as a result. You forgot to charge that extra battery or to bring a polarizing filter for the lens or the mounting plate for your tripod, and as a result, not being prepared cost you what felt like the photograph of a lifetime. It's painful but preventable. All you need is a list.

For the *Passenger Seat* project, I knew that my opportunities would be limited both by the amount of time I had to dedicate to the project as well as by the time spent in the passenger seat making images. I had to be prepared if I was going to take advantage of the opportunities as they presented themselves. In a proactive attempt to avoid being my own worst enemy by accidentally forgetting essential equipment, I chose not to rely on my memory but instead to write down a list of what I would need. The equipment list, as short as it was, reminded me at a glance of everything that I needed to have on hand before heading out the door. I also tried to check the list ahead of time, in case I needed to charge batteries or free up space on a hard drive.

As you can see by this list, I didn't need to carry around a lot of heavy photographic equipment to make the images:

- **Camera.** I wanted to be sure to use the highest-quality camera that I owned, so I turned to my Canon 5D Mark II. I set the camera to capture the highest image quality: an uncompressed 21Mp RAW file.
- **Lens.** I found my 28–105 f/4 lens to be the most practical lens for this project. I wanted the flexibility of the wider angle while having the zoom available for when the roads had a larger shoulder and the distance to elements in the landscape increased. It was an absolute necessity that the lens had auto-focus. I probably would have smashed the car window if I had used a longer lens.
- **Neutral density filters.** Because most of the traveling occurred during midday, I often used a neutral density filter to reduce the amount of light and help slow the shutter speed.
- **SD or Compact Flash cards.** Camera cards are relatively inexpensive and worth the investment. This project required that I take a significant number of photographs to be successful, and I didn't want to get forced into deleting images in the camera to conserve space. Certainly, you

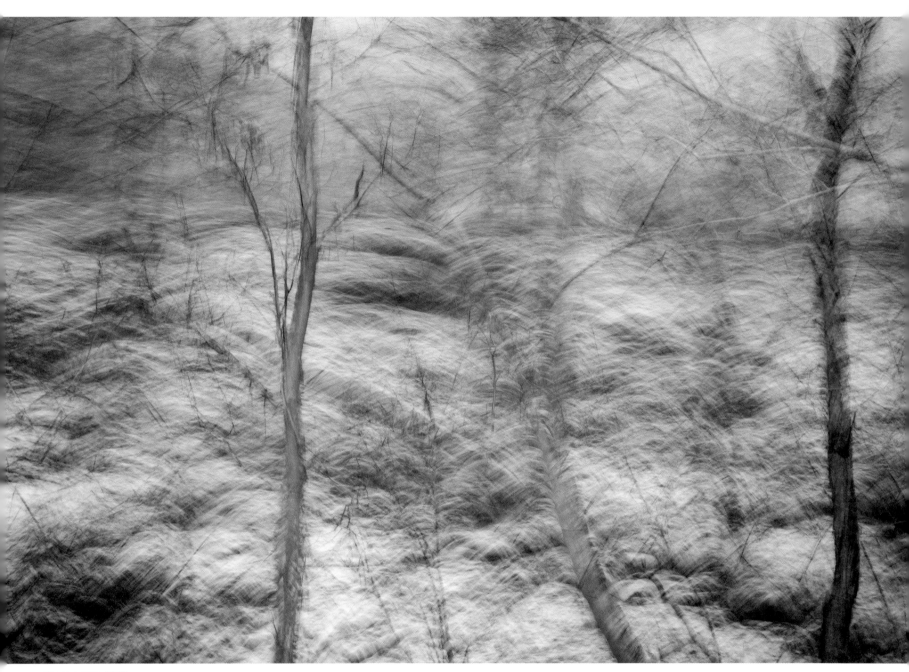

Pennsylvania, 2010

can reference the back of the screen on a camera to see if your camera settings are correct, but for a number of reasons I don't recommend that you rely on that tiny little preview to make editing decisions. First of all, it takes too much time to zoom in and check focus—time that could be better spent making more images. Secondly, it's too easy to make a rash decision and delete the wrong image. And finally, we perceive images very differently at different sizes, so making a decision to delete a tiny image could be a huge mistake; that image might look fantastic when printed on a billboard. I would also recommend that you label the cards with your name and contact info just in case you accidentally lose them.

- **Batteries and chargers.** Don't underestimate how long you are going to want to shoot. I always carry at least two fully charged camera batteries plus a charger.

- **GPS-enabled device.** Because my camera doesn't have GPS built in, I used the GeotagPhotos app on my iPhone to record GPS locations. The app creates a GPS track log that can be paired with the images (based on the time) in Lightroom. To keep the phone charged, I also needed to bring a car adapter.

- **Notebook and pencil.** You never know when you're going to want to jot

something down. For example, if you don't have a GPS device, you might need to write down the frame that you've captured before driving into another state.

- **Shot list.** There might be times when you are looking to make specific images to round out your project.

- **Lens cloths.** No matter how careful you try to be, every lens gets a spot on it at some point!

- **Black tape and dark towels.** Depending on the interior of the car, you may need to cover items, like chrome on the dashboard, that can cause reflections (especially when shooting through the window).

- **Personal attire.** Depending on the situation, you may or may not be able to photograph with the window down. For me, because this project took place on vacation and wasn't the primary reason for the road trip, it was important that the driver was comfortable. On warm trips, it was easy (although windy and noisy) to shoot with the window down, so reflections from clothing weren't an issue. When it was cold and snowing, I simply wore black to prevent reflections in the window.

- **Window cleaner and towels.** It's far easier to clean the windows than to try to avoid the dirty spots.

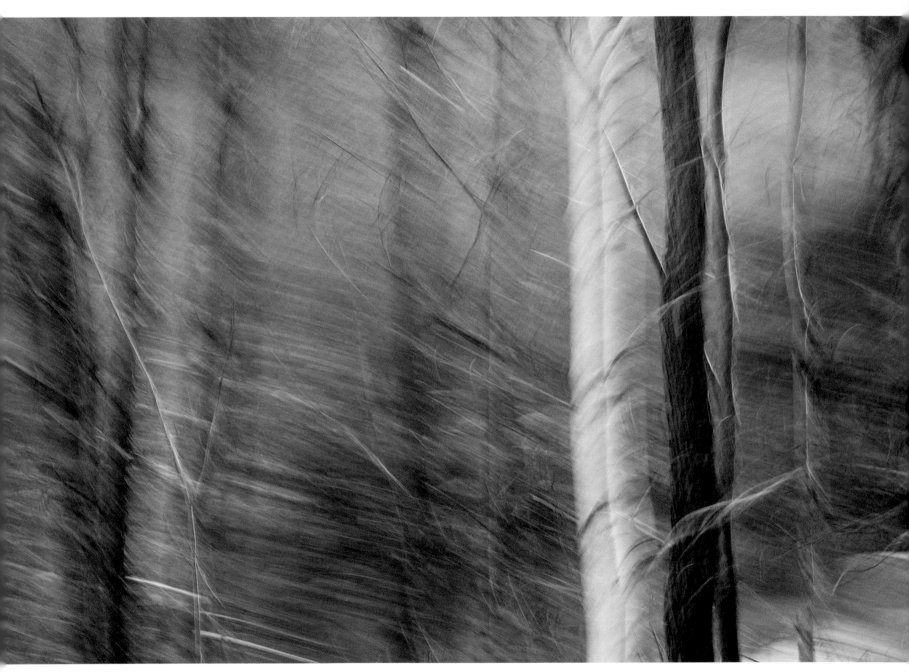

New York, 2010

- **Ginger candy.** While I was taking photographs along winding back roads, ginger candy helped me avoid motion sickness numerous times.

- **Laptop computer and AC adapter.** On the trips where we were traveling overnight, I brought my computer equipment to download images and start editing. If I knew that I was going to be doing extensive toning of images or layers and masking work in Photoshop, I would also bring a Wacom pressure sensitive tablet, cable, and pen for editing.

- **Card reader and cable.** Again, I needed these to download images to my laptop.

- **Secondary external backup drive.** After downloading images, I always want to make sure that I have a secondary copy of the photographs before reformatting my cards. In case of theft or a lost item, I find it's always a good idea to keep this drive separate from your other equipment when traveling.

Although it wasn't equipment, I also had to remember to take into account the time of day. Because this project was really a byproduct of getting between two locations, I didn't have a lot of control over lighting or direction of travel. However, while taking the train between Washington DC and New York, I made sure that I took into account the time of day and direction of the train so that I wouldn't be shooting into the sun.

Of course, your projects might have very different requirements. In which case, here are some additional questions that you might want to ask yourself about key equipment:

- **Cameras.** What camera bodies are you going to take? Do you need a backup? Do you have additional specialized cameras that you want to bring that will capture something, such as infrared, or do you need a smaller, more compact point-and-shoot camera or cameraphone that won't get noticed? If you are testing equipment, or have new equipment, would it be prudent to slip the manual into your bag?

- **Lenses.** Do you need to take several lenses? Will you be photographing in low light and therefore need a fast lens? Do you need to be able to zoom? If you're traveling, is it worth it to rent that specialized lens, needed only once in a lifetime, to take with you?

- **Lighting.** Do you need to bring your own lighting on location? Will you need a power pack with flash heads, monolights, or continuous (LED, fluorescent, HMI) light sources? Will you need light modifiers (barn doors, soft boxes, umbrellas) and reflector brackets? What about power cords, power strip, adapters, battery packs, remote triggers, radio slaves, and gobos and light stands? What about taking along a flashlight to do some

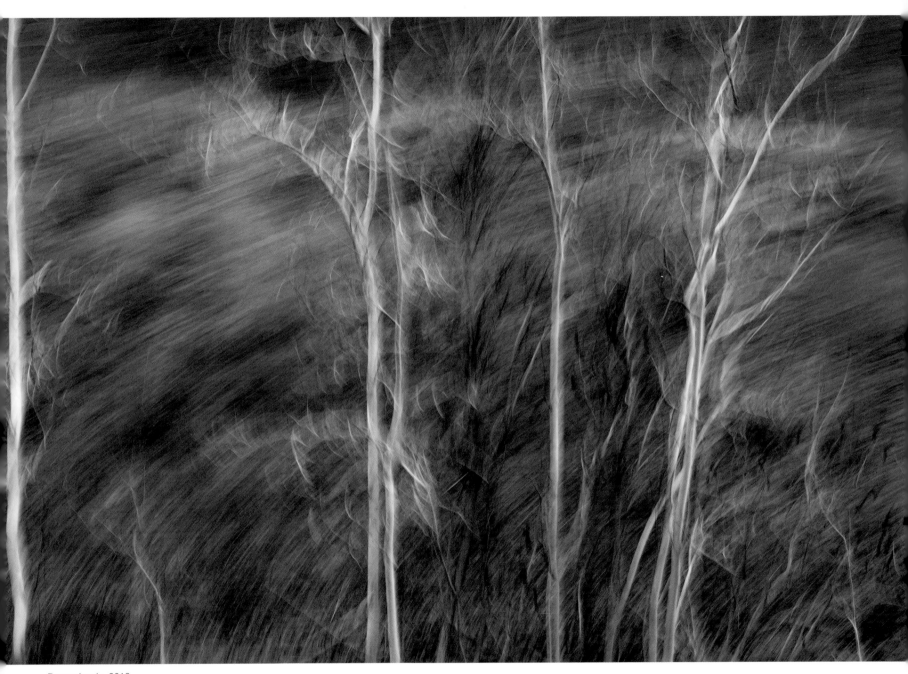

Pennsylvania, 2012

light painting at night? And don't forget your light meter!

- **Image stablization.** Will you need a tripod to capture long exposures like moving water? If so, don't forget the mounting plate attachment and a coin, or whatever is needed, to attach and remove it. If you're shooting sports, will a monopod be sufficient for stabilization and give you greater mobility? If you're concerned about weight, can you manage with a small tripod or other means of camera support such as a beanbag?

- **Camera controllers.** If you're planning on taking time-lapse images, would an intervalometer, electronic cable release, or mobile app help trigger the shutter over a longer period of time? Would it make sense to shoot tethered or use a Wi-Fi–enabled device, such as the CamRanger, to control the camera when making images at night or in cramped quarters?

- **Color references.** If you're shooting in multiple lighting scenarios, would it make your life easier to take along a neutral gray balance card or color chart? Taking an image with the chart can help quickly correct color balance in images taken under the same lighting conditions.

- **Filters.** Although many changes can be made in post, it can still be to your benefit to use filters on the camera for changing overall light intensity, eliminating reflections through a polarizing filter, and changing magnification using close-up filters.

- **Props, tape, and clamps.** Are you going to bring your own props for the image? Do you need a background and stands or adjustable stools for people or items, or apple boxes? What about gaffer tape, clamps, and other tools (including screwdrivers or Allen wrenches)?

- **Personal items**. If you're going to be out in the elements, do you need sunscreen, insect repellent, or a hat? If the weather turns foul, do you have an umbrella, waterproof clothing, and extra plastic bags for your camera?

- **Food and nourishment.** Will you need anything for you and your models or clients? This could range from catering at a venue to emergency energy and water when hiking.

- **Emergency information.** Do you have contact info, directions, and a map in case you're meeting people or you simply find yourself lost?

As you can see, the more complex your project becomes, and the more limited the number of opportunities you have to complete it, the more important it is that you are prepared. Just thinking through the project and anticipating what you will need will increase your odds of a successful project.

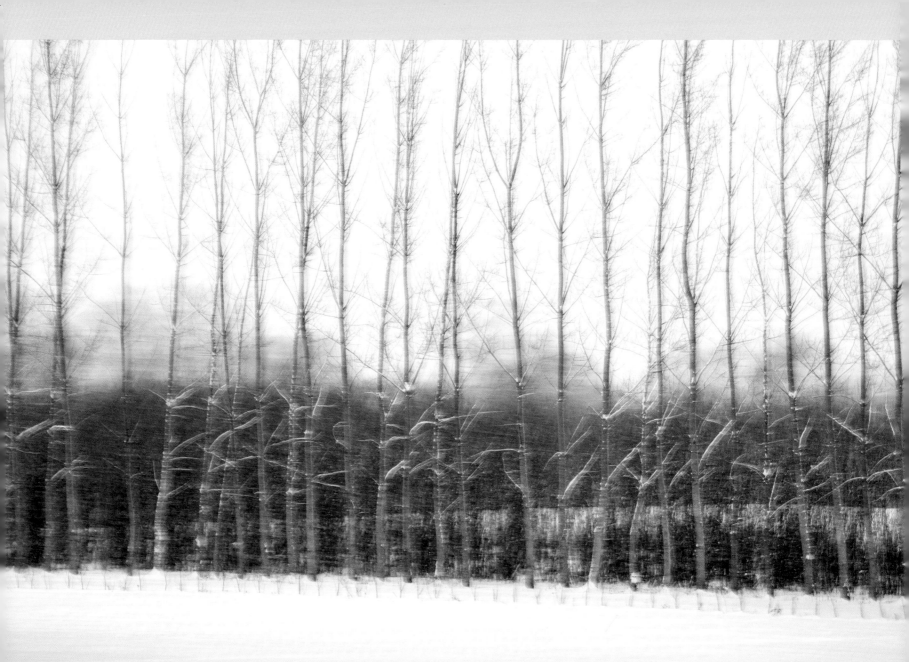

New York, 2012

CHAPTER 9 # Master Your Tools

An amateur practices until he can do a thing right, a professional until he can't do it wrong.

—UNKNOWN

Having the right equipment at the right time is a good start, but it won't do you any good if you don't know how to use it. Today we have access to some of the most advanced camera and post-processing technologies in the world. The cameras have extremely advanced metering systems, fast auto focus, and they allow us to instantaneously see what we've captured so that we can refine our settings. After capture, we can use software like Lightroom and Photoshop to make nondestructive changes to the image, processing them in post (as many did in the darkroom before us) in order to add our own mark, style, or look to the images to tell the story as we remember it or as the reality that we want to create.

It's a smart photographer that takes advantage of technology. Technology always has and always will revolutionize the way that we make images. We need to embrace it and master the camera and post-processing software in order to use them to their full potential. When you invest your time in learning how things work, you can make intelligent decisions as to what settings you want to use, as well as when and why. An investment in technology will pay you back tenfold. Don't dismiss it; take the time to master your tools.

The Right Tool at the Right Time

For the *Passenger Seat* project, I could have added the sense of motion in post-processing with Photoshop, but that was not the intent of the project. I was relying on the camera to capture an image that I couldn't observe with my own eyes. Therefore, my goal was to capture each image—including the blur—entirely in camera. Moreover, most of these images would have been very difficult (if not impossible) to mask and realistically blur in post because of the overlapping elements (trees, leaves, and branches).

The basic premise for capturing these photos was fairly simple. Because all the images were taken while moving forward in some type of vehicle (most often from the passenger seat of a car, with a few exceptions for trains and buses), I slowed down the shutter speed and then panned the camera, trying to stay focused on my subject (a tree for example) as the vehicle drove by. As a result, the subject (the tree) would be in focus, while everything around it would be enveloped in blur.

At least that's the how the process works in theory. In reality, you'll run into a number

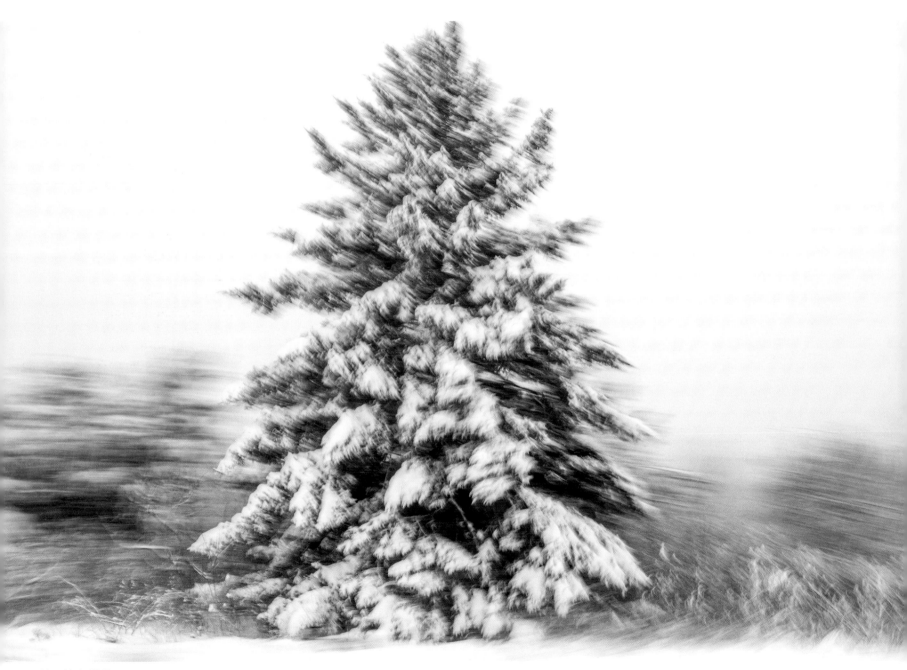

New York, 2012

of variables that are all interconnected when trying to capture these types of images: the speed and direction of the vehicle, the distance between the camera and subject, the motion of the camera, the shutter speed and f-stop, the focal plane, and more. Variables often change your plans for you. That's one of the reasons that this project was engaging. I was never quite sure what I was going to get as a result. I respect the element of chance—a happy accident waiting to introduce itself as a part of the process. With that said, without knowing my camera, I would have had much less success attaining the images that I did.

At the beginning of the project I was using a point-and-shoot, converted infrared camera and capturing in the JPEG format. I quickly realized that was the wrong tool and file format for the job; if I was going to pursue this project and print the highest-quality images for an exhibition, I would need to take advantage of a camera that captured uncompressed information at the largest size I could manage.

Switching to my DSLR, I was able to start capturing the images in the camera manufacturer's RAW file format. This gave me an uncompressed image with the most latitude to make changes when processing in Lightroom and Photoshop. If you capture images using the JPEG format, the files will be smaller, and although you can capture more images faster, you will end up with a file with less

color and tonal data that can be changed in post-processing. Because speed was not an issue (the camera could capture images and write them to the card faster than I could make them), it was an easy decision to make the switch. Capturing in RAW gave me the quality I would need when processing the files.

Fine-Tune Your Settings

Choosing my DSLR also gave me more flexibility and control over the camera settings. Specifically, I set my camera to Shutter Speed Priority mode; the light changes too quickly for me to use Manual mode while shooting from the passenger seat. This project is a great example of technology being able to calculate the proper exposure much more quickly than I would be able to under constantly changing lighting conditions. When traveling between 30 and 60 mph, I find that a shutter speed between 1/10 and 1/60 of a second produces very interesting results, including the images that have the primary subject in focus and yet, are surrounded by blur. Of course, the results also depend on the other variables, such as your panning speed. As you make more and more images using this technique, you will get a much better feel for when the shutter speed, vehicle speed, and panning speed are in sync. Slowing down the shutter speed even farther can also create beautiful abstract impressions

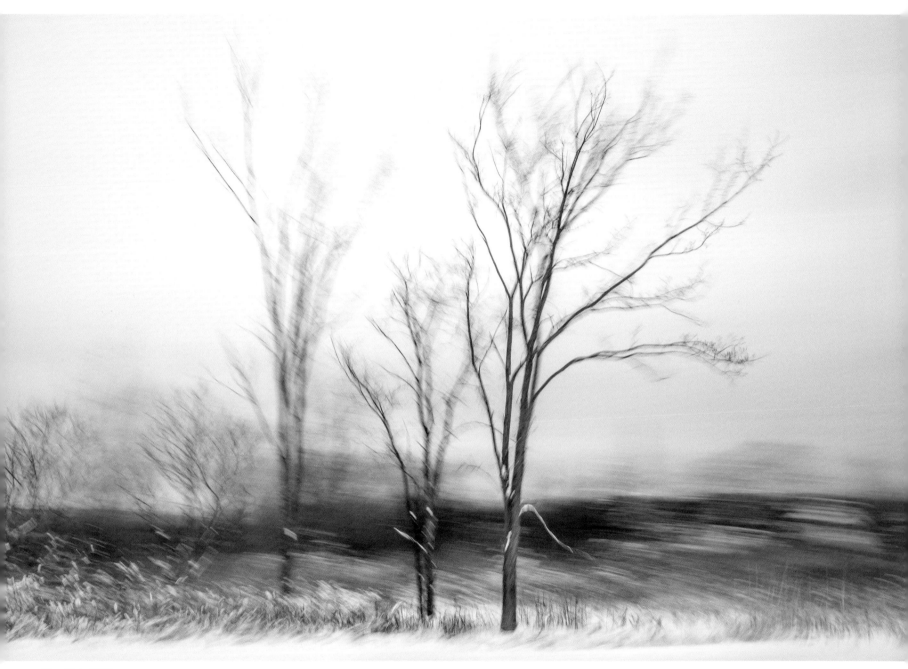

New York, 2012

of the scene. It really depends on the out-come that you are trying to achieve.

Even though I shoot in Shutter Speed Priority mode, I still pay attention to the aperture the camera automatically selects so I can use the smallest aperture possible to record the greatest depth of field. The greater the depth of field, the more likely the subject will be in focus. I prefer to photograph at f/16 or f/22, but if there is not enough light, I will increase the ISO to maintain that depth of field. Increasing the ISO has its trade-offs as well; setting it too high can introduce noise in the image. On bright, sunny days, the opposite problem can occur; you may need to use a neutral density filter to block some of the light in order to reduce the shutter speed.

On days when there is a significant amount of contrast between the darkest and lightest values in the scene, I find that it can be difficult to simultaneously hold detail in a bright sky and a shady foreground when capturing motion blurs. Because I want to make sure that there is detail in the high-lights, I find that underexposing the image by up to a stop (using the exposure com-pensation option to override the camera's decisions) can help maintain detail in the sky. Fortunately, metering to make sure that there is detail in the highlights doesn't make a significant difference in the density of the shadow areas (because the shadow areas are blurred with lighter areas in the foreground),

so I am able to avoid introducing unwanted noise in the shadow areas.

It's also very important to minimize the time between when the camera autofocuses on the subject and when the photograph is taken. Setting the camera to continuous focus can improve your success rate—as long as the camera auto-focuses on the correct subject to begin with! I find the camera's ability to track focus to be much better when the subject is well lit (and is significantly less accurate when used in low light). I also find it helpful to create custom settings in my camera so that I can quickly change settings when the speed of the vehicle changes (de-pending on whether you're on the highway or on a little side street).

Open and Closed

Your project may challenge you in ways you never imagined. For example, I found that I needed to learn how to photograph with both eyes open to anticipate the shot. The left eye becomes the dominant eye as it looks out the front window to see what's coming (a tree, a barn, a lake). As the vehicle passes by the subject, the right eye takes over, look-ing through the viewfinder and panning on the subject to take the photo. It takes practice, and it has to happen quickly while you're moving, but I found the technique indispensable when trying to capture images for this project.

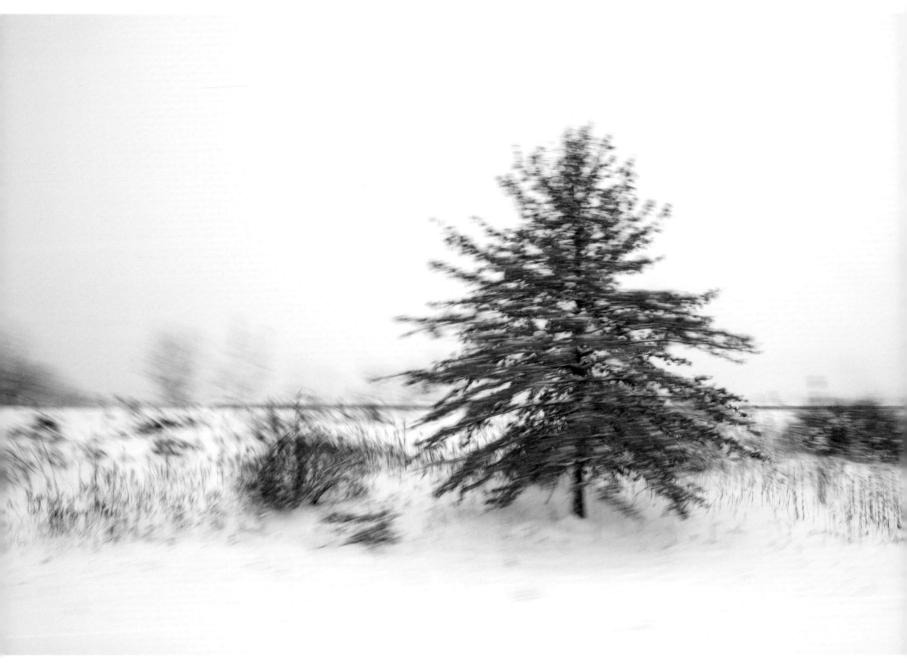

New York, 2012

Every artist was
first an amateur.

—RALPH WALDO EMERSON

I will confess that for the majority of images, I was photographing with the window closed. The primary reason that I was in the car wasn't to make images; I was on a journey with a friend and wanted to make sure that we were both enjoying the ride. Therefore, when it was too hot or too cold, too wet or too windy, the window went up. If you're going to close the window, it had better be clean and free of reflections. Opening the window can add another element of motion to your image if your lens happens to venture into the air stream—this could be a benefit or an impediment. You might want to consider the time of day and direction of travel in order to anticipate when would be the best time to shoot, as well as the direction of the sun.

On narrow winding roads, when the subjects were close, I found that I had to pace myself (ginger candy was also helpful); otherwise, I was likely to get nauseous. Even on straighter roads, I needed to take "time-outs" because the constant panning was making me motion sick.

There's nothing wrong with learning as you go, but it also pays to practice when you're not under pressure. Throughout this project, I tried different blur techniques whenever I had the chance—when I was in a cab in Atlanta, on a bus in Quebec, going to the grocery store with a friend—it didn't matter that the images were of the city and wouldn't make their way into this body of work. I was practicing, developing my technique, and increasing the odds of creating a successful image.

Of course, you don't have to do any of these things. You can try any combination of settings and don't even have to look through the viewfinder if you don't want to. What worked for my project may not fit yours as well. The most important thing to remember is that if you have a limited amount of time to capture images and finish your project (like I did), it's a huge advantage to master your tools and techniques to increase your odds of capturing engaging images.

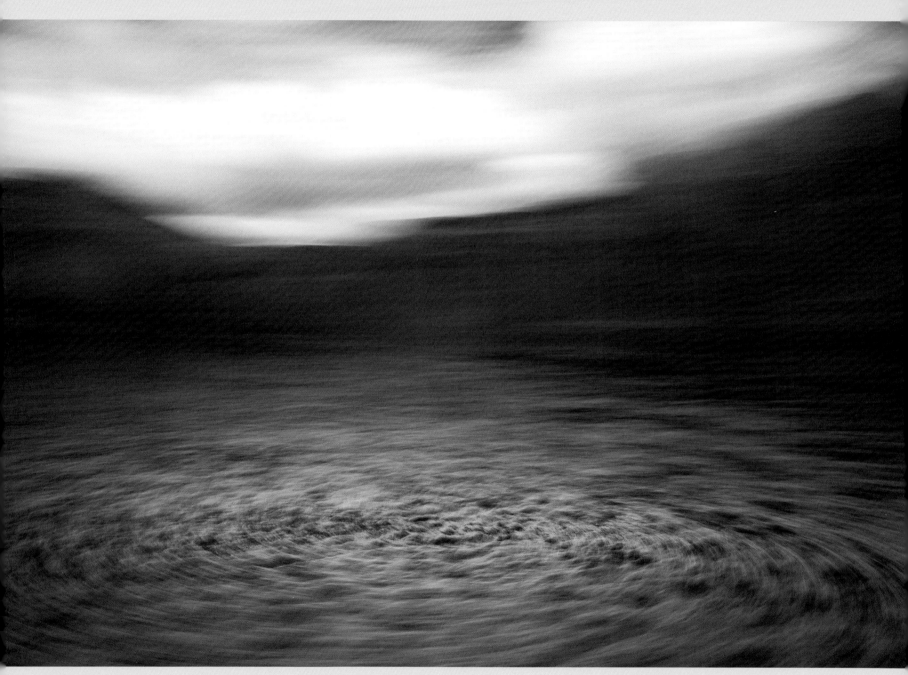

Iceland, 2012

CHAPTER 10 # Motion Blur Techniques

> Vision is the art
> of seeing what is
> invisible to others
>
> —JONATHAN SWIFT

Although creating movement while the camera's shutter is open seems straightforward, the variations of motion blur that result are as endless as your choice of motion. While the shutter is open, you can move the camera, your position, the subject's position, or any combination thereof. The movement can be exaggerated or subtle, fast or slow, left or right, up or down, smooth or jerky; you can pan, zoom, rotate—the possibilities go on and on.

Blur, Pan, and Stop Motion

One fundamental way to create motion when photographing a still subject is to move the camera. Using a combination of slower shutter speed and camera movement, you can introduce a motion blur into the image. Depending on the length, direction, and path of the camera movement, the resulting abstraction can create interesting shapes and ghostlike figures.

A common way to freeze the motion of a moving subject in a photograph is to move (*track*) the camera at the same rate of motion as the subject. For example, when photographing a car going around a racetrack, you would stand in one place, following the car

with your camera. This technique is known as *panning*. Using a relatively fast shutter speed will stop the motion of the subject that you are panning with, but because the camera is moving in tandem with the subject, anything that is not moving at the same speed as the subject is typically blurred. This method is a great way to show the relationship of the subject within its environment.

Although the same panning technique was also used to create the images in *Passenger Seat*, in this case, the photographer (and therefore the camera) was moving while the landscape (the subject) stayed fixed. The result was that the subject is seen as being motionless while its surroundings are in motion. However, I found that using a relatively fast shutter speed typically won't create enough motion around the subject to make the image visually compelling. In order to add additional motion, the shutter speed must be slowed down.

The resulting images also turned out completely different based on the distance that the subject was from other foreground or background elements in the scene, the direction and speed of the vehicle, and the motion path of the camera (pan direction and motion path of lens); there was a continuum

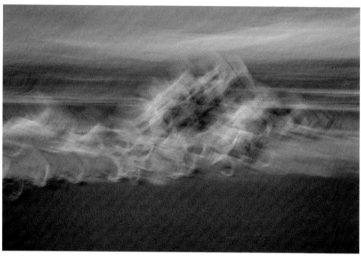

Moving the camera while the shutter is open is one way to introduce motion into a photograph.

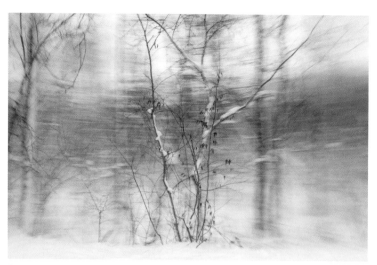

Panning the camera with the subject while in a moving vehicle can result in the subject being motionless while the surroundings are in motion.

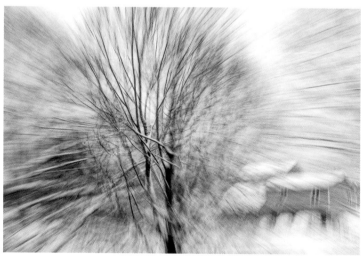

Zooming the lens while panning creates another dimension of motion in an image.

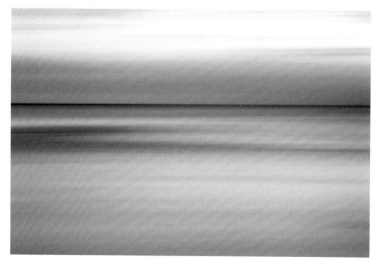

Without panning, long exposures from a moving vehicle can turn a landscape into streaks of color.

What I cannot see is infinitely more important than what I see.

—DUANE MICHALS

of "sharpness" and varying degrees of movement throughout the imagery. These images resulted from the unique orchestration of all these variables and the movements within the scene, all while the shutter was open.

It wasn't always necessary to have a sharp subject in the image. The long exposures recorded movement, patterns, and abstractions that were otherwise invisible.

You can add another variable by zooming the lens while the shutter is open. This technique, often referred to as *racking the lens*, adds another dimension of motion to the scene, as you can see in the image of the tree in the snow. Personally, I found the effect too jarring—almost to the point of being violent—to fit with the results that I achieved from panning with the subject instead.

For a softer effect, you can increase your shutter speed and, while the vehicle is in motion, simply hold the camera still to let the camera capture streaks of color from the scene. I found that when I was looking for a more tranquil, peaceful, and moody way to represent a location, this technique worked perfectly. Sometimes color can speak for itself, as you can see.

Rhythm Not Rules

It takes a lot of practice—and a lot of luck—to achieve the correct combination of shutter speed, rate of panning, distance between camera and subject, focus, and vehicle speed to get the image that you are looking for. Not to mention the fact that you can't actually see what you're capturing when you click the shutter. There are no hard-and-fast rules for drive-by photography.

While I was capturing images for *Passenger Seat*, many times the camera's auto-focus selected a different subject than I had hoped for, I failed to pan at the correct speed, or the depth of field was too shallow because the distance between the subject and car changed. It could have been a recipe for complete frustration, but I decided at the very beginning of the project that there was no way that I could actually take credit for these images. They are all gifts, and I am grateful for each and every one of them. And I find that when I'm really present, I get into the rhythm of the car moving through the landscape, like a dance with a variable tempo, and I follow my intuition. Go ahead and try to let go, move forward with a project, and see if it lifts like a kite in the wind. Remember that if you don't risk anything, you risk everything.

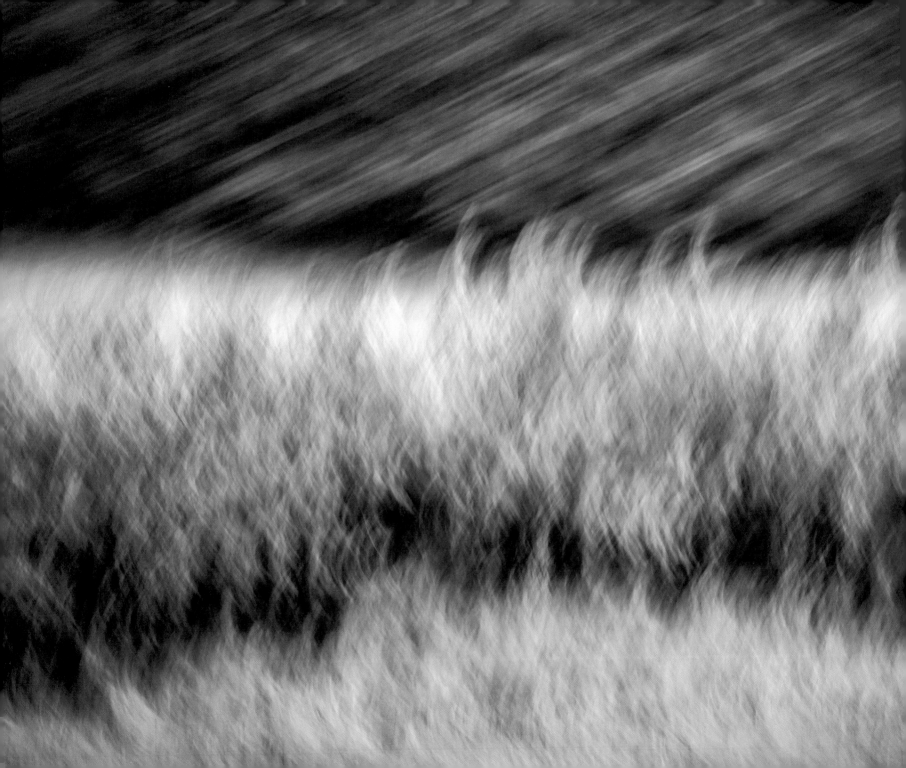

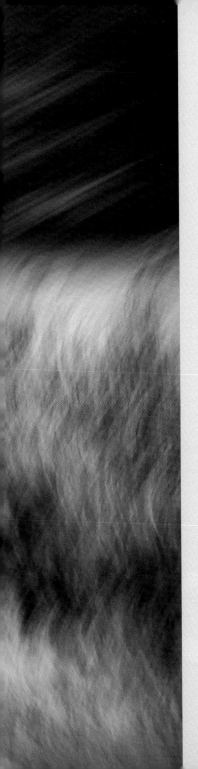

THE PHOTOGRAPHS

A Visual Interlude

Maryland, 2011

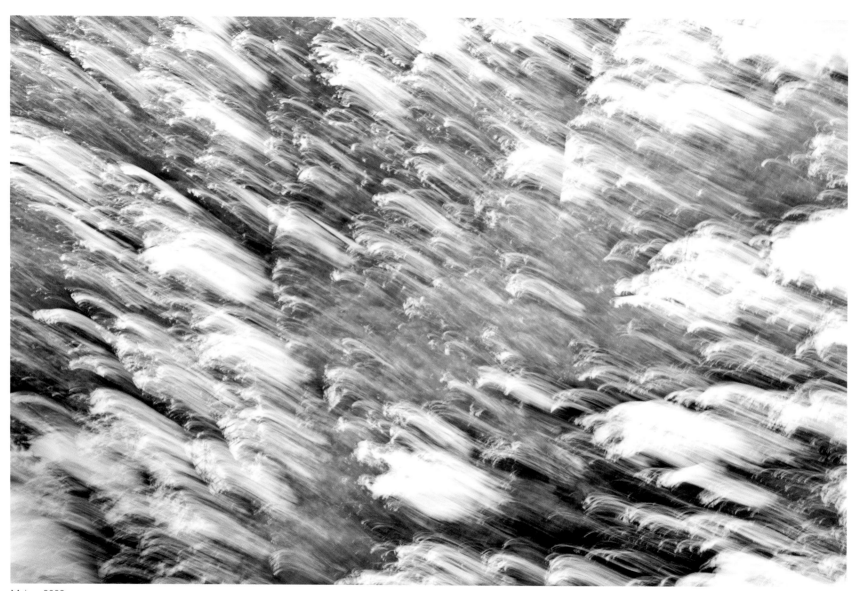

Maine, 2009

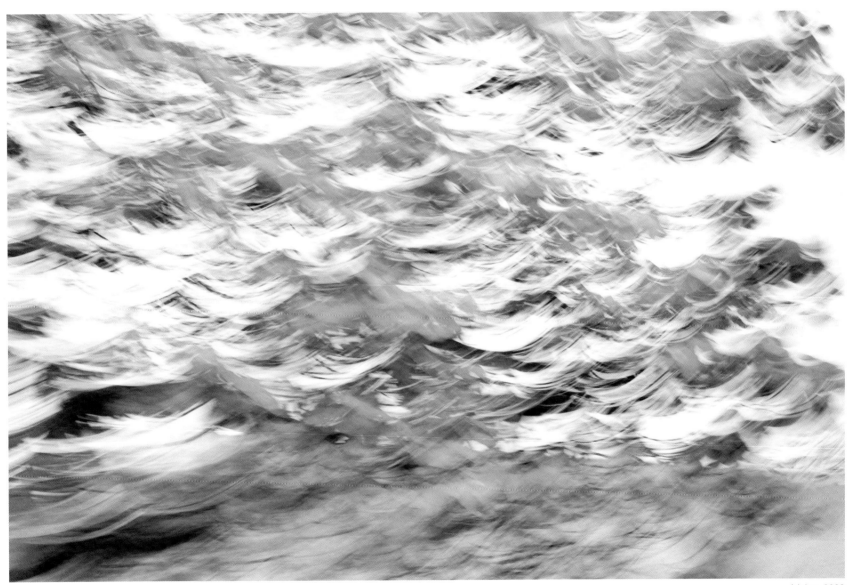

Maine, 2009

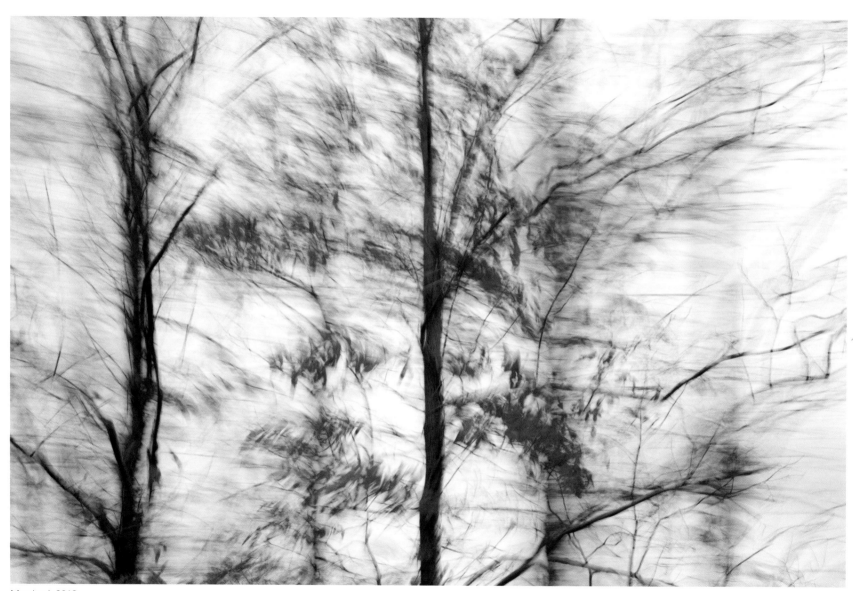

Maryland, 2013

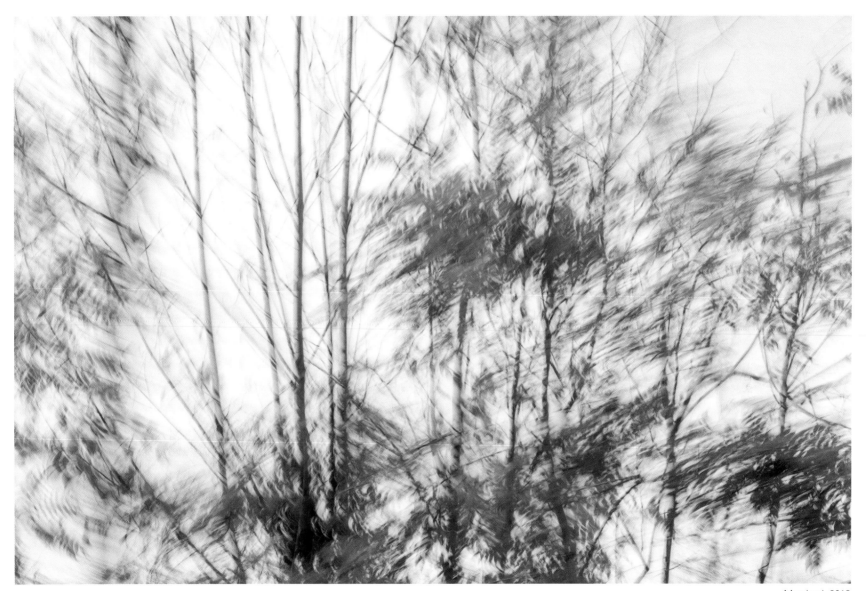

Maryland, 2013

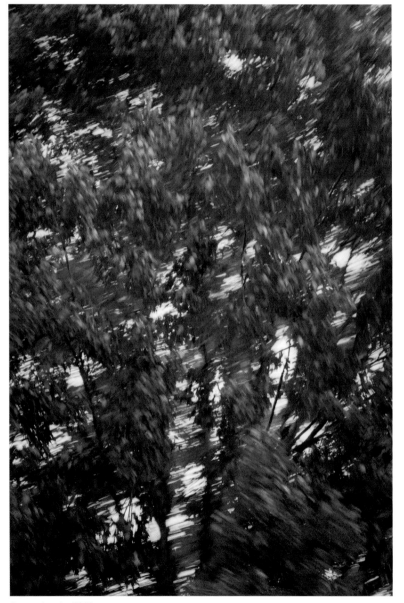

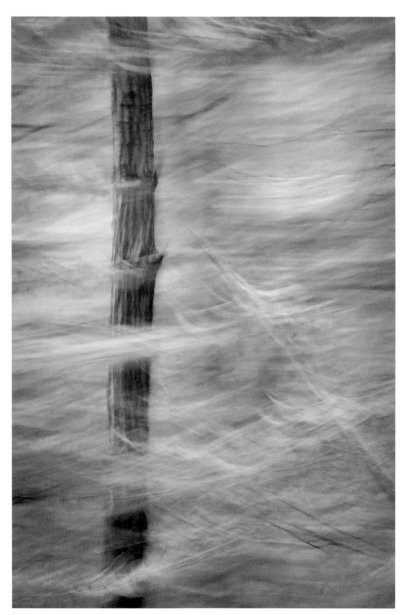

Pennsylvania, 2013

New York, 2009

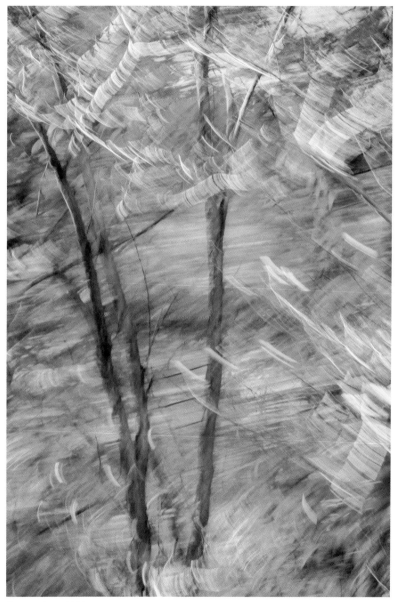

Connecticut, 2009

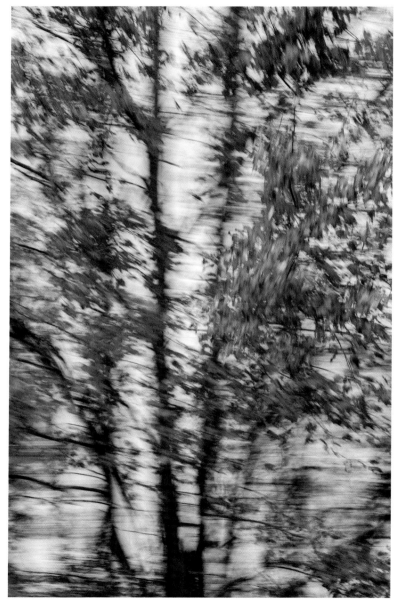

Virginia, 2010

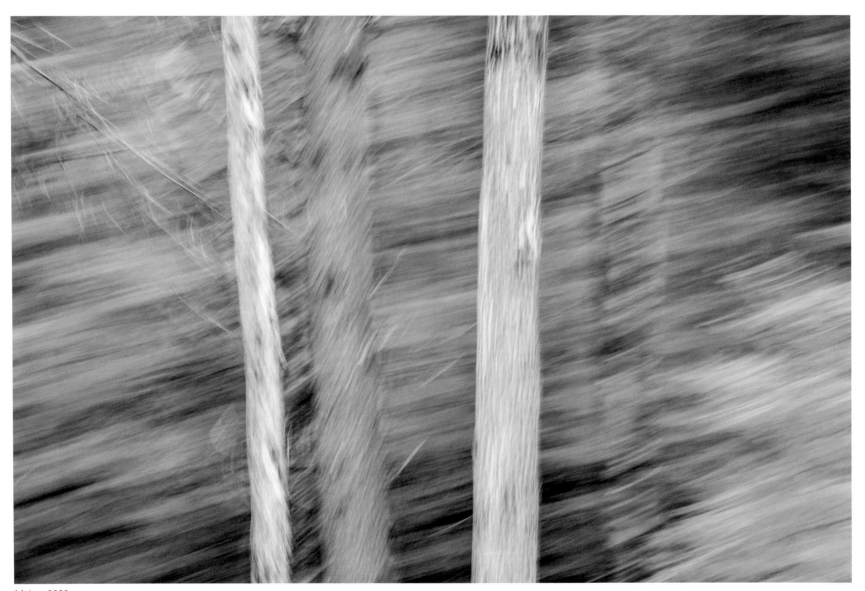

Maine, 2009

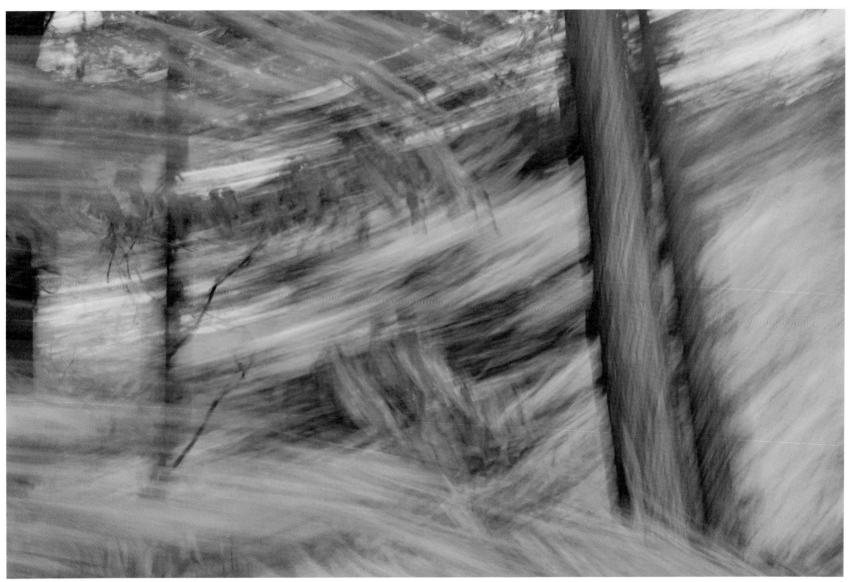

New Hampshire, 2009

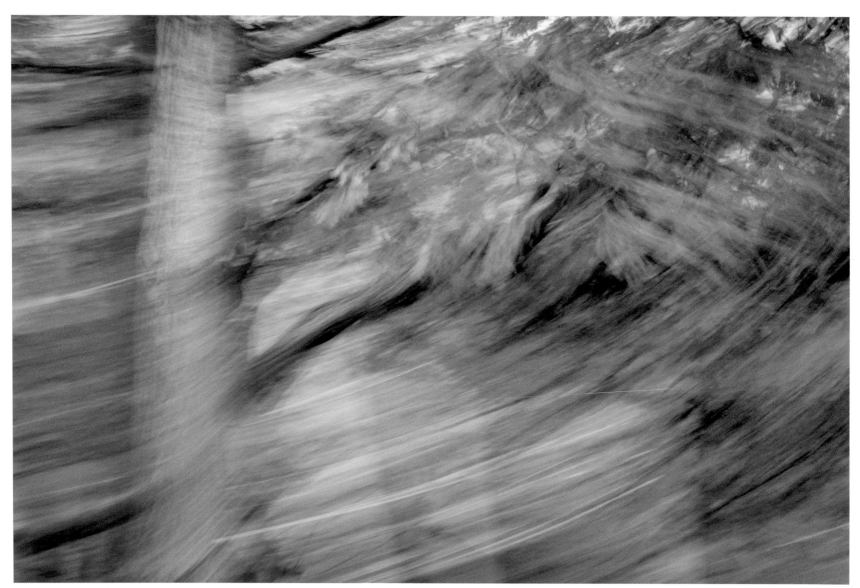

New Hampshire, 2009

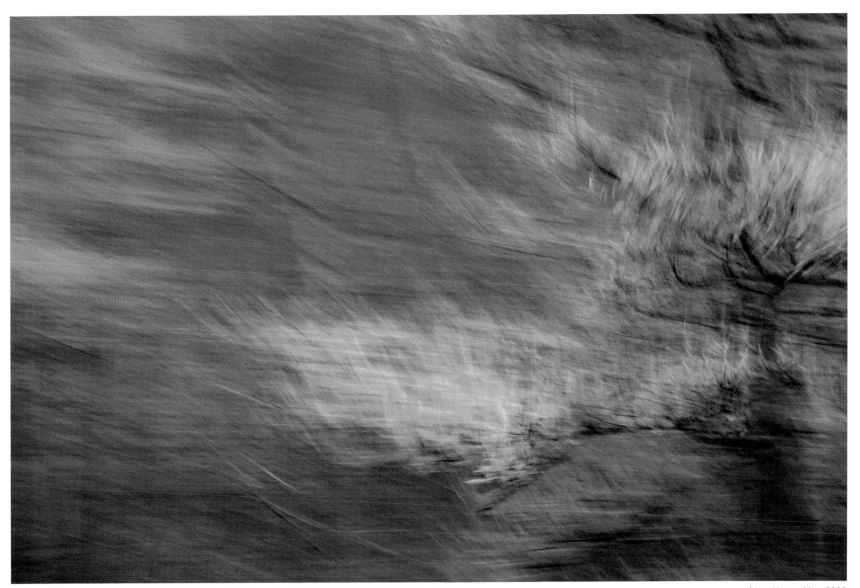

New Hampshire, 2009

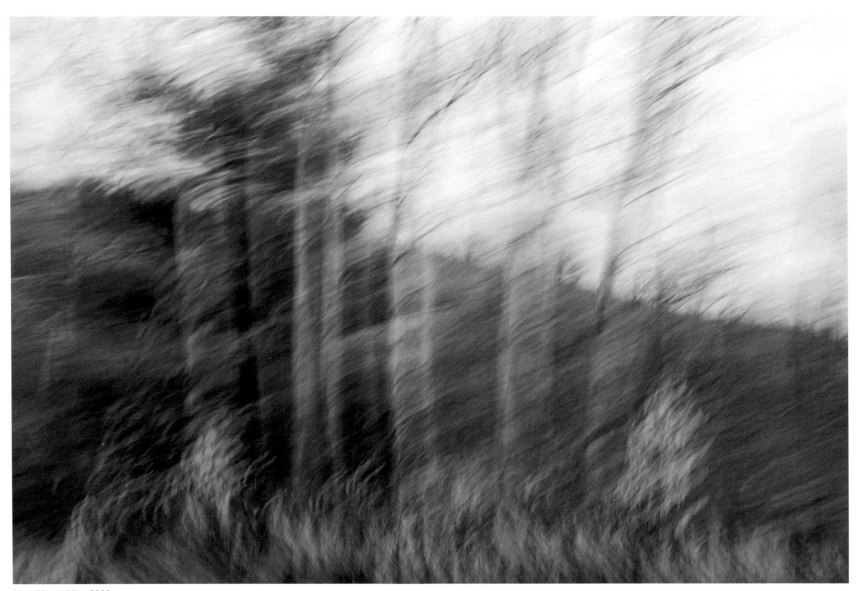

New Hampshire, 2009

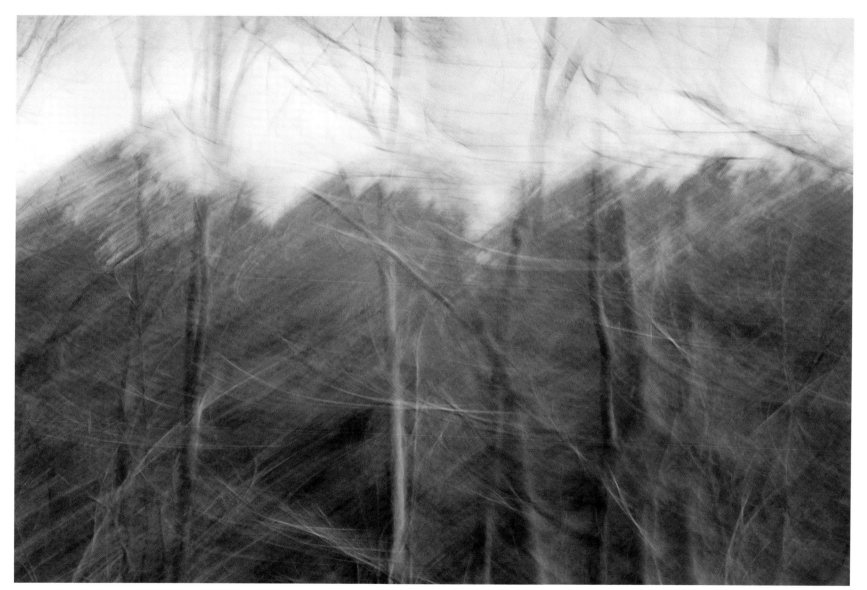

Massachusetts, 2009

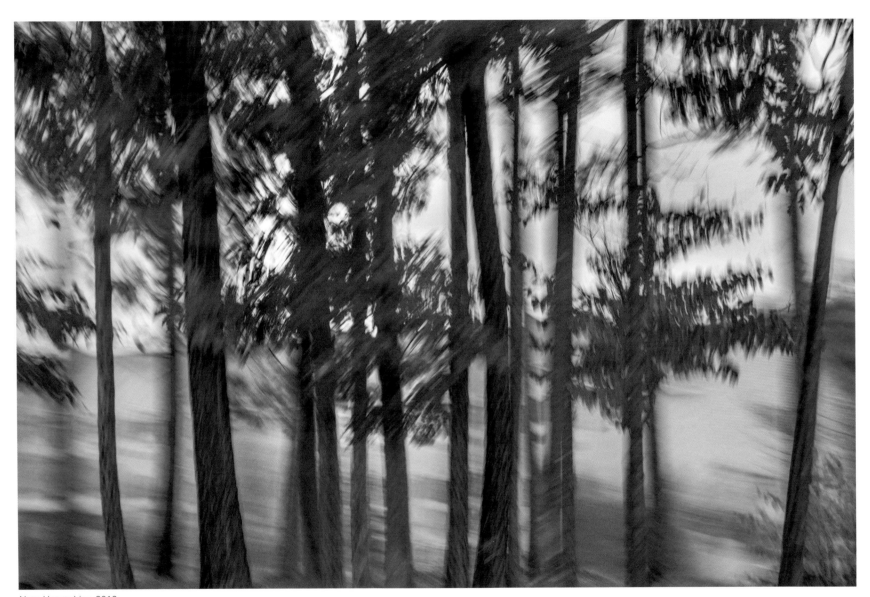

New Hampshire, 2010

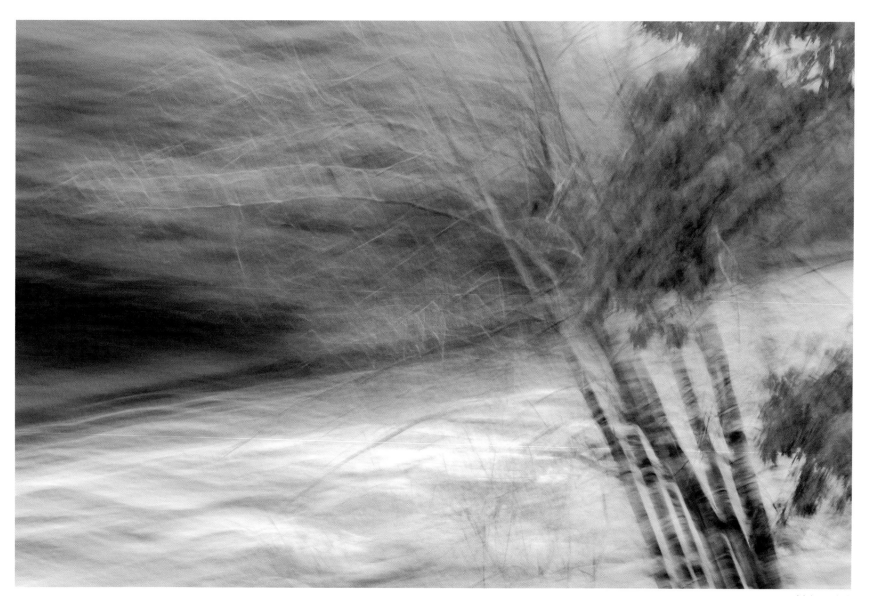

Maine, 2009

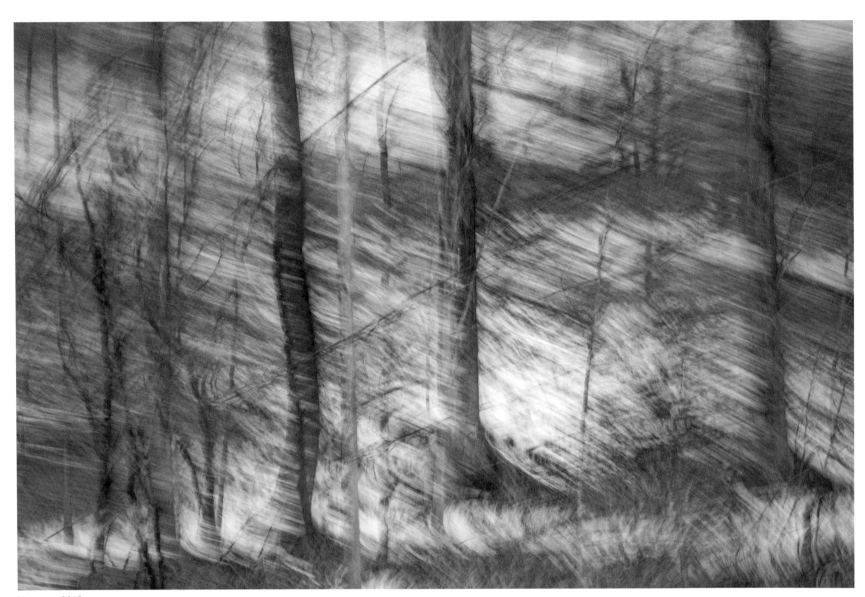

Vermont, 2010

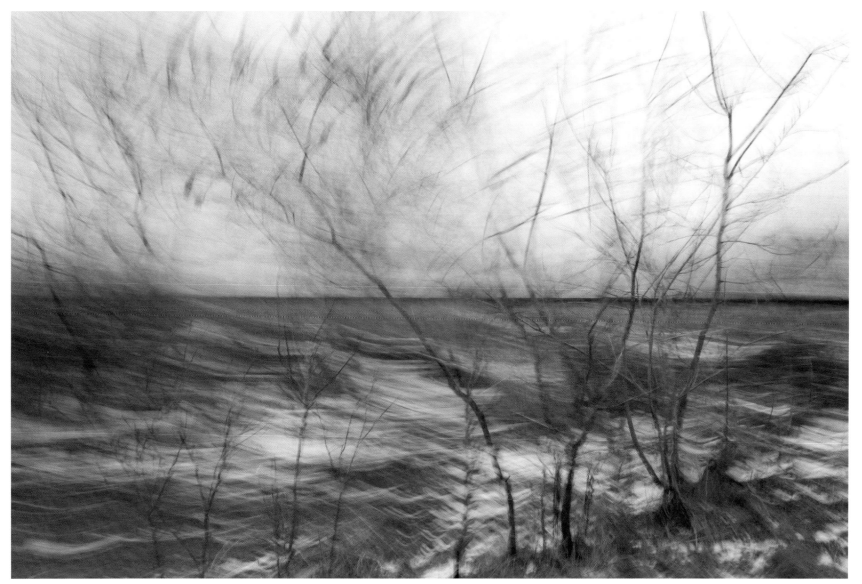

Vermont, 2010

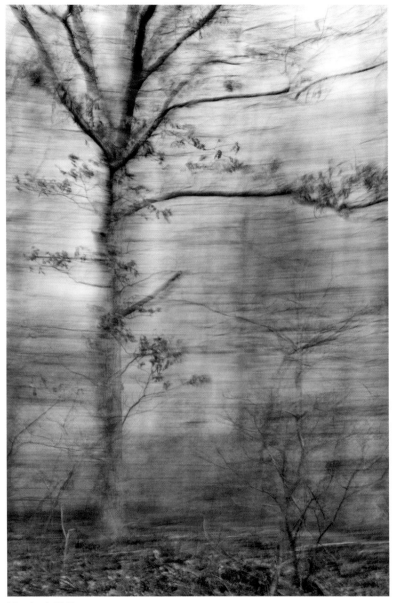

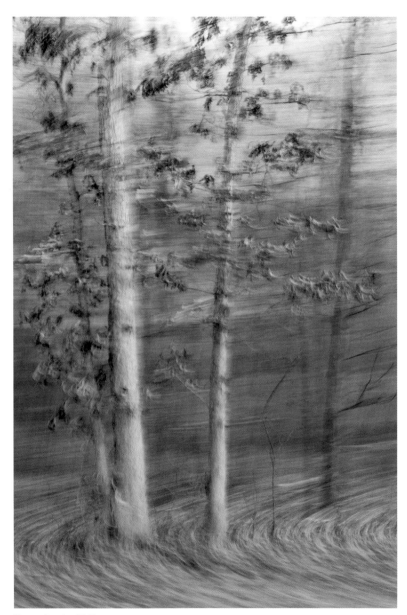

Maryland, 2012

Pennsylvania, 2010

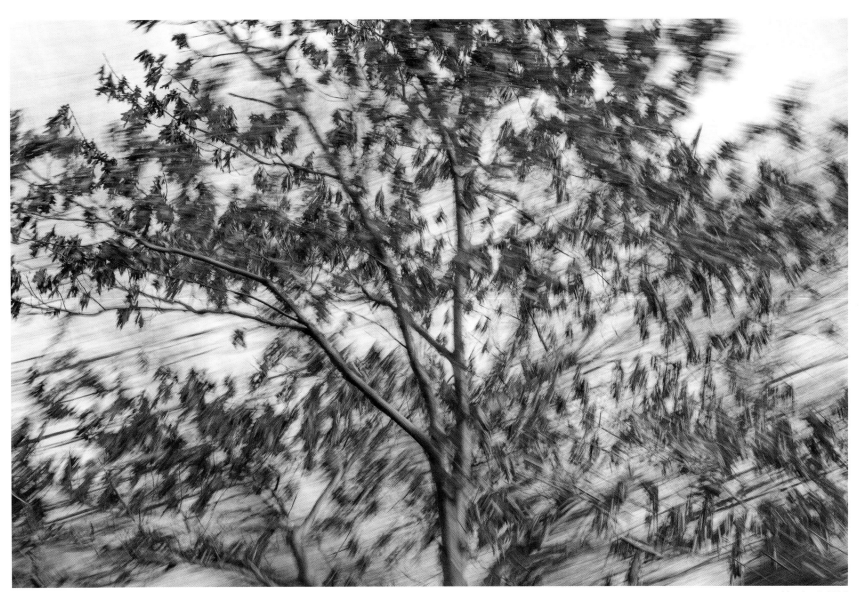

Maryland, 2010

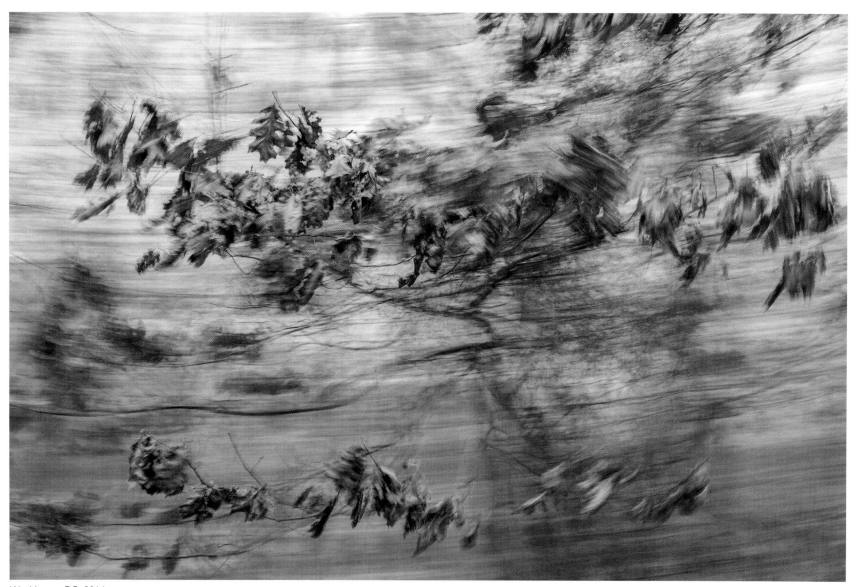

Washington DC, 2014

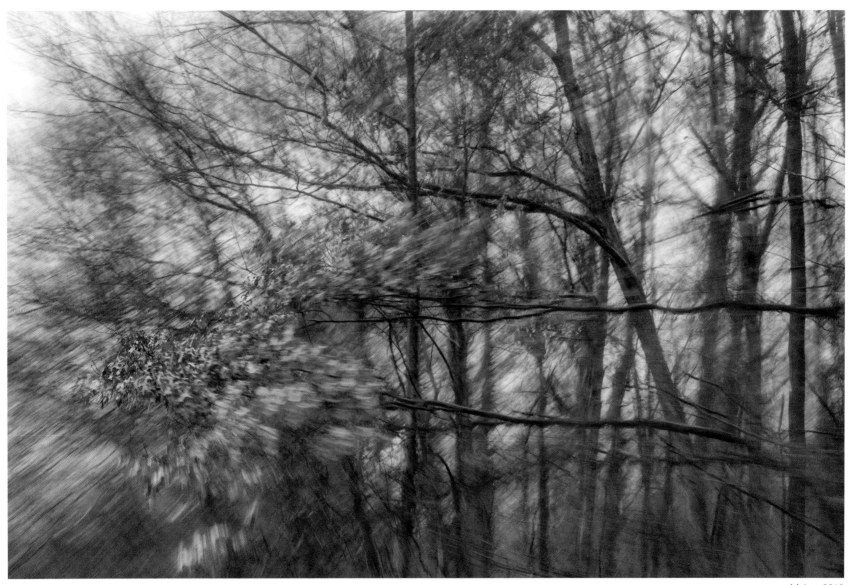

Maine, 2013

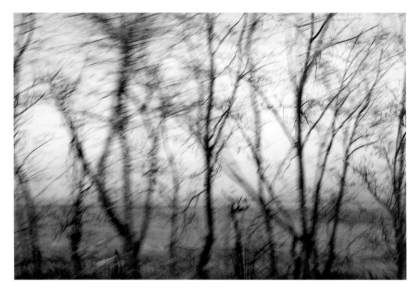

Poland, 2014

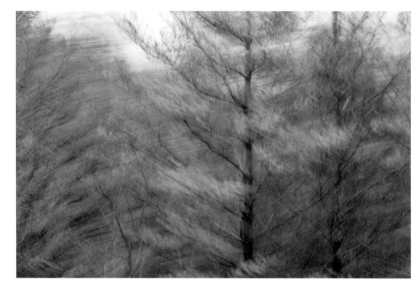

Vermont, 2012

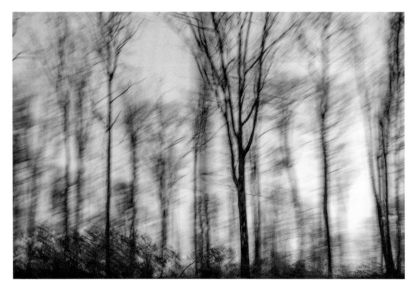

Pennsylvania, 2011

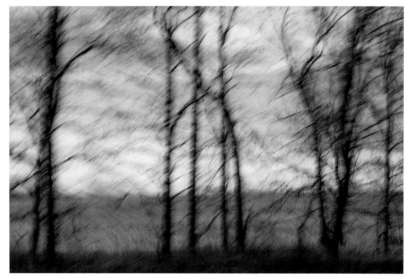

New York, 2010

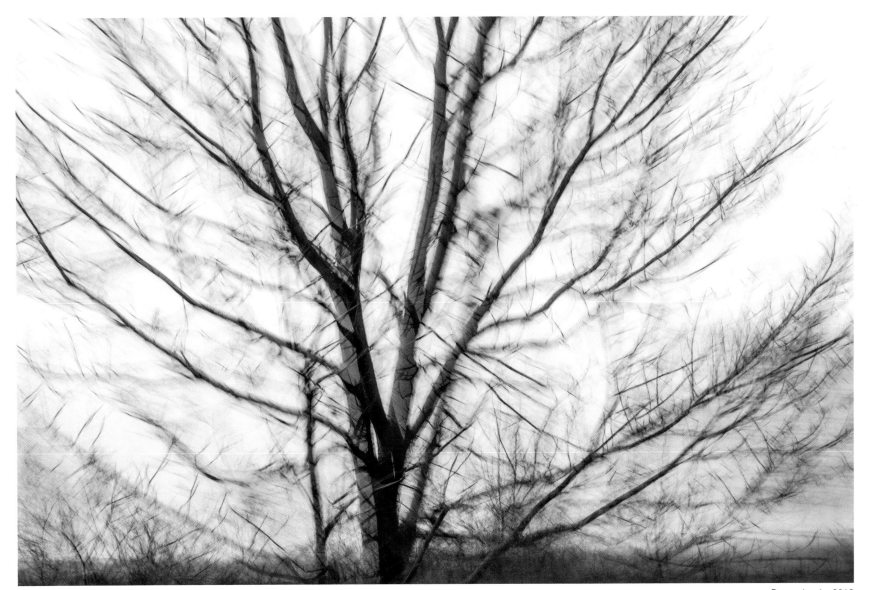

Pennsylvania, 2012

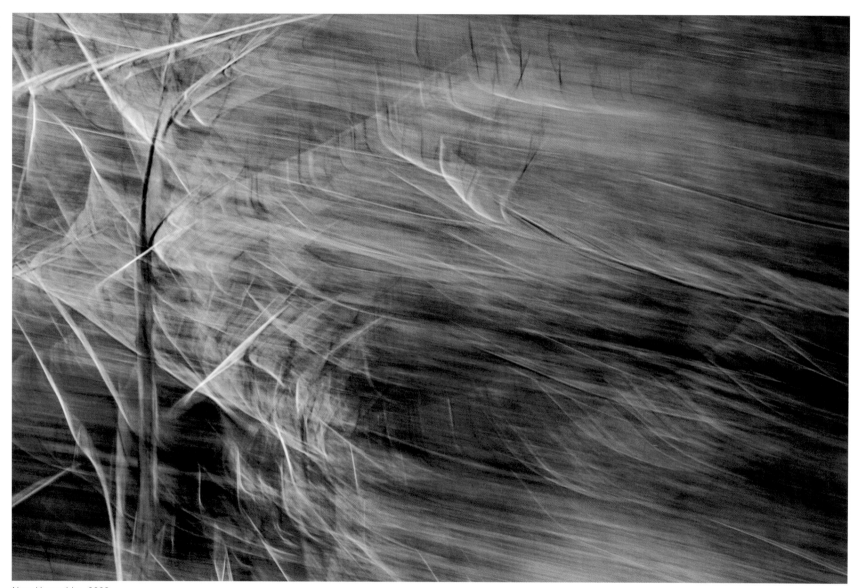

New Hampshire, 2009

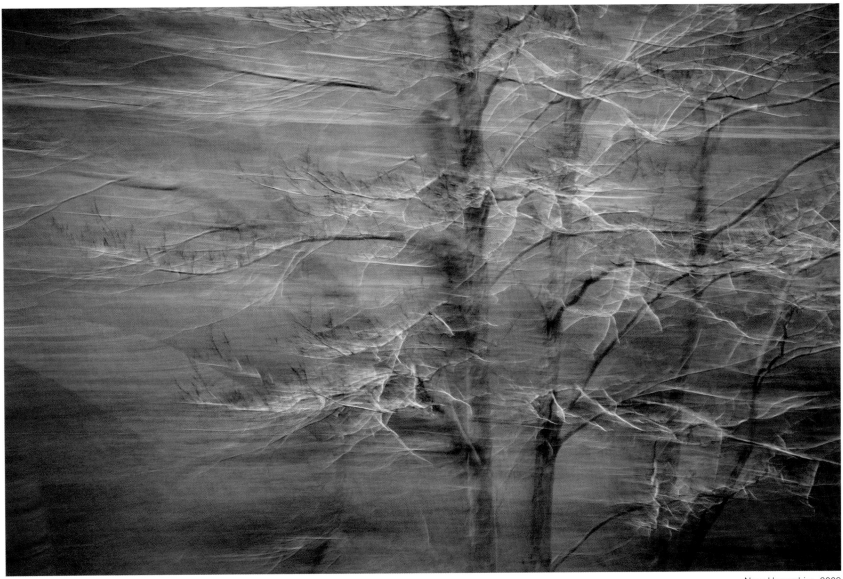

New Hampshire, 2009

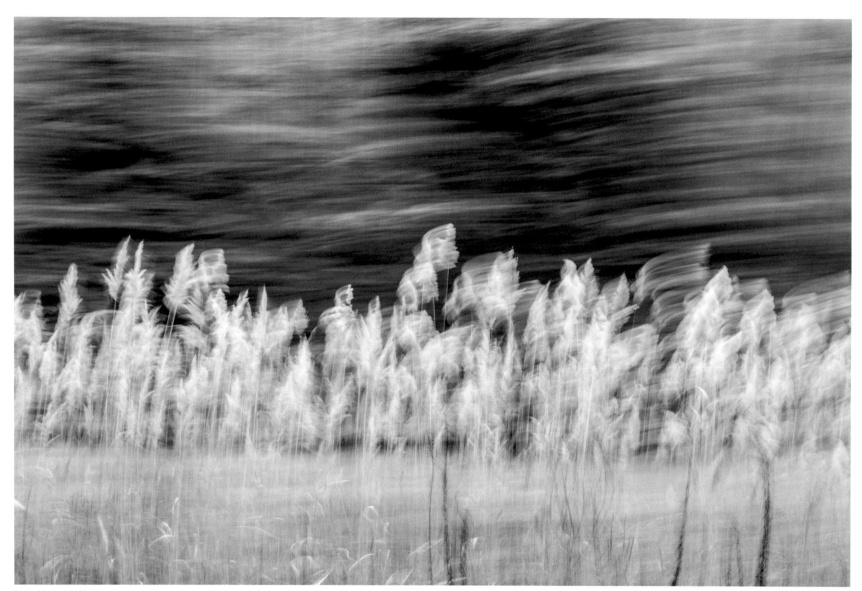

New York, 2013

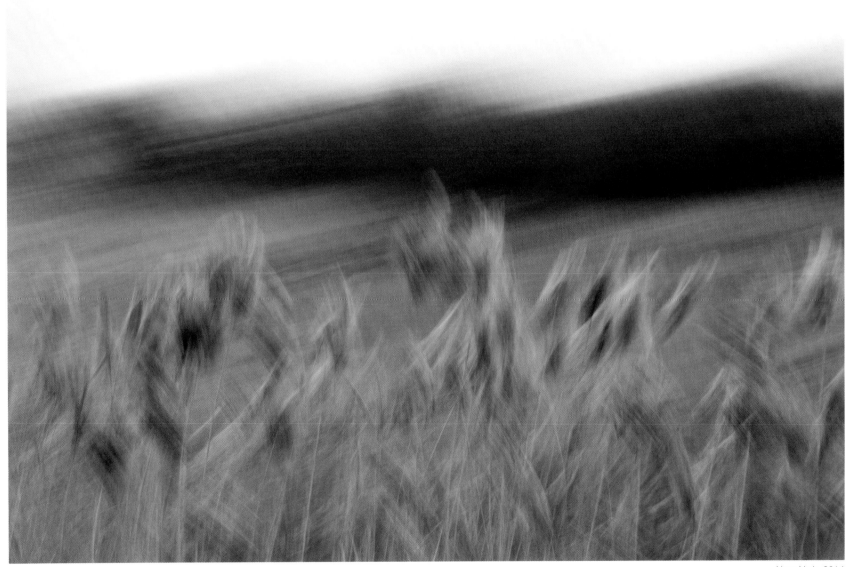
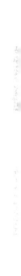

New York, 2014

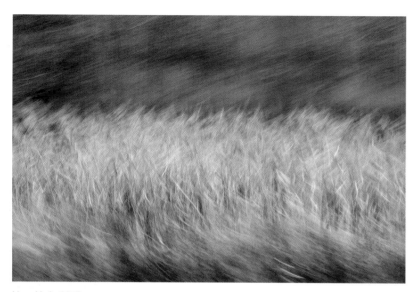

New York, 2012

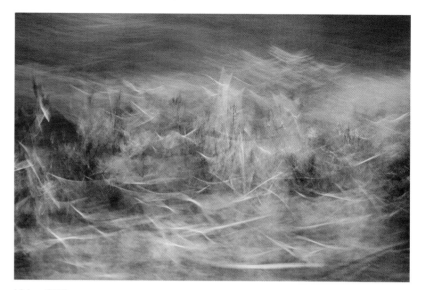

Maine, 2009

Maine, 2009

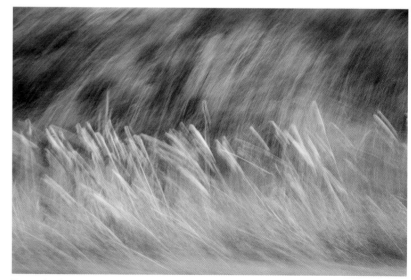

Pennsylvania, 2010

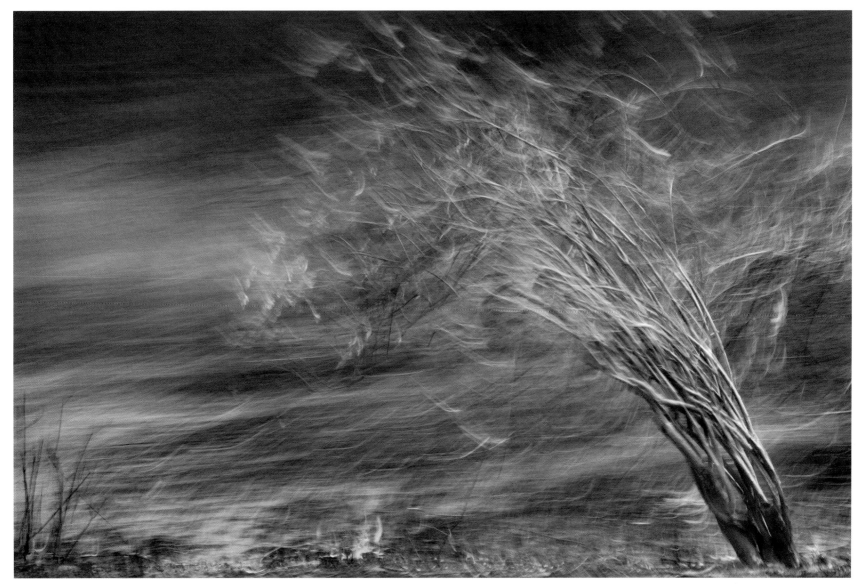

Queensland, Australia 2012

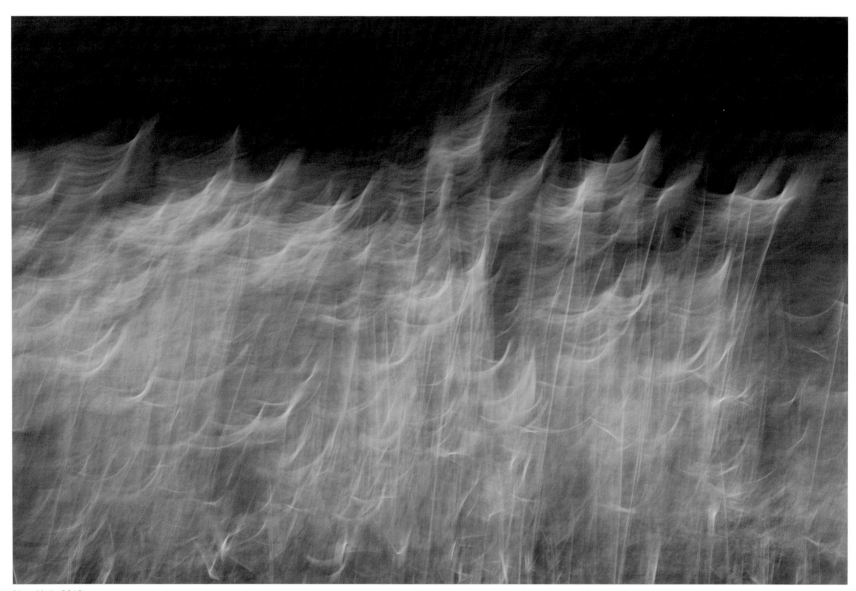

New York, 2010

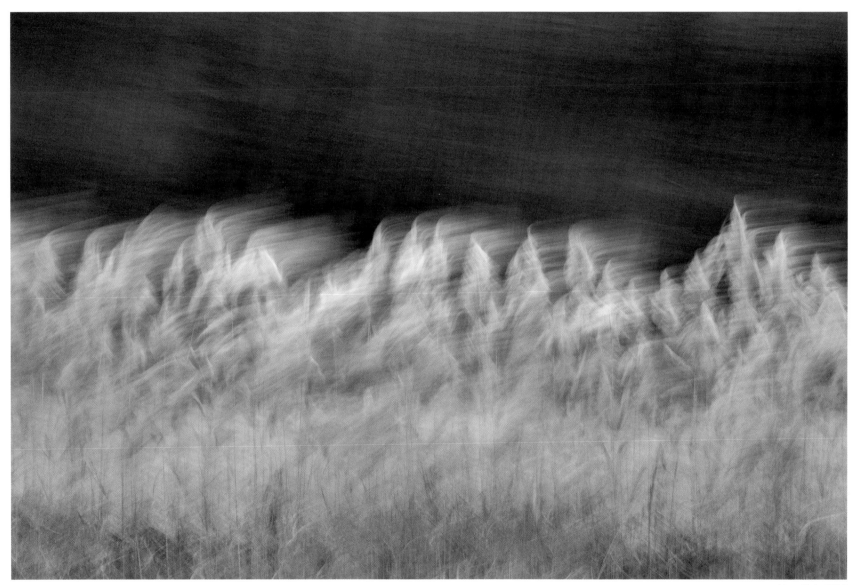

New York, 2014

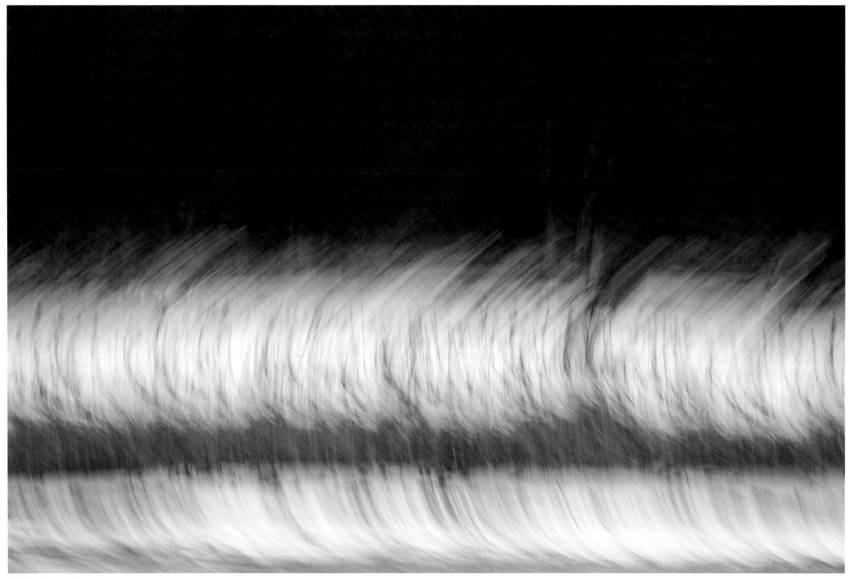

New York, 2010

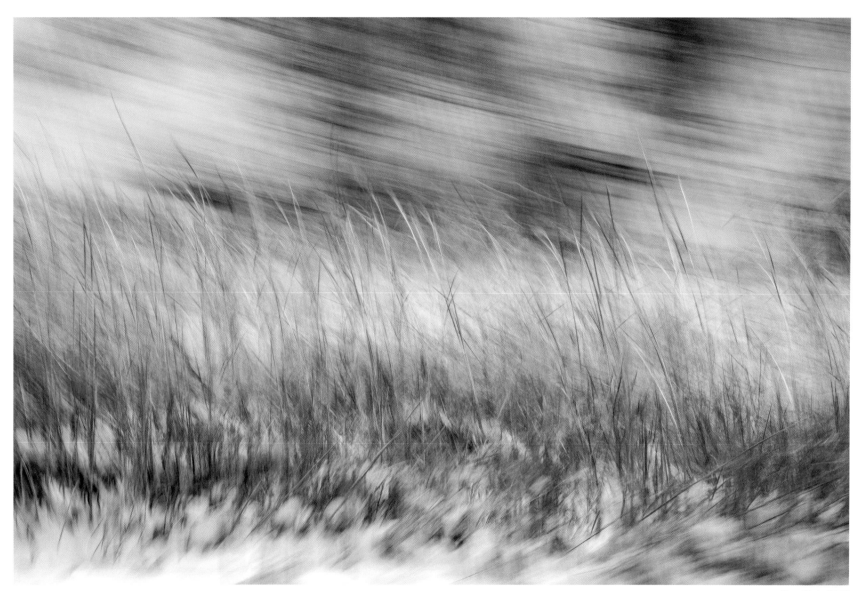

New York, 2010

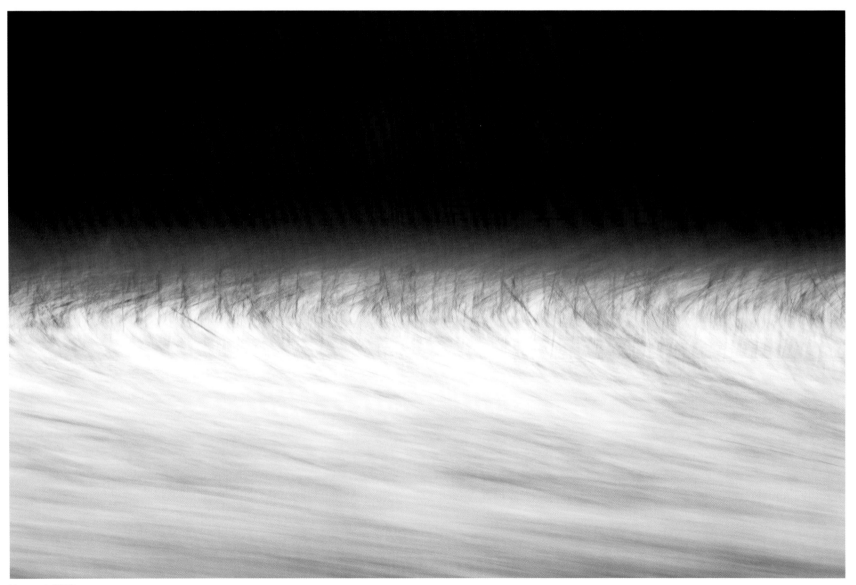

Vermont, 2010

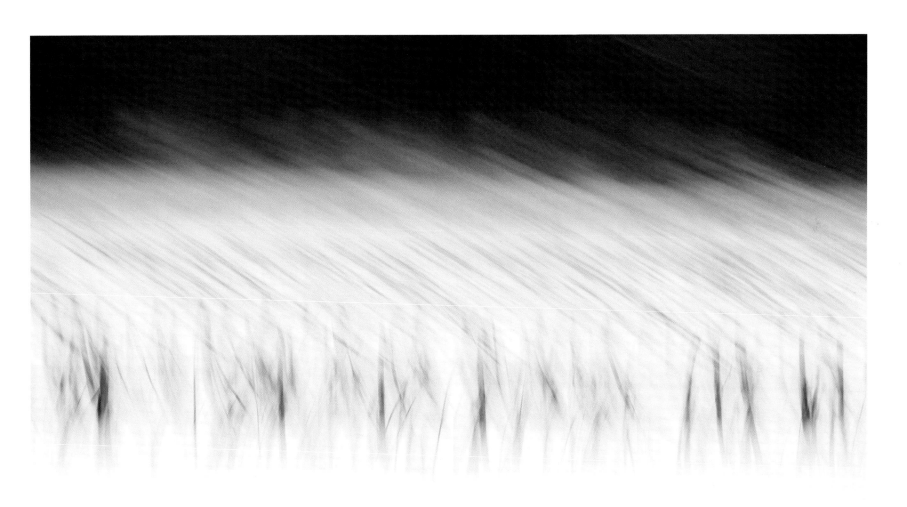

New Hampshire, 2010

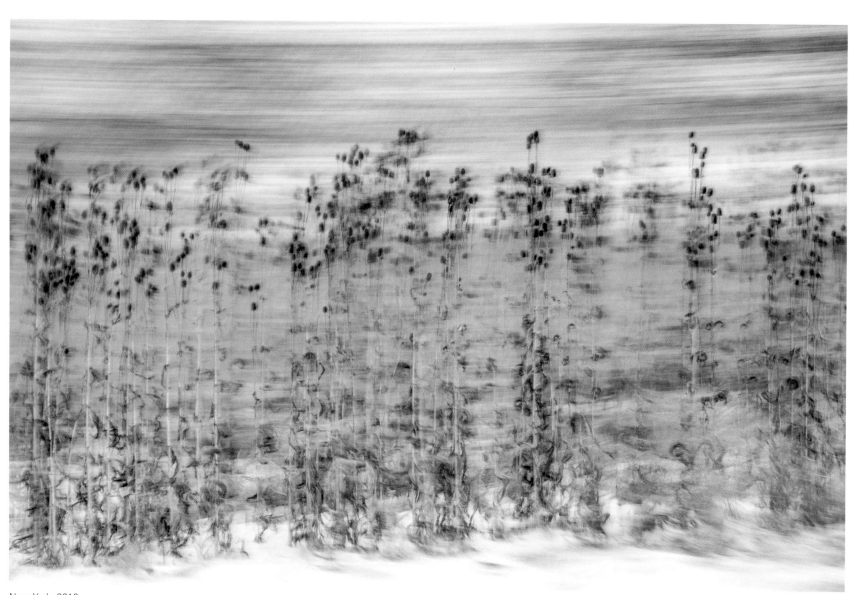

New York, 2010

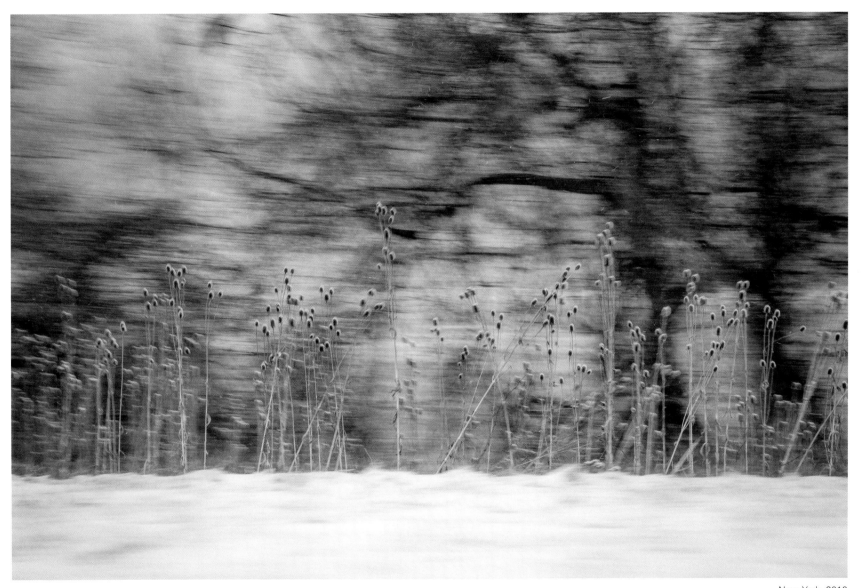

New York, 2010

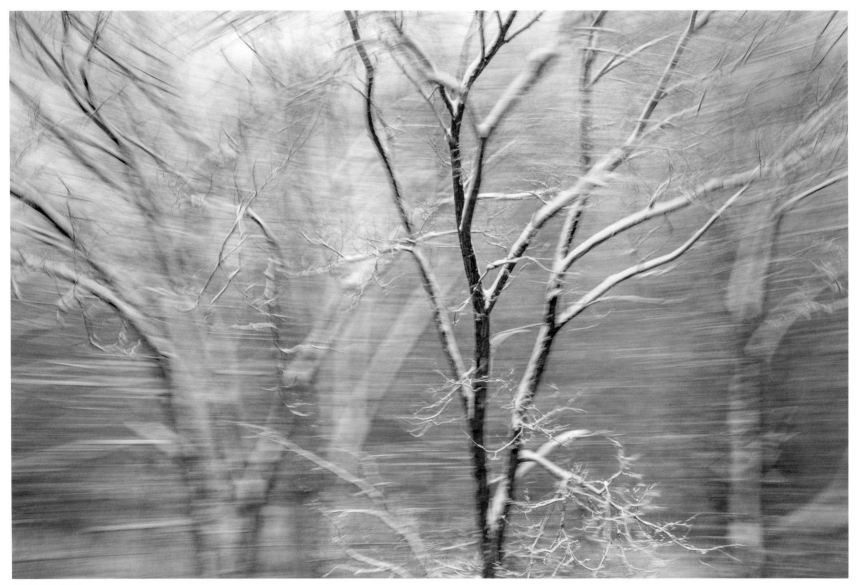

New York, 2012

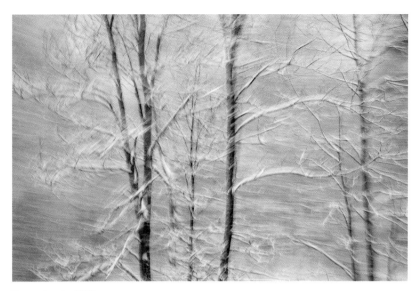

Pennsylvania, 2012

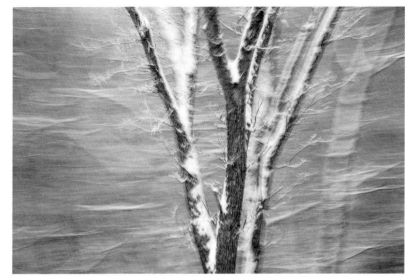

Pennsylvania, 2012

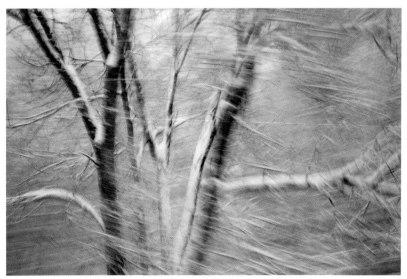

New York, 2012

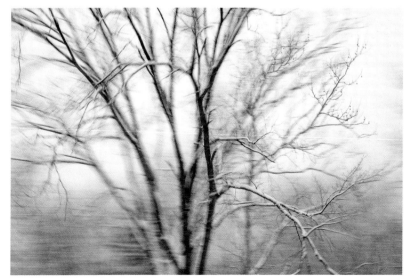

Pennsylvania, 2012

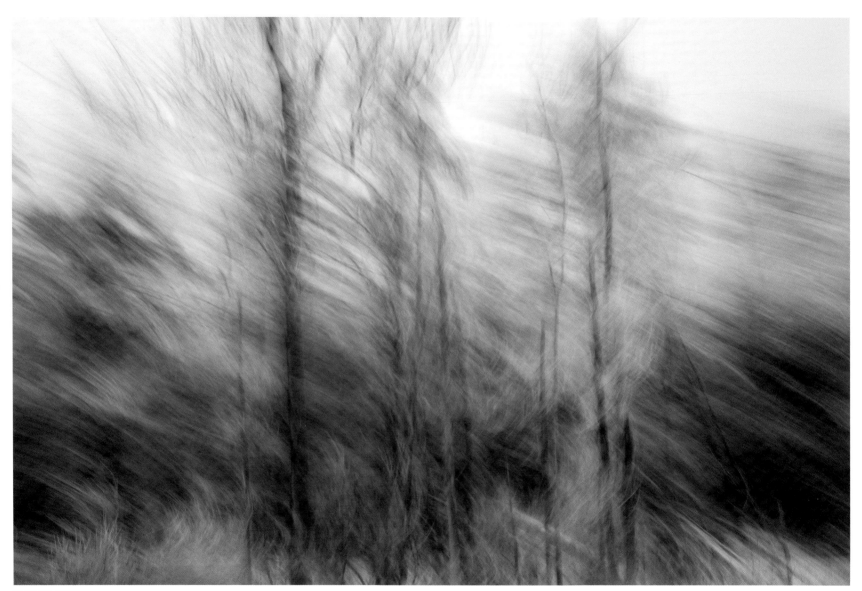

Vermont, 2010

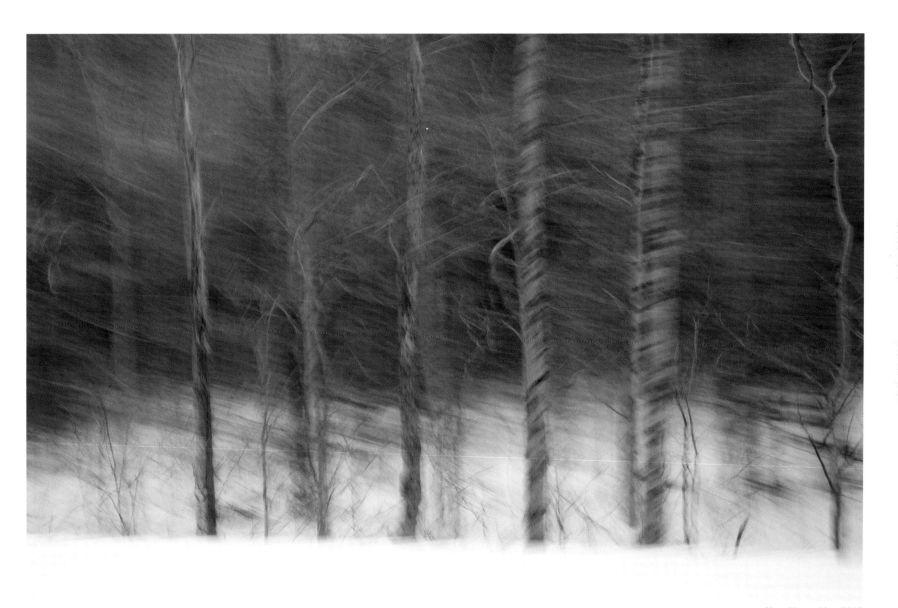

New Hampshire, 2010

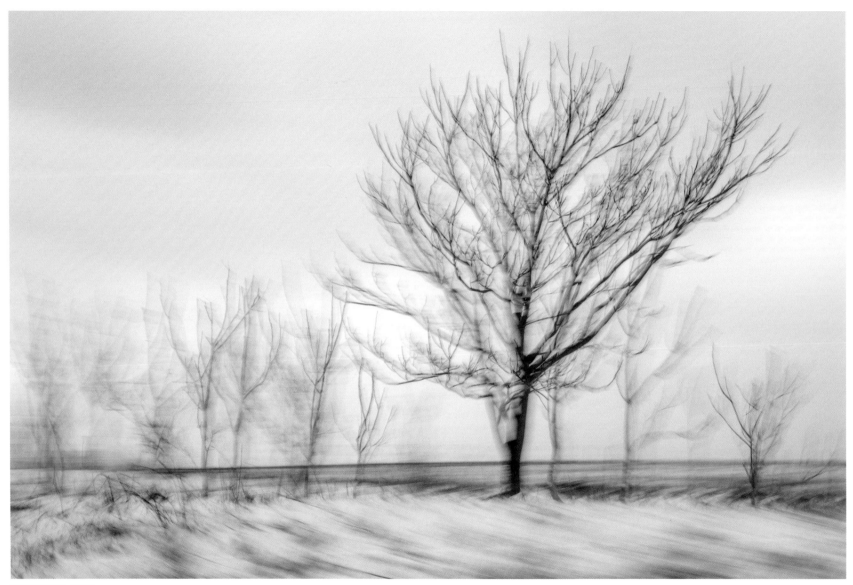

Pennsylvania, 2012

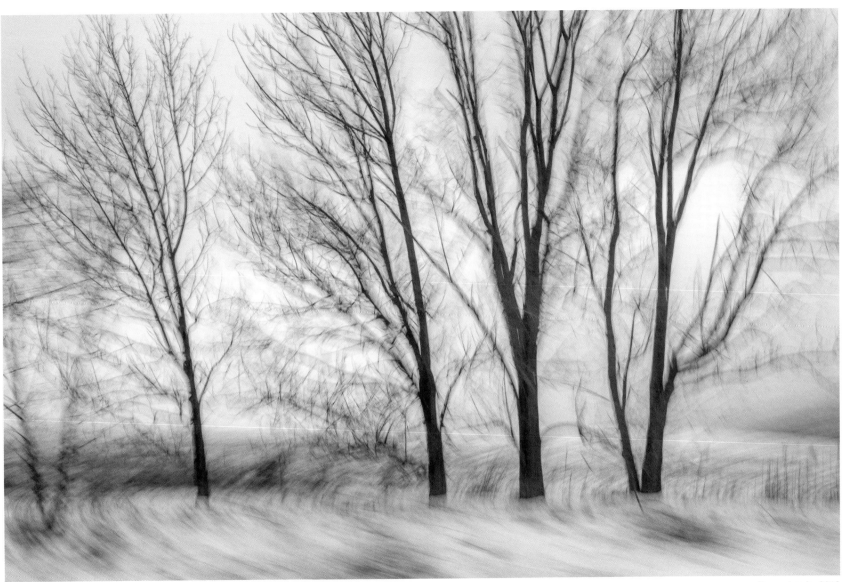

Pennsylvania, 2012

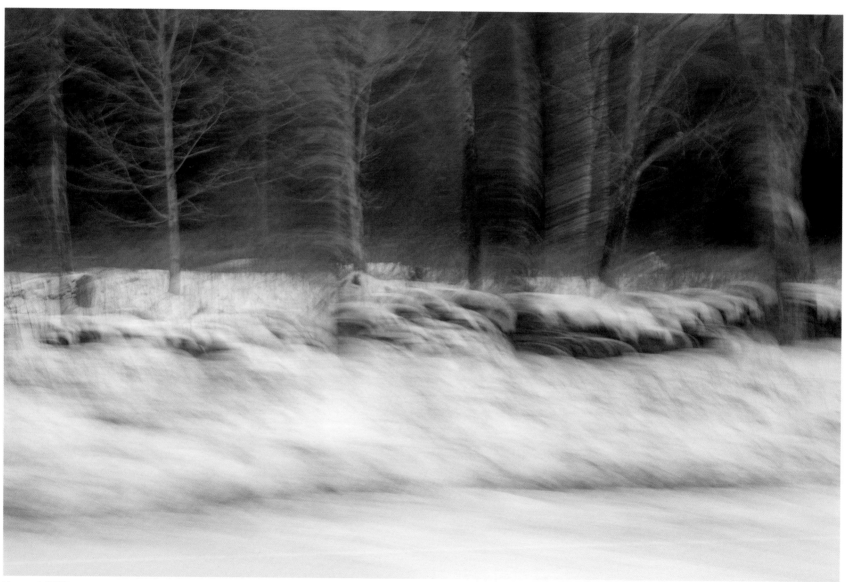

Vermont, 2010

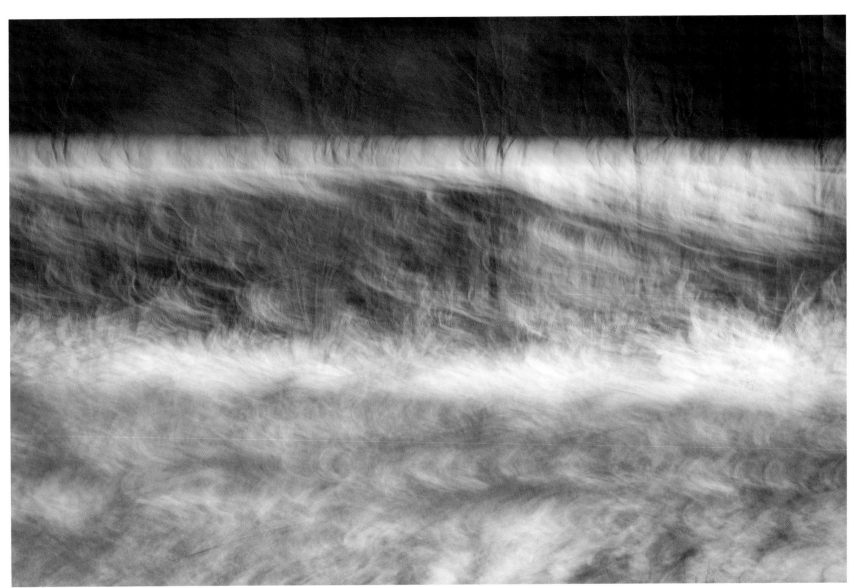

Vermont, 2010

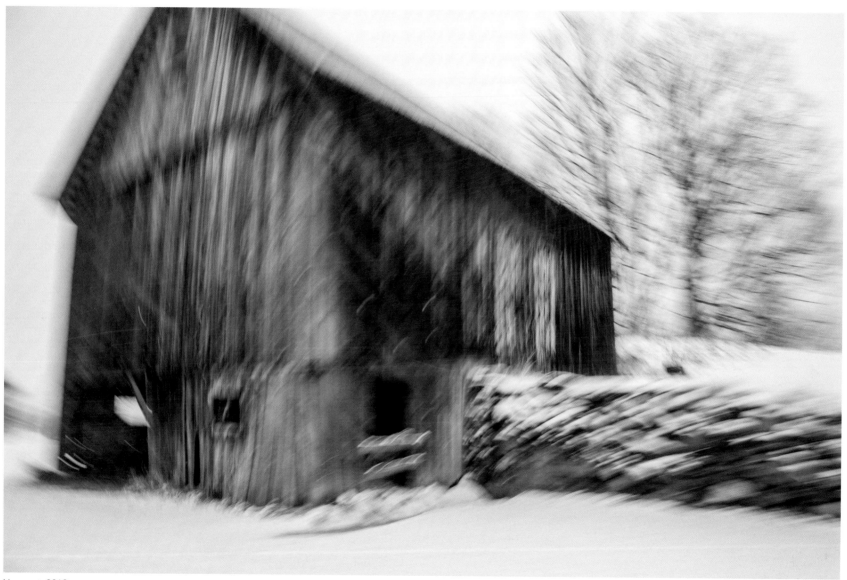

Vermont, 2012

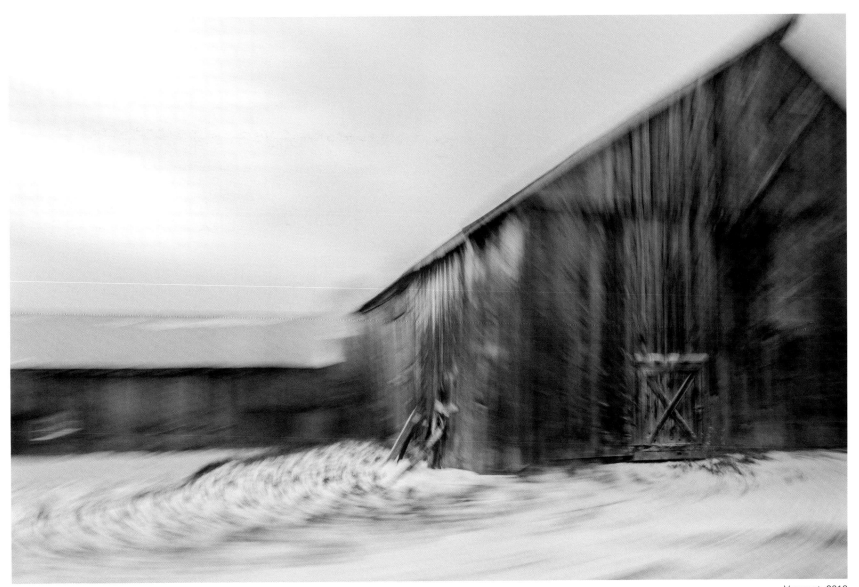

Vermont, 2012

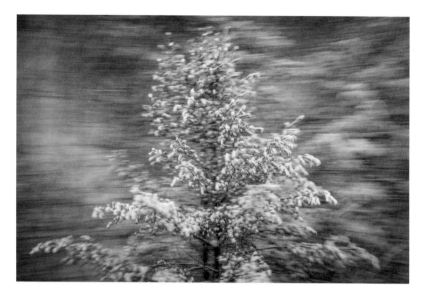

New York, 2012

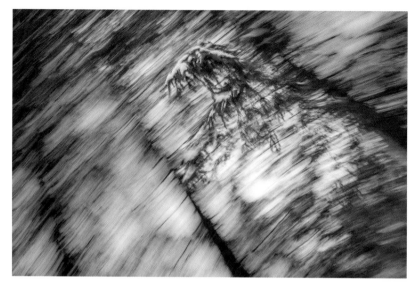

Vermont, 2012

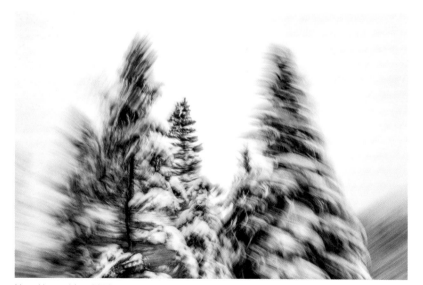

New Hampshire, 2010

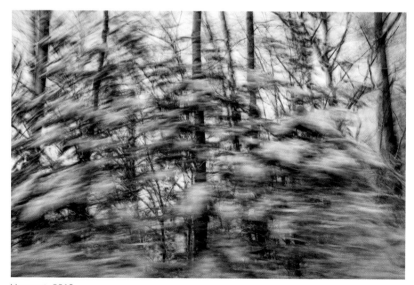

Vermont, 2012

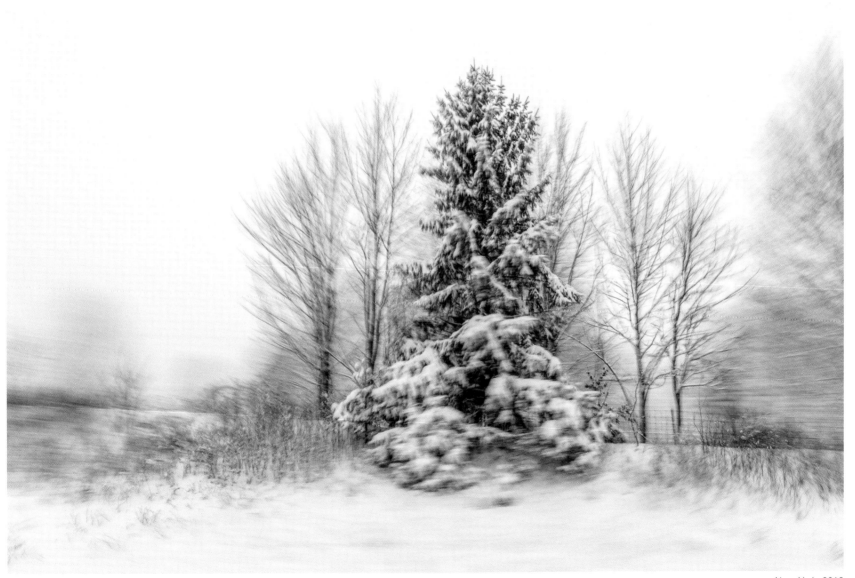

New York, 2012

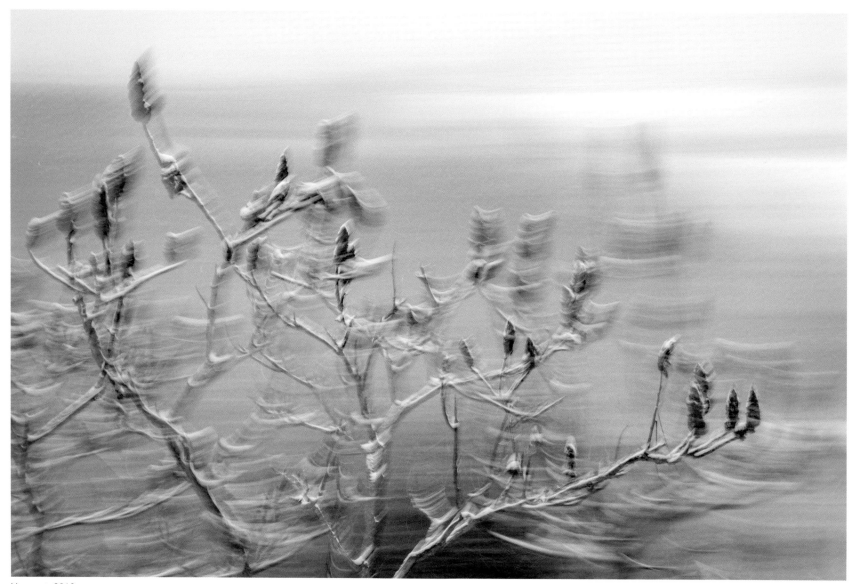

Vermont, 2010

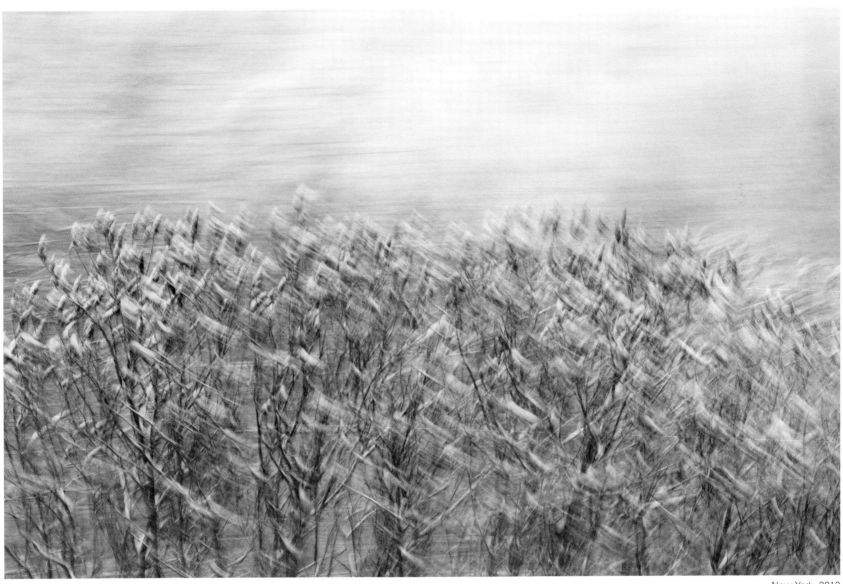

New York, 2012

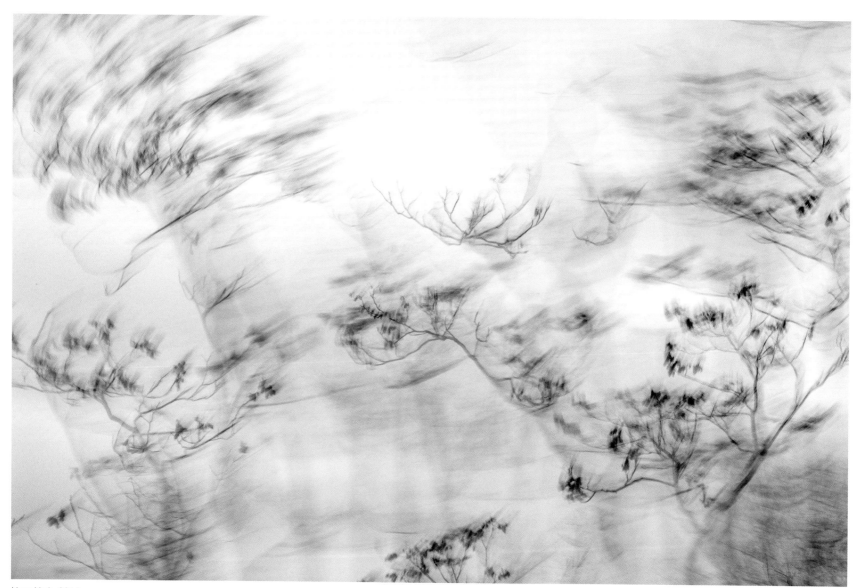

New York, 2014

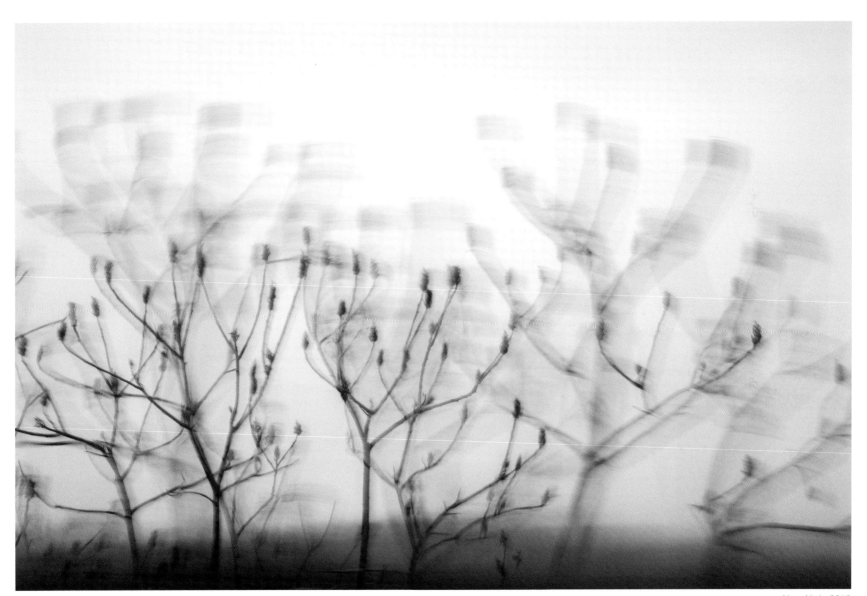

New York, 2012

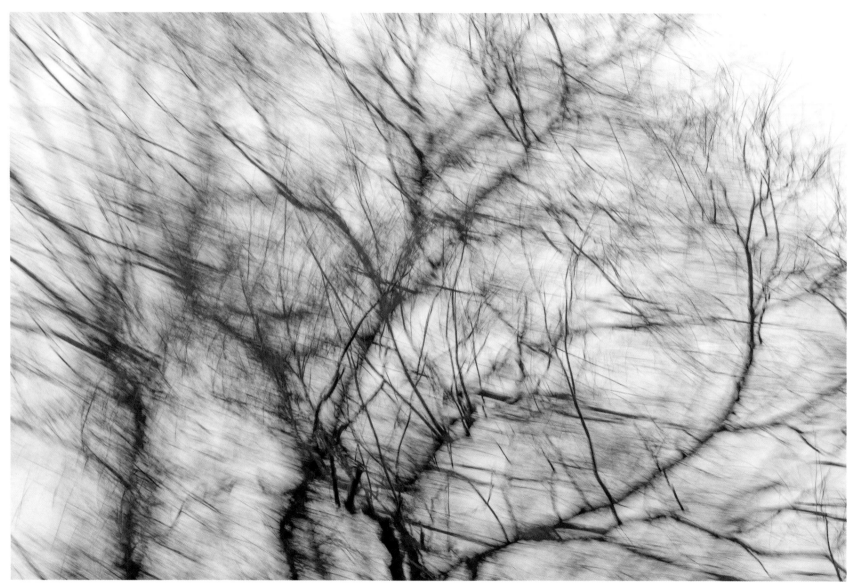

New York, 2014

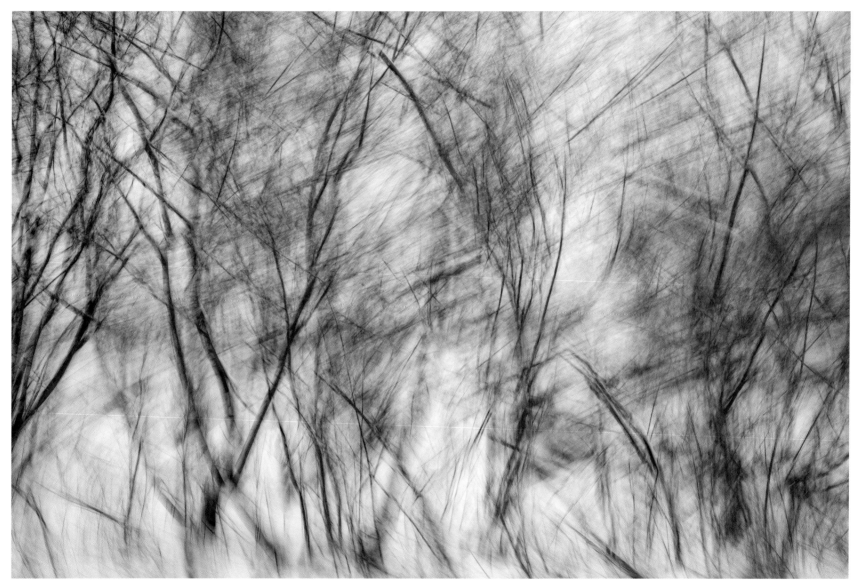

New York, 2012

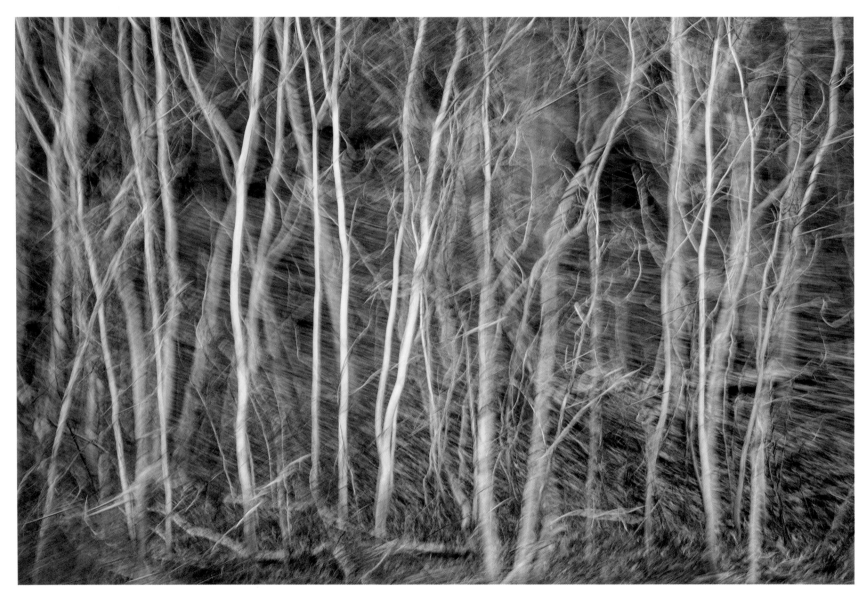

Pennsylvania, 2010

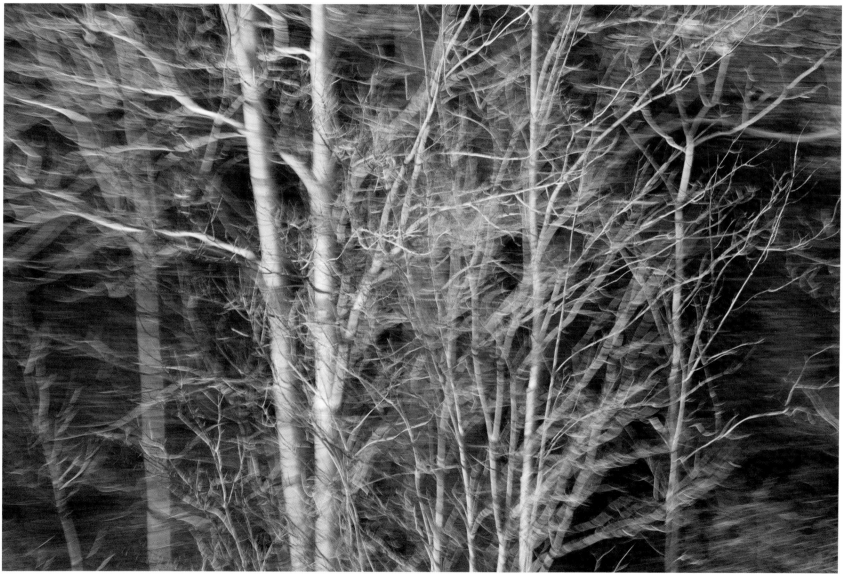

Connecticut, 2013

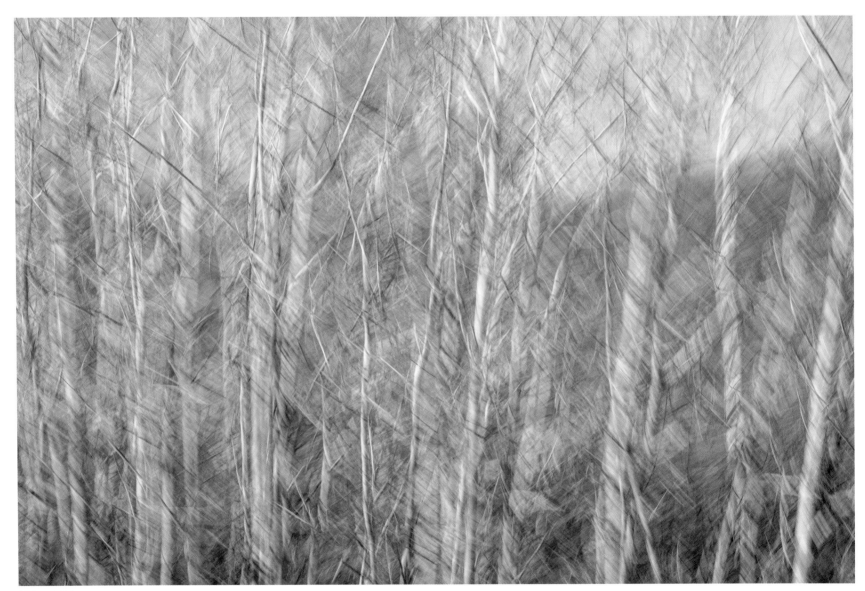

Maine, 2014

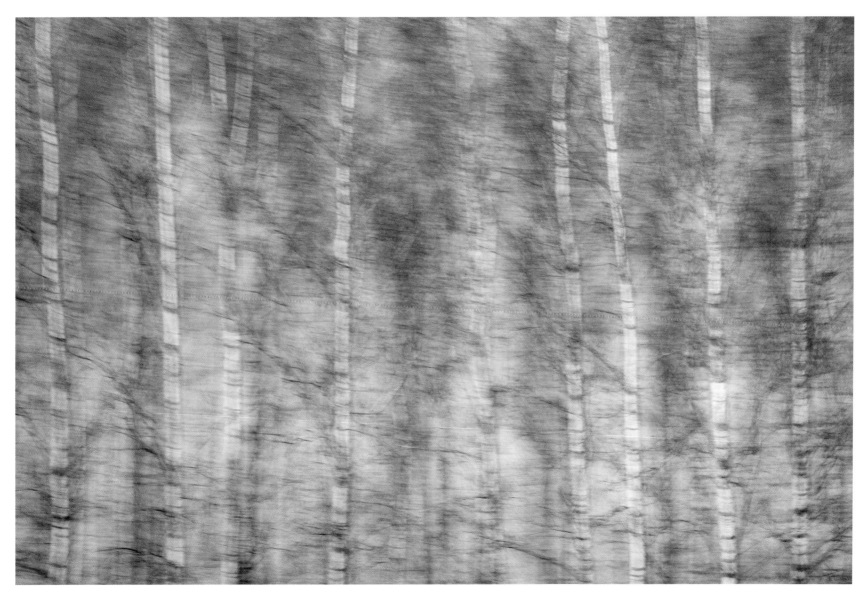

Krakow to Warsaw, Poland, 2014

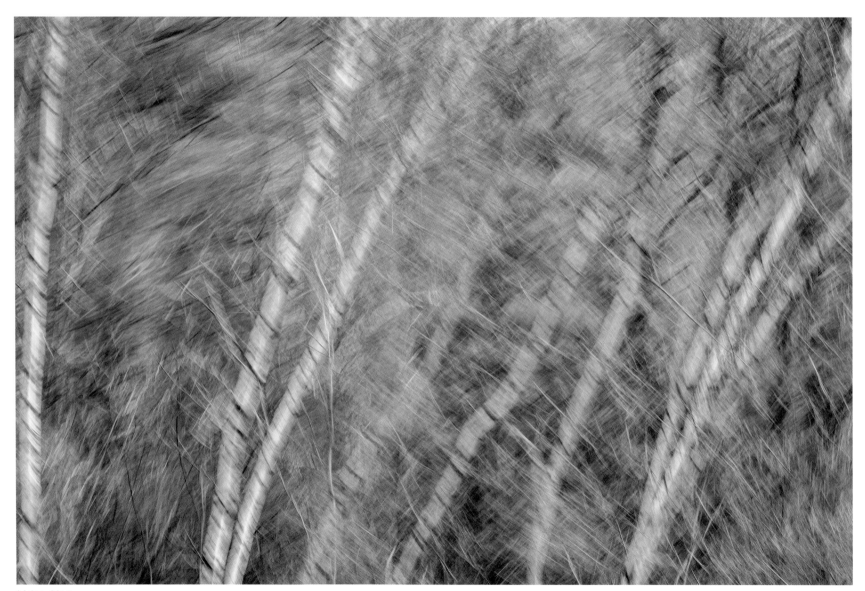

Maine, 2014

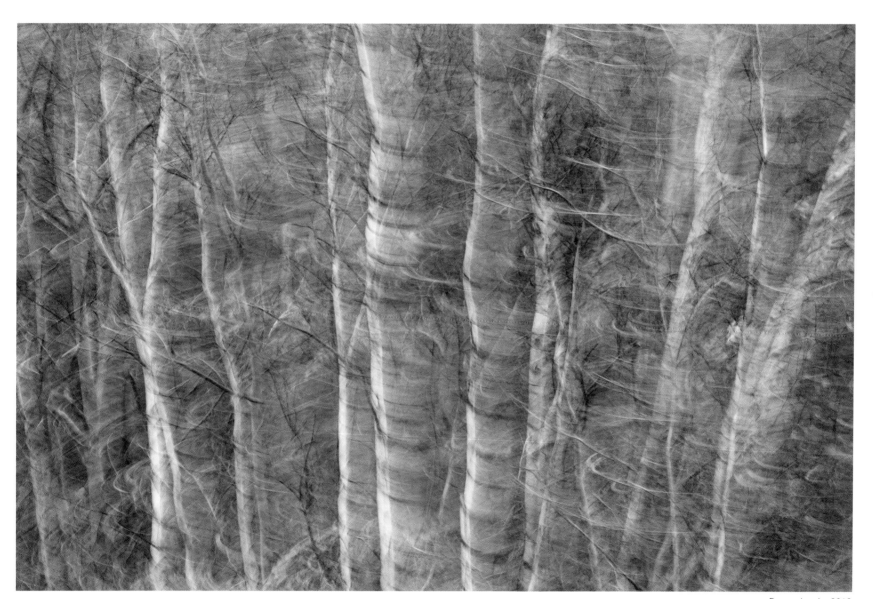

Pennsylvania, 2012

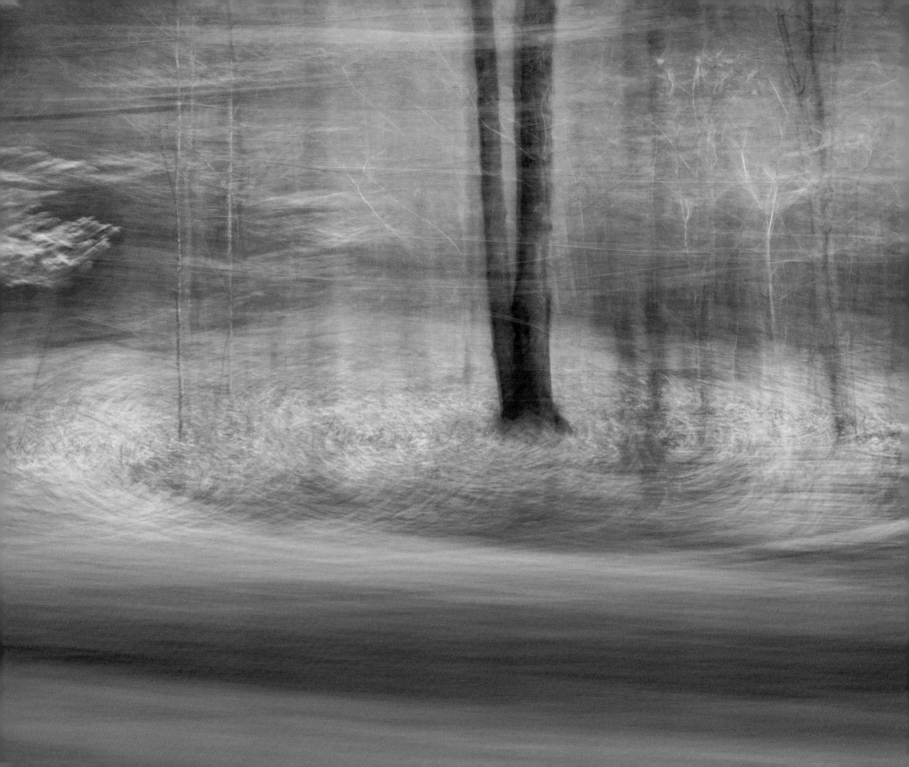

PHASE III

Organizing and Editing Your Images in Lightroom

New Hampshire, 2009

CHAPTER 11 **Organizing Your Workflow**

Organizing is what you do before you do something, so that when you do it, it is not all mixed up.

—A. A. MILNE

Every photographer is going to have his or her own unique way to organize and keep track of images. Although I've come to the conclusion that there isn't a single, definitive *right* or *wrong* way to organize your images, there are some things that are worth thinking about as you get started that can potentially save you both time and frustration in the long run. After working in Lightroom for a number of years and creating hundreds of Lightroom video tutorials, I'm pleased to be able to share what I've learned through working with the engineering team, watching others, and a process of personal trial and error.

You certainly don't have to incorporate every aspect of my workflow; after all, each and every one of us has a different way of thinking, and ultimately you will find the way that makes the most sense to you as you figure out your own path. Your solution will be different from mine, and for both of us it will be a result of personal preference and the kind of photography that we do. My goal is to show you what works for me so that you can choose to take the bits that will help you. So let's get started.

Organizing and Importing Images

Before we dive into Lightroom, you need to know a little about how the program works. When you first launch Lightroom, behind the scenes, the Lightroom application creates what's called a *catalog*. Lightroom saves this catalog file (and a few other files) in a folder named Lightroom, which it creates in your Pictures folder. This catalog file is where Lightroom keeps all of the information about the images that you work with.

It's essential to realize that your photographs are completely separate files from this catalog. The catalog contains only *pointers* to the photographs. Therefore, you need to decide where you want to store your photographs and how you want to organize them. Because I have more than 150,000 photographs (several terabytes of data), I store my photos on large, fast external drives. All of my photographs are organized into a hierarchy, with a single folder, named Image Vault, at the top level. Within that folder, I have subfolders for each year. Within each year's folder, I organize individual shoots into folders by location or subject. If you prefer to organize folders differently (by date, client,

or another category altogether), go ahead. What's important is that the folder naming convention and hierarchy that you choose remain relevant and informative later. Once you decide on a structure, keep using it and keep it consistent.

Now for a confession: Because the *Passenger Seat* project was so specific, I broke my own rule and created within the Image Vault folder a new folder called Motion Blur. I organized all of my images pertaining to the project within that folder, organizing subfolders the same as I did for my other work: by year and then by trip or location. Although separating these images into their own folder wasn't technically necessary, I found that this organizational structure allowed me to see all of the images pertaining to this project more quickly (by selecting the Motion Blur folder).

Tip

If it seems too overwhelming to think about going back and reorganizing all of your legacy files, you can always commit to an organized structure moving forward. Then, as time permits or as you want to work with older files, you can add them into your organized folder hierarchy on an as-needed basis.

Once you decide how you are going to organize your images, it's time to make Lightroom aware of the images that you want to work with. There are two primary methods

An organized folder structure makes finding photos much easier.

that you can use to start working with your photographs in Lightroom:

- You can launch Lightroom, click the Import button, and select your camera card to copy the photos to a specific location on your hard drive.

- You can copy the photos from your camera card reader to a specific location on your hard drive using the operating system. Then, launch Lightroom, click the Import button, navigate to the folder, and add those files to your catalog.

The Single Catalog Advantage

It is possible to create and work with several different Lightroom catalogs. For example, some photographers prefer to use separate catalogs for each project or client. I prefer to use a single master catalog to organize and work with all of my photographs for simplicity's sake. Using one catalog provides several advantages:

- You can search the entire catalog to find images that might cross over different projects and portfolios

- You can sync collections of images within a catalog with Lightroom mobile and Lightroom web. (To learn more about the benefits of collections, see Chapter 14.)

- You can store your single, all-encompassing catalog on an internal drive (probably your fastest drive) while storing your photographs (several terabytes of data, in my case) on any number of external drives. Many photographers who use the "one catalog per client" approach store the catalog with the photographs on slower external drives, which can delay the editing process because Lightroom has to constantly write the changes made to images (including keywords, metadata, changes in the Develop module, and so on) to the catalog.

I prefer the second method even though it requires me to first create the desired folder (Motion Blur > 2015 > New York to Vermont, for example) using the operating system, because not only can I copy all of the photographs from multiple cards at one time using the operating system, I also know that if there is a problem copying files, it's more likely to be something amiss with the card or card reader and not Lightroom.

Customizing Lightroom

To customize the import process, I like to change a few of Lightroom's default settings. You only have to do this once, then you're set for all future imports. In the Preferences > General window, I suggest turning off (unchecking) "Show import dialog when a memory card is detected" as well as "Select

You can adjust Lightroom's import options when adding photographs to the catalog.

the 'Current/Previous Import' collection during import." Turning off these defaults will help you keep focused on your task at hand, instead of allowing Lightroom to interrupt you either by displaying the import dialog unnecessarily or by automatically switching focus to the folder being imported or added.

In the Catalog Settings, under File Handling, set Standard Preview Size to Auto. This will make sure that Lightroom generates the correct size for your monitor if you choose to render standard previews when importing. (If you do use multiple catalogs, you will need to change the Catalog Settings for each catalog that you work with.)

With these defaults set, you're ready to start importing your photographs. In the Library module, choose Import. Because I chose the second method to import (previously outlined) and have already copied the files from my camera card to a specific location on my hard drive, I just need to select the new photographs as my source. Under File Handling, set Build Previews to Standard. Standard previews will take longer to create than the Minimal option, but will make moving through images in Loupe view a much more pleasant experience. I prefer to wait for Lightroom to build the standard previews before I start the editing process so that I won't have to pause when moving from one image to the next while Lightroom renders them. I can always find something to

Use metadata templates to quickly add copyright and contact information to photographs.

do while it processes—clean my lens, properly pack my gear, or get a cup of coffee.

If you plan to share your images with a broader audience, you will want to add metadata to them that will help other people find out about you, the photographer. To streamline your workflow, you can create a metadata template that includes copyright,

contact, and any other important information that you want to embed into your files. During import is the perfect time to add this information.

Create a custom metadata template in the Import dialog using the Apply During Import settings. Select Edit Presets from the Metadata drop-down menu. Fill in any information that you want to have applied to all images on import, and select Save Current Settings as New Preset from the Preset drop-down menu. Name the template, and click Create and Done, to save the template. Your new template will be available in the Metadata drop-down menu from now on.

Rendering 1:1 Previews

If you know that you are going to need to view your images at 100% to compare and check focus, you can select 1:1 as the Build Previews option when importing your photos. However, because 1:1 previews take even more time to render than the standard previews (as well as taking up more space on a hard drive), you might not want to set it as your default.

If you decide not to build 1:1 previews, you don't have to worry—if you need to zoom into an image, Lightroom will build the necessary 1:1 preview on the fly (it just might take a moment depending on your system).

In addition, the Metadata template will be available in the Metadata panel in the Library module in case you want to apply it to any images that have already been imported. If you prefer, you can also create and edit metadata templates in the Metadata panel in the Library module (or by selecting Metadata > Edit Metadata Preset), which will become available when importing.

If you want to be able to search through your library of images, it can be very helpful to add keywords to images to make them easier to find. For example, I added "Motion Blur" as a keyword to all of my images for this project. Just be careful: Although you

Tip

Even after you import your files, you can always choose to build standard or 1:1 previews (perhaps after selecting your most compelling images) by choosing Library > Previews and then selecting your option.

can add keywords when importing, *all* of the images will be assigned this keyword, so you will be limited to broader, all-encompassing keywords. You can add more refined keywords to individual images later, in the Keywording panel in the Library module. (To learn more about the benefits of keywords, see Chapter 13.)

Tip

If you add additional images to a folder that has already been imported into Lightroom, you might want to use the Synchronize Folder feature to make Lightroom aware of them. Select the desired folder in the Folder panel and choose Library > Synchronize Folder. In the Synchronize Folder dialog, you can choose to view the Import options (so you can add metadata and keywords for example), or simply click Synchronize and add the metadata after adding them to the catalog.

The more we can organize, find, and manage information, the more effectively we can function in our modern world.

—VINT CERF

CHAPTER 12 Editing and Culling Images

Patience is not simply the ability to wait—it's how we behave while we're waiting.

—JOYCE MEYER

Have you ever had a session where every image you captured was exactly as you envisioned? Me neither. Culling the winners from the also-rans is inevitable. In the *Passenger Seat* project, because the ratio of good images to bad was really pitiful, I knew that I would be deleting the majority of images that I made—thousands of blurred, boring, or improperly exposed images that were basically too flawed to be useful for any reason—because I prefer not to waste hard drive space with images I know I'm never going to use.

Some photographers have no problem deleting images; others never delete a single file. It's a personal choice: It's up to you as to whether you throw away images that you know you will never use, or whether you prefer to keep them all because, well, you never know what the future might bring.

I feel that there is a lot to be learned from the mistakes we make, so if you choose to delete images, take some time to study the ones that you reject before throwing them away. Try to discover what didn't work in the image and figure out what you would do differently next time to correct the problem. If you took the photograph for a reason, there must be some importance to it. It

might be very helpful to print out a contact sheet. Look at the images you took before and after the one you're discarding to see if there is a relationship between them. Can you see your photography evolve over the course of a day, and what does that tell you?

The Edit Cycle

Fortunately, regardless of the type of photography you do, Lightroom can make the process of culling your images easier. Whether you're looking for the single most effective photograph from a shoot or a sequence of images for a long-form project like *Passenger Seat*, Lightroom can help you quickly determine your best images, tag them, and make them easy to find down the road.

I will admit that the *Passenger Seat* project is unique. On average, I was rejecting and deleting from 70 to 80 percent of my original photographs. Because this percentage was so high, I decided that a multi-pass editing process would be the best plan of attack. The first edit is very quick. The only decision that I make is whether to keep or delete the image.

Although you can certainly edit in Grid view, I prefer to review larger images one at

a time. To do this, I switch to *Loupe view* or go into *Full Screen mode* (tap the E key to view a photo in Loupe view or the F key to view it Full Screen mode). To quickly move forward through the images, I use the Right Arrow key (use the Left Arrow key to return to the previous image). When I decide an image isn't worth keeping, I press the X key to flag the unsuccessful image as a Reject. You can also tag your images by clicking the respective icons, but using the keyboard shortcuts for the commands that you use most frequently can be much more efficient.

Tip

Having the Caps Lock key enabled automatically advances to the next image when you assign a flag, star, or color label in Lightroom.

I rarely needed to zoom in to an image during this first pass, as it was pretty evident which images weren't keepers. However, a single click in the image area in either Loupe view or Full Screen mode will render and display the image at 100% (click again to zoom out).

Once the first pass is complete, I return to Grid view. Choosing the Attribute option in the Filter bar and then clicking the Reject flag icon allows me to quickly see only the files tagged with the Reject flag. Selecting all of the files and tapping the Delete key gives you two choices: "Delete from Disk" and

Remove. "Delete from Disk" moves the file to Finder's Trash (or, on Windows, the Recycle Bin), whereas Remove simply "unimports" the image, making Lightroom unaware of the file while leaving it on your hard drive in its current location.

Tip

You can quickly delete images that have the Reject flag applied to them (bypassing the need to filter) by choosing Command+Delete (Mac) or Control+Backspace (Windows).

If you're not going to be deleting a lot of your images, you may never tag a single image with the Reject flag. In fact, many people don't. When we used to shoot film, we didn't go through a roll deleting the images that we didn't like; we just flagged the ones that we did. But this project was unique in that there were so many files that I knew that I was never going to use, and it would have been a waste of space to keep them. Psychologically it's probably not the best thing to reject so many images, so you need to decide if this first pass is necessary for your project.

In the second editing pass, I use the star rating system to promote my more successful images. Adding star ratings can be time consuming, depending on how quickly you are able to make decisions about the quality of your images. For some photographers the picture editing comes naturally; they're able

to move through their photos quickly, determining which are the best while ignoring the rest. For others, culling down a shoot takes more time, as they make complex decisions regarding how the images will fit together to tell their story.

I knew that I would want to zoom in and check focus on a large number of images, so before I started the second edit, in Grid view I selected all of the remaining images and chose Library > Previews > Build 1:1 Previews. (Pre-building the 1:1 previews enables me to move from one image to another without having to pause as each image loaded.)

Returning to Loupe view or Full Screen mode so that I can see each image on its own, I press the 1 key to assign one star to photographs I feel are strong, compelling, and noteworthy (both technically successful and aesthetically pleasing) and the 2 key to assign two stars to those that I think are outstanding. I reserve three stars for images that I believe are extraordinary. I ask myself questions such as, Does the image have stopping power or is it mundane and overfamiliar? I want to make sure that I can see the unique perspective that I bring to the work in all of my highly rated images. You need to determine your own criteria for rating images, and then stick to it for all of your shoots.

Looking at the numbers, out of 1000 images, I deleted 700 to 800 right away. Out of those 200 to 300 that were left, I tried to

be very conservative, promoting only about 25 percent of those images to one star. From my one-star images, I further reduce the edit, and I'm pleased if I promote 25 percent of the one-star images to two stars. Hopefully, a handful of those will be promoted to three stars and eventually end up in my portfolio, an exhibition, or a gallery!

Tough Choices Made Easier

You need to determine your own criteria and timing for rating images, but a few tips can make things easier. Above all, limit your options. I find that if I try to use all five stars, then the process takes forever; there are too many choices. Fewer choices help, as can more passes. Sometimes it's obvious which images should get one versus two stars on my first pass through the shoot. Other times, I find it easier to rate everything that meets or exceeds the one-star criteria by setting a single star on my first pass, setting the filter to display only those one-star images, and making a second pass to promote two-star images as I see them. Printing a few exemplary one-, two-, and three-star images from your project also makes a helpful reference for making quick, consistent decisions. Without a reference, I find that I can grow more strict or lenient throughout a project.

Sometimes you may not need to see each image in Loupe view or Full Screen mode, and you might be able to make an editing decision while in Grid view. Making the thumbnails larger in Grid view (using the Thumbnails slider in the toolbar) can help you scan through the images, quickly selecting the ones you like and pressing the corresponding number key to rate them. The Painter tool in Lightroom can also help to assign ratings to images. Select it from the toolbar, load it with the desired rating, and then click an image thumbnail in Grid view to rate it. Click-dragging through several enables you to rate them all at once. There are also times when I want to tag an image for another reason, such as converting to grayscale, so I use the Pick Flag or Color labels. There is no right or wrong way to tag your images, but some might be better aligned with the way you like to work. With some experimenting, I'm sure that you'll find the method that you're most comfortable with.

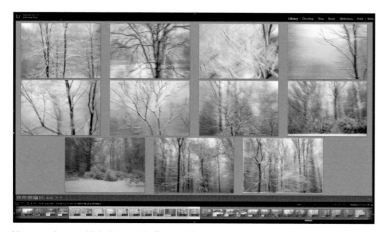

You can view multiple images in Survey view.

You can view two images in Compare view.

Lightroom offers two additional views for looking at multiple images. *Survey view* enables you to view several images at once, which is extremely helpful when you need to compare a number of images or are trying to figure out the best sequence to present them. When trying to decide between very similar images, however, I like to use *Compare view* so that I can zoom in and view different parts of each image, checking focus and details to see which photograph I prefer.

I strongly suggest that you remain in the Library module when you are selecting your images. The urge to select an image and move it to the Develop module to start refining can be very tempting, but try to resist it. I find that if I have the willpower to stay in the Library module until I have selected the body of work that I want from the shoot, I avoid wasting time toning photographs that I end up not using. If an image needs a quick white balance or exposure adjustment to help with the editing process, you can use the Quick Develop panel in the Library module to make rough adjustments to make sure that you will be able to fix the image as desired, but don't invest a lot of time until you are sure that you are going to choose that photo to use in your project.

The passage of time also makes the process of editing much easier. When I first return from a shoot, I tend to think that many of my images are very good. Days or weeks later, I can step back and be more critical. I need to live with my photographs for a while in order to make a solid decision with regard to their importance and significance.

The difference between something good and something great is the attention to detail.

—CHARLES R. SWINDOLL

View Settings

I like to customize the "slide mount" area around images (in Grid view) to see relevant information about an image. To do so, select View > View Options. In the Grid view, I set Show Grid Extras to Expanded Cells. Under Options, turn off "Tint grid cells with label colors." In the Expanded Cell Extras section, enable Include Color Label and select the labels to be displayed in the header. I prefer File Base Name, File Extension, Crop Dimensions, and Megapixels. When in Grid view, press J to toggle through these Grid view styles.

Within the same View Options dialog, clicking Loupe View enables you to display two different overlays of information about your image. Select your preferences from the list. Then, while in Loupe view, press I to toggle through the views.

Customize your view settings to display relevant information in Grid view.

CHAPTER 13 # File Naming, Keywords, and Important Metadata

What you do today
can improve all
your tomorrows.

—RALPH MARSTON

Today's cameras may be able to focus faster and calculate light more accurately than we can, but when it comes to adding intuitive and memorable information about the captured files, they need our help. Fortunately, we're not starting from scratch. Most cameras automatically add a significant amount of data to the file, including when the image was taken; the camera make, model, and lens that were used to capture the image; and even such camera settings as f-stop, aperture, and ISO. But if we are going to be able to find these images days, months, and years from now, we should take the time to include a few additional bits of meaningful information about the contents of the photograph. Because no matter how great an image is, if you can't find it when you need it, it's worthless.

Renaming Conventions

While some photographers never feel the need to rename a single file, I prefer to add to the file names my last name as well as the year that the photograph was made and a sequence number. This way, when I send a file to anyone or post one online, the viewer can easily see who created the file and what year the photograph was taken.

It's important to know that when you rename your files in Lightroom, the files are renamed not only in the catalog but also on your hard drive. If you decide to rename your photographs, I suggest you wait to rename until after you delete the images that you don't want from a shoot. This saves you from renaming images you're going to discard anyway, and prevents gaps in your renumbering sequence. To rename your images, select the files you want to rename and, in the Library module, choose Library > Rename Photo. The resulting dialog provides a drop-down menu that includes a number of presets to choose from, but I prefer to create my own custom file naming convention.

When I started the *Passenger Seat* project, I was using a separate catalog for the project (which I have since combined). However, at the time, to avoid ending up with multiple files with the same name, I needed a naming convention that was unique. For all of

my other photographs, I was using my name, the year, and a sequence number, with the renamed files following this pattern:

- JKOST_2015_00001.crw
- JKOST_2015_00002.crw
- JKOST_2015_00003.crw

For the *Passenger Seat* project, I decided to simply insert MB (for Motion Blur) into the name. Selecting Edit from the File Naming drop-down in the Rename Photo dialog, I typed JKOST_MB_ in the Filename Template Editor. Then, using Lightroom's ability to use metadata information, I chose to insert Date (YYYY) to add the year from the metadata in the file, typed another underscore, and inserted Sequence # (00001) to have Lightroom create the five-digit sequence. The renamed files now followed this new pattern:

- JKOST_MB_2015_00001.crw
- JKOST_MB_2015_00002.crw
- JKOST_MB_2015_00003.crw

I saved this preset so that I could use it for the duration of the project.

There is one drawback to this method. Because I keep a single sequence that spans multiple shoots, I need to check the previous shoot to pick up the sequence number from the last named file. To find the number, I click the folder for the current year, make sure that I'm sorting by capture time, and then scroll down to find the last renamed image in Grid view. (Alternatively, you could

use the Date metadata filter to quickly find the last shot from your previous shoot, if you remember when it was.)

Note

You'll notice that at this point in my workflow my photos are still in my camera's proprietary file format (.crw). When I'm finished editing them, I will convert them to DNG (more about that in Chapter 27).

Another popular renaming convention is to include the entire date as part of the file name. In the Filename Template Editor, insert Date (YYYYMMDD) and the Sequence # (00001) to create the resulting files:

- 20150505_00001.crw
- 20150505_00002.crw
- 20150505_00003.crw

I prefer not to include the entire date in my file names, however, because I find it difficult to read. Plus, the capture date is stored in the file's metadata, making it easy to filter files based on date.

Many photographers also like to keep the sequence number that the camera applies to the file, but remove any other characters and append the name with additional information. Choosing to insert the original File Number Suffix in the Filename Template Editor and adding additional options can quickly change files from:

Create filename templates for consistency throughout your workflow.

- IMG_3345.crw
- IMG_3346.crw
- IMG_3347.crw

to something more identifiable, such as

- KOST_3345.crw
- KOST_3346.crw
- KOST_3347.crw

Finally, if you want to rename each of your shoots uniquely, insert the Custom Text option. There isn't a single right or wrong way to name your files, so choose a naming convention that works for you and then be consistent.

Enrich with Metadata

Although renaming your files can help you keep track of them, adding other types of metadata to your images can help you find them at a later date. Keywords, captions, and titles are good examples of this type of information. For example, I typically try to add four to five keywords to my images, including the location (city, state, country), the subject (barn, tree, snow), and additional attributes that will help me to find an image in the future (motion blur, upbeat, cold). You can add *general* keywords when you import files (because all of the images in the import will be assigned the same keyword), but you will want to use the Keywording and Keyword List panels in Lightroom to add these more refined, image-specific keywords.

If you don't know whether or not you should keyword your images, next time you are trying to find a photograph, figure out what would have made it easier to find. For example, if you are looking for an image of a temple that you know you took in China, at least you know that it's somewhere in the China folder (along with the other 10,000 images you made on that trip), so it might be relatively simple to find. If you are looking for a photograph that you know you made on a certain day, that's easy, the date is in the file, so you can use the Filter bar to search on Metadata > Date to narrow down the options.

But if you're looking for all of your images of temples from around the world, taken over the past 15 years, well, that's when it would be a distinct advantage if all those images had been keyworded with "temple."

I find it easiest to select images in the Grid view and then enter the keywords in the Keyword panel. As you add keywords to your catalog, Lightroom will offer suggestions from recently used keywords. The Keywording panel displays Keyword Suggestions (based on proximity and capture time), as well as Recent Keywords (in the Keyword Set section) that can be added by clicking the keyword (instead of having to type them in). If you find that you often add a specific set of keywords, in the Keywording panel, use the drop-down menu next to Keyword Set and create your own custom set of up to nine keywords. Saving this set keeps those keywords available as long as necessary in the panel.

Adding keywords can be time consuming, but depending on the type of photography that you do, it can be worth its weight in gold if you need to find your files quickly. In fact, I don't typically make subfolders within shoots, because I find that while folder organization is a good start, it isn't nearly as powerful as metadata. I know that I will be able to quickly find 99 percent of the images that I need for this project based on keywords, file names, capture date, or a

Use the Keywording panel to add descriptive information about an image.

Adding keywords using custom sets can save time.

combination of those.

There's no right or wrong time to add keywords and other metadata, but I do try to add them before going to the Develop module to process my images. If I don't, I find that it's more difficult to return to the images and keyword them at a later date, which gets out of hand quickly. I try to be disciplined: I keyword first, then reward myself by going to the Develop module.

If you are planning on adding captions or titles to your images, it is also best to add them in Library module's Metadata panel so that the information will be added to the file and available throughout Lightroom's output modules. If you add text to a photograph, such as adding Photo Text in the Book module or Custom Text Overlays in the Slideshow module, it will be included as part of those specific projects only and will not be accessible to other modules. If you need to add long captions, it's helpful to select Large Caption from the drop-down menu in the Metadata panel header for more space to see what you're writing.

Tip

If it's too overwhelming to think of keywording all the images that you already have, just start today, and from this moment forward be sure to include keywording as part of your workflow.

GPS: Sometimes Low Tech Can Save the Day

For the *Passenger Seat* project, I felt that it was important for me to keep track of where the images were taken. Unfortunately, my camera doesn't automatically record GPS, so early on I decided that keeping track of the state would be enough. As we crossed state lines, I tried to make sure that I photographed the road signs. When I missed those, I would manually write down the image number and the state. It wasn't too scientific, but it worked.

For a few of my trips, I used an app on my mobile phone to record a track log that I then imported into Lightroom to automatically apply GPS coordinates to the images using the Map module. The benefit of knowing the GPS coordinates is that Lightroom can then use them to provide address suggestions (such as city, state, and country). Although this was much easier, it meant using data roaming, which proved too expensive when working on the project in other countries. There are other alternatives for tracking GPS; it's up to you to decide how important location information is to your project.

What is the intersection between technology, art, and science? Curiosity and wonder, because it drives us to explore, because we're surrounded by things we can't see.

—LOUIE SCHWARTZBERG

CHAPTER 14 **Making Collections**

I am always doing
that which I cannot
do, in order that I may
learn how to do it.

—PABLO PICASSO

Although I appreciate having a well-defined organizational structure for my images on the hard drive and find star rating an excellent method for culling my images so that I can quickly see the best from a shoot, I find Lightroom's collections to be the key to organizing my images into projects, whether they're books, portfolios, or slideshows. Using *collections*, you can assemble an unlimited number of groups of images without ever moving or duplicating the originals on the hard drive.

When you create a collection using Lightroom's Collections panel, the thumbnails that you see in the collection are pointers to the original files that are still safe and warm in their original folders. When working with collections, you can:

- Add the same image to multiple collections without wasting space by duplicating files on your hard drive
- Leave the original file exactly where it belongs on your hard drive
- Make edits once and have them update across all collections (including making changes to keywords, metadata, and edits in the Develop module)
- Sync your images in the cloud for use with Lightroom on mobile devices

Lightroom offers four choices for collections:

- Smart collections, which are automatically created based on filter criteria
- Regular collections, which are user defined
- Collection sets, which are folders used to organize and store collections
- Quick Collection, which is a single, temporary collection

Create a collection by choosing Library > New Collection and the + (plus) icon in the Collections panel header, or by using the shortcut Cmd/Ctrl+N and selecting the desired option from the menu.

Let Lightroom Do the Work

Smart collections are based upon the results of searching on particular criteria. They are extremely useful for viewing images across multiple folders, yet have certain common attributes. For example, you may want to create a smart collection that shows all of the photographs that have two-star ratings, were taken in 2015 and have the keyword "horse."

The available search criteria are much more powerful than the simple example

above. The search criteria can be refined using a number of additional options, such as dates (including date range), camera settings (including ISO, f-stop, shutter speed, and so on), size and aspect ratio, captions, creator, and more. You can set up smart collections to show images that are missing keywords or metadata like copyright and contact information. Using smart collections is similar to using Library filters, but smart collections are more convenient for long-term projects because they remain accessible in the Collections panel for as long as you want them to, allowing you to move on to different tasks while knowing they'll be there when you return.

In addition, smart collections auto-update as you make changes to your images. If your smart collection is based upon two-star images and you decide to demote one image to one star, Lightroom will automatically remove it from the smart collection. Unfortunately, images in smart collections cannot be manually reordered, so they're not the best solution if you're trying to sequence images. That's where regular collections excel.

Taking More Control

Regular collections are extremely valuable when you want to create a collection of images that don't necessarily share common attributes like ratings, keywords, or other metadata. For example, you might want to put images of the Statue of Liberty and an apple in one folder because you are creating a collection of things that remind you of New York. In addition, you can reorder images in a regular collection, making it a powerful tool for sequencing images.

I often start by using the Filter menu to find images for a project, drag them into a collection, and then refine the collection. For instance, I first filter on two stars or greater and the keyword "motion blur," and Lightroom finds 150 images that match those criteria. If I'm creating a slideshow that can contain only 75 images, I would first add the 150 two-star images to a collection and then delete the ones that I don't want in the slideshow. Deleting images from a collection is different from deleting from a folder. When you delete from a collection, it simply removes the photograph from the collection but the file is still in the folder. The images in a regular collection can then be reordered in a custom sequence to best present the story.

Lightroom also has the option to create a *target collection*. When creating a collection, you can choose "Set as target collection" in the Create Collection dialog, which adds a small plus icon to the right of the collection's name in the Collections panel. When I want to add additional images, and I have designated that collection as the target collection, instead of dragging each new image that I find to the collection, I can simply select the

A dream doesn't become reality through magic; it takes sweat, determination, and hard work.

—COLIN POWELL

image and tap the B key to add it. Or if I am adding lots of images, I switch to the Painter tool, set it to paint with "Target Collection," and click (or click-swipe across) multiple images to add them. At any time you can change the target collection by right-clicking another regular collection and choosing "Set as target collection." You can have only one target collection at a time, and smart collections can't be target collections (because they're based on search criteria).

Use the Quick Collection, in the Catalog panel, to make a temporary collection of images that you know you aren't going to keep long term.

I have found that over the past few years, I spend far more time working with collections than I do with folders. Folders remind me of record albums: Each album contains a number of songs that you enjoy listening, to as well as some that you really would prefer to skip. Folders are my records. Collections are the playlists of my greatest photographic "hits."

CHAPTER 15 # Sequencing Images

Be willing to step outside your comfort zone once in a while; take the risks in life that seem worth taking. The ride might not be as predictable if you'd just planted your feet and stayed put, but it will be a heck of a lot more interesting.

—EDWARD WHITACRE, JR.

Once you have selected the images that you want to use to tell your story, you need to start thinking about the order in which the photographs will be displayed to achieve the greatest impact. Sequencing images to assemble a visual narrative is definitely an art form, and a lot depends on the story that you are telling and the images you have to tell it. It takes practice and patience. Sometimes the images fall right into place. Other times it takes careful planning to appropriately reinforce the story.

Lead the Viewer

The way the images will be displayed plays a huge role in choosing the right images and showing them in the correct order. The final presentation provides a framework in which to create a relationship between images. Laying out images for a book, for instance, might be very different than for a slideshow or gallery exhibition. One might require a single, isolated image to tell a story, whereas the other might depend on multiple images to create meaning.

There are an infinite number of ways to put images in groupings: by subject, mood, color, feeling, emotion, time, and so on. The very act of sequencing images creates a relationship between the photographs. Putting images next to each other (on the same page, for example) encourages the viewer to create a relationship between them. The viewer then creates his or her own story based on personal life experiences and creates a unique "third" meaning based on this relationship.

The body of work should take on its own rhythm in its presentation. Varying the subject, camera angle, or field of view are all ways that help establish the cadence. Some images have more impact when printed large; others want to be viewed closer, so printing them small can create a more intimate relationship with the viewer. Some images will be your "heros," while others will lead or follow in a more supportive role.

Text and imagery must reinforce one another. Be sure to select a typeface that tells the same story as the photographs, and format them accordingly. A lightweight font with increased kerning and leading might pair well with a cheerful, high-spirited project, while a bold, heavier-weighted font might help reinforce the more somber mood

of a serious or melancholy project. The written word on the page or on the screen also becomes an image. As the creator of the content, you get to choose the sequence by which you lead the viewer through your story. You help them navigate within a new world through your eyes.

Sequencing in Lightroom

For small projects that contain maybe a dozen or so photographs, I select the images from my collection and use Survey view in Lightroom to freely drag the images to create a custom sort order. If the project is larger, then I try to break up the sequence into smaller chunks so that I can still see the previews relatively large in Survey mode. How well you know each image will determine how many you can work with at one time.

When sequencing more images than I can easily view at one time on my monitor, or when I need to see a broader overview of the scope of the project, I find it helpful to print them. Because images can look different at various sizes, I always try to print them at the size at which they will eventually be displayed. When that's not possible (if you don't know the final size, there are too many, or it would be cost prohibitive), I print the images as large as possible for the space I have. For example, I know I can comfortably view and rearrange about 50 4 x 6-inch images on my

dining room table.

Often I'll create multiple collections in Lightroom that contain the same images, establishing different relationships between images through different positioning within a sequence as well as different categories or groupings. I like the challenge of reaching more than one solution for the problem. If you go with your first idea, you'll never know what solution you might have missed by not looking for the second solution. I entertain many different ideas, knowing that one will often lead to another. Let them incubate, develop, and come to fruition. Don't be afraid to experiment. It helps to have a problem-solving approach. If the number of images in a sequence seems overwhelming, break it down. Every sequence can be broken down into smaller sequences, just as every problem can be broken down into smaller problems. To compare different sequence orders, I print a contact sheet of the images.

One great way to practice sequencing images is to take from a number of different shoots; a series of images that are seemingly random and arrange them so that they tell a story. It's a great way to kick-start your imagination and to see the relationship between images that might otherwise be overlooked. We put so much work into creating our images, we need to invest in and care for how they are presented with just as much diligence.

Creativity is just connecting things. When you ask creative people how they did something, they feel a little guilty because they didn't really do it, they just saw something. It seemed obvious to them after a while. That's because they were able to connect experiences they've had and synthesize new things.

—STEVE JOBS

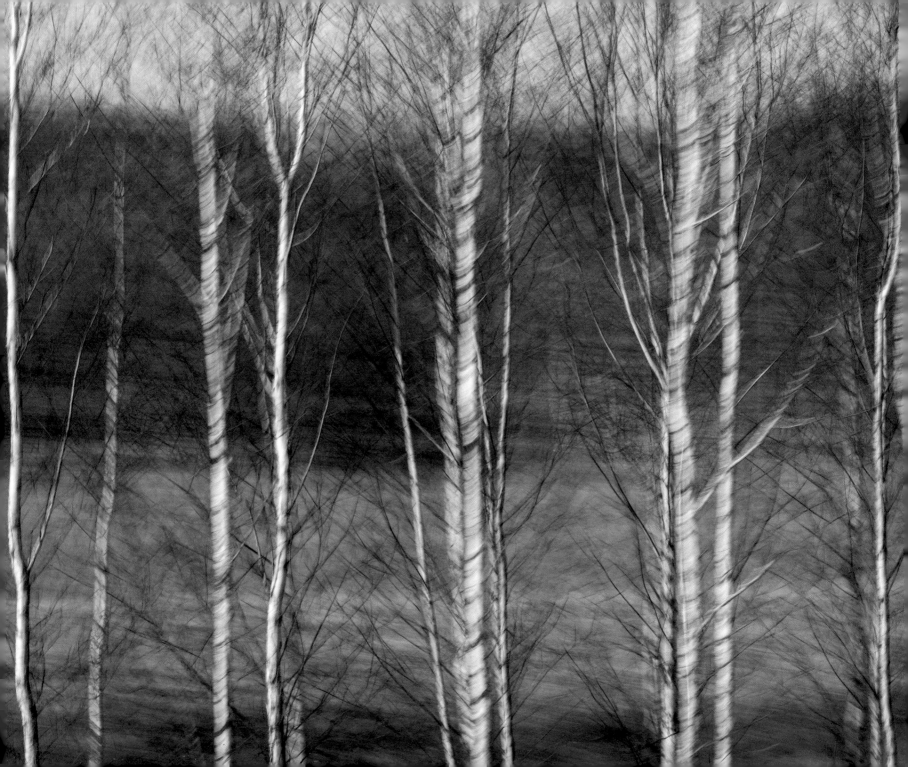

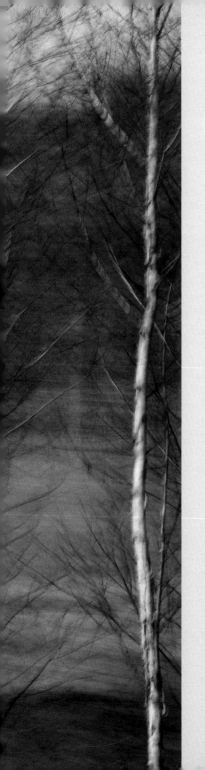

PHASE IV

Transforming Your Story in Lightroom's Develop Module

Poland, 2013

CHAPTER 16 Removing Distortions and Correcting Perspective

The fact is that relatively few photographers ever master their medium. Instead they allow the medium to master them and go on an endless squirrel cage chase from new lens to new paper to new developer to new gadget, never staying with one piece of equipment long enough to learn its full capacities, becoming lost in a maze of technical information that is of little or no use since they don't know what to do with it.

—EDWARD WESTON

Photography and post-production are two parts of the same process. Just as it's important to know your camera in order to capture the content and composition of the photograph, it's equally important to know what can be accomplished after capture using software to process the image. The more you can visualize what is possible to do in Lightroom and Photoshop, the greater the advantage you will have when capturing your images. I do not look at the adjustments that I can make on the computer as a way to correct what should have been captured in camera, but instead as a way to craft an image, refine it, and add the photographer's mark in order to tell a story. We shouldn't think of Lightroom or Photoshop simply as a way of correcting mistakes; we should be using the computer as a way to *evolve* our images into something that can't be created with any other medium.

Today, photographers are able to make adjustments to their photographs using flexible, efficient, nondestructive methods. Instead of using different exposure times, chemistry baths, paper grades, and contrast masks in the darkroom, we are able to refine our images using software with more control and precision than ever before. Instead of being limited by developing our negatives once, we can use Lightroom to process our RAW files—our "digital negatives"—any number of times, applying different settings to correct perspective, remove lens distortion, crop, tone, correct and enhance color, convert to grayscale, add special effects, and more.

Once I am confident that the images I have selected in my collection are going to become a part of my project, I move to the Develop module in Lightroom. A few of the advantages of working in Lightroom's Develop module include:

- **Nondestructive editing.** You can change the settings for processing the files without permanently changing the original images.

- **Flexibility.** You can always return to an image and reprocess it without any loss of quality if you change your mind or your vision, which gives you the freedom to explore different techniques and stylistic effects. Instead of being stuck using a

single film for a project, you can change the look and feel of an image at any time to match the visual narrative of your story.

- **Virtual copies.** You can process the same photograph multiple times with different settings to create a grayscale and color image, for example, from the same negative—all without having to duplicate the file on the hard drive.

- **Batch processing.** You can correct individual images or choose to batch process multiple files, applying the same settings without having to start over on each photograph.

Remove Distortion Automatically

The first correction that I made to my *Passenger Seat* images in the Develop module was to remove lens distortion. Most camera lenses introduce some degree of distortion to the photograph. The wider the angle of view, the greater potential for distortion (although the quality of the lens also plays a large role). Sometimes, especially with extremely wide-angle lenses, the distortion is part of the story, but for the *Passenger Seat* project, I preferred to remove it.

Instead of removing distortion on each image one at a time, I find it far more efficient to change Lightroom's default image processing settings to handle the corrections

automatically when I add images to my catalog. To customize Lightroom's default settings, load any image from the desired camera into the Develop module and click the Reset button to remove all changes made to the image. In the Lens Corrections panel, click the Basic tab and select both the Enable Profile Corrections and Remove Chromatic Aberration settings.

Tip

It is necessary to reset any changes made to the photo before customizing defaults because Lightroom records *all* changes made to the image in the Develop Module when saving new default settings. Usually, you would not want to save such adjustments as changes to exposure or white balance as part of your default processing for all future imports.

The Enable Profile Corrections setting reads the metadata in the file and applies a profile based on the camera model and lens to correct such things as barrel distortions, pincushion distortions, and optical vignetting. The Remove Chromatic Aberration setting removes color fringing in an image that occurs due to the lens's inability to focus all colors on the same plane. This distortion is typically more apparent near the edge of the frame in areas of high contrast.

With Enable Profile Corrections and Remove Chromatic Aberration applied to the

image, choose Develop > Set Default Settings and select Update to Current Settings. From that point on, any images imported into Lightroom (taken by the same camera as the example image) will have these newly defined default lens correction settings applied. Because Lightroom reads the metadata for each image, even if you switch lenses, Lightroom will apply the appropriate lens correction for that camera model and lens combination. Of course there is an exception to every rule; a few unique lenses cannot be (or have not been) profiled for Lightroom, such as tilt-shift and extreme fish-eye lenses, so the program won't correct for them.

Tip

Lightroom's default image processing settings are camera model specific. If you shoot with multiple camera models, you will need to take a file for each camera into the Develop module and set new default settings for each desired camera.

Even if you periodically use a lens to purposely create lens distortion, I prefer to make lens correction the rule and undo the correction on the few "intentionally distorted" exceptions. Depending on your system, it might take a bit longer to render the previews for the images that have lens correction applied, but I feel that's a small tradeoff for correcting the distortions.

If you prefer to leave Lightroom's default

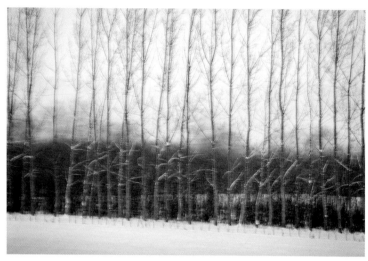

Original RAW capture

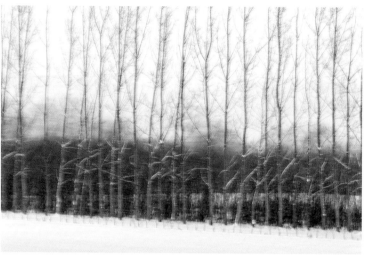

Lens corrections applied to remove distortions, vignetting, and chromatic aberration

image processing settings alone and apply lens corrections only to a subset of images, you can create a preset. Lightroom is exceptional at automating tasks, and presets are a great example of how you can become more efficient while using the program.

To make the preset, make the corrections to an image by going to the Lens Corrections panel, clicking the Basic tab, and selecting both Enable Profile Corrections and Remove Chromatic Aberration. Next, select Develop > New Preset. In the New Develop Preset dialog, select Lens Profile Corrections and Chromatic Aberration (making sure that no other settings are enabled). Then, name and

save the preset into the User Presets folder or wherever you can most easily find it. Now, when you need it, you can access the preset in the Preset panel and apply lens corrections with a single click.

Because Lightroom is a nondestructive image-editing application, these changes (as well as any changes made in this module) can be "undone" at any time by deselecting the Enable Profile Corrections and Remove Chromatic Aberration options in the Lens Corrections panel. See Chapter 26 to find out more about applying presets to multiple files using Sync and Quick Develop and when importing files.

A Matter of Perspective

The Lens Corrections panel can also help correct perspective distortion caused by the relative positioning of the camera to the subject. To level a crooked horizon, straighten trees, or remove keystoning in buildings or other converging vertical or horizontal objects in the frame, use the Upright modes in the Basic tab of the Lens Corrections panel. Turning on Enable Profile Corrections and Remove Chromatic Aberration *before* applying Upright modes can produce superior results, so be sure to do so.

Clicking Level rotates the image in an

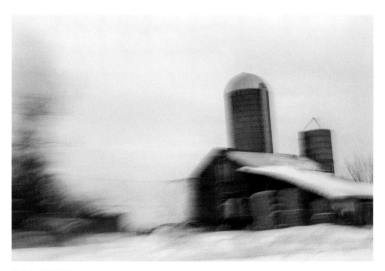

Original RAW capture

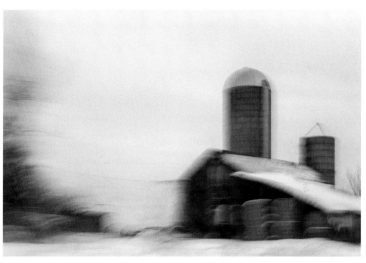

Auto Upright mode applied to correct perspective

attempt to correct a horizon. Auto performs a gentler, more natural perspective correction, which may be more pleasing to the eye. If you need the vertical lines in your image to be corrected, however, Vertical may be a better option, and Full is a good choice if you need both vertical and horizontal lines in your image to be corrected. The more pronounced the horizontal and vertical lines are in the photograph, the more likely Lightroom will be able to automatically fix the distortion. For additional control (or to add creative adjustments), use the Manual tab in the Lens Corrections panel to adjust the variety of Transform options. For example, the

> # The only man who never makes a mistake is the man who never does anything.
>
> —THEODORE ROOSEVELT

Aspect slider enables you to compensate for vertical and horizontal distortions in images.

Because applying any lens and perspective corrections causes the image to change within the frame, I crop after applying any corrections. Plus, by default, applying an Upright mode resets any cropping applied to an image.

Tip

To make scrolling through the Develop module's panels easier, I set the panels to Solo mode. In Solo mode, Lightroom displays only the currently selected panel, automatically closing (minimizing) other panels when another one is chosen. To enable Solo mode, right-click any panel header (except Navigator and Histogram) and choose Solo mode.

CHAPTER 17 # Cropping

> A great photograph is one that fully expresses what one feels, in the deepest sense, about what is being photographed.
>
> —ANSEL ADAMS

In the *Passenger Seat* project, cropping images was the exception rather than the rule. When I was capturing the photographs, my goal was to fill the frame as fully as possible to yield the greatest amount of information. I knew that I wanted to print these images as large as possible, yet images lose definition and sharpness as they are enlarged, so filling the frame was essential.

When to Crop

Sometimes, however, the entire frame isn't necessary for telling the story or creating the desired effect. Cropping can eliminate unnecessary or irrelevant information, thereby improving the final image. At other times, the aspect ratio of the capture device doesn't match the framing you have in mind for the photograph. For example, I might be limited to using a camera that records an image with a 2:3 aspect ratio, yet I capture a subject that would be better off being oriented as square or panoramic. In this case, I would capture the image and crop the "extra" information later.

For consistency, I try to limit the number of different aspect ratios (crops) that I work with in a single project, but in the end, I go with what feels right. It's more important to me to make sure that each image has the right crop for that specific photograph than to make sure that every aspect ratio is the same. I planned for the *Passenger Seat* book to be horizontal, and therefore I captured as many horizontal images as possible, flipping to vertical only as needed.

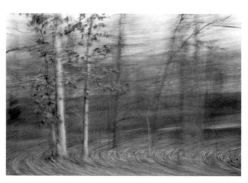

Uncropped image

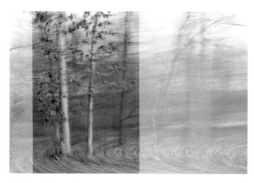

Image cropped to remove extraneous elements

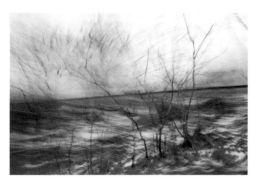

Original RAW capture

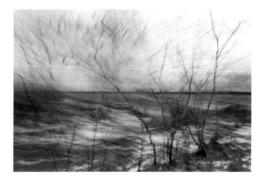

Horizon straightened using the Angle tool

How to Crop

To crop in Lightroom, select the Crop tool and choose your desired aspect ratio from the list of Crop presets. Because the original aspect ratio for this body of work was 2x3, I could choose Original or "2x3 / 4x6." I then dragged to reposition the crop handles (also known as the crop's bounding box) and applied the crop as needed. To toggle the aspect ratio, press the X key. To undo a crop

without undoing any other changes made to the photograph, click the Reset button in the Crop options. When needed, you can create a custom aspect ratio by selecting Enter Custom from the list of Crop presets.

Tip

A number of shortcuts will take you from the Library to the Develop module, including pressing the D key. If, however, you want to move to the Develop module and use a specific tool, you can press R for Crop, W for White Balance, K for the Adjustment Brush, and so on.

Many of the images in this project also needed to be straightened. I could have used the Level Upright mode, but for more control or when there wasn't an obvious horizon line, I chose the Angle tool in the Crop options and manually drew a line across a horizon. After I released the cursor, Lightroom automatically rotated and leveled the image. You can also rotate an image while using the Crop tool: Click-drag outside of the crop handles with the double-headed arrow to rotate the image.

Cropping is a personal choice—your decision—with no official right or wrong. If you're photographing your personal project in a studio and you have control over the lighting, the subject, and other necessary factors, then by all means compose the image full-frame so you have the largest amount of information to work with. On the other

Automate Cropping

Because each one of my photographs required a unique crop for the *Passenger Seat* project, I found it difficult to take advantage of Lightroom's ability to automate cropping. If however, you need to crop multiple images to exactly the same aspect ratio, straightening angle and/or x,y coordinates, you can simplify your project by automating the cropping.

To do so, crop the first image manually, then select additional images to crop using the filmstrip. Make sure that the image that you cropped manually is the one that is most selected (the one that you can see in the large preview area), and click Sync. In the resulting Synchronize Settings dialog, select Crop.

If you need to sync only the angle or aspect ratio, you can choose to enable only those options. If you do, however, remember that the image will not be cropped to the same x,y coordinates, because the Crop option is not enabled. (To find out more about automating Lightroom, see Chapter 26.)

hand, if you are on location with no control and are trying to contort yourself into position to capture a scene that is moving by at 60 miles per hour, don't miss the shot just because the telephone pole might appear at the edge of the image. You can crop it out later. And if cropping an image focuses the viewer's attention on what is important, then by all means remove that extraneous information.

CHAPTER 18 # Dynamic Range and Histograms

Just what technical discoveries can do to assist the interpretive powers of the artist is not clear.

—EDWARD HOPPER

Because of the constantly changing land-scape and lighting conditions while shooting from a car window, it was nearly impossible to establish the proper exposure using the reflective meter in the camera. Consequently, some of the photographs in the *Passenger Seat* project required a wide range of tonal and color adjustments, while others required very little adjustment. Many times all that was needed was a slight boost in contrast to extend the dynamic range to make the flat exposure pop, while others needed a lot more coaxing, such as decreasing contrast to reveal the subtle details in the shadows and highlights. Fortunately, Lightroom has the tools to help make these changes in tonality as well as monitor how the changes modify the information in the file to ensure that we don't inadvertently lose important detail in the process.

Dynamic Range

When photographing under controlled lighting conditions, we can adjust lighting and exposure to capture the full dynamic range (from black to white) while maintaining detail in both the highlights and shadow areas. During the *Passenger Seat* project, however,

photographing from a moving vehicle in the middle of the day with light striking my subject from one direction one moment and another direction the next due to constantly winding roads, I wasn't in what I would consider to be an ideal controlled lighting environment. If I were traveling in one direction on a straight road, with consistent lighting conditions for an extended period of time, I could manually set my exposure to produce consistent results regardless of the subject. As you can imagine, this just wasn't the case on the back roads of Vermont.

Without being able to control the lighting, I preferred to capture a flat image, knowing that I would be able to add contrast and extend the dynamic range in post-production. During the project, I predictably had more success capturing detail in both the highlights and shadows when the light was less contrasty, such as on overcast days or when making images in the "golden" hours of early morning or late afternoon.

Even on brighter days, when there was significant contrast in the scene (bright skies and dark shadows), I knew that I could reveal the details in the shadows and highlights in Lightroom—as long as I captured in RAW and the camera could capture the information.

Unfortunately, there were also instances when the difference in tonality between the bright sky and dark shadows made it impossible to capture the entire dynamic range of the scene with a single exposure using current digital technology (and of course to capture the motion, only one exposure of a scene was possible).

Using the camera's automatic metering system to determine the exposure of a moving scene, while using a slow shutter speed, compounded the problem because the lighting, and therefore the exposure, changed quickly.

In these situations, I knew that I was going to have to sacrifice detail in either the shadows or the highlights. Because our eyes are so sensitive to patterns, and because I knew that I was going to print these images, I had to make sure that I held detail in the highlights—even if that meant losing detail in the shadows if they were pushed to pure black. To ensure that I captured highlight detail, I used the camera's manual override to decrease the exposure by up to a stop. As a result, I prevented the highlights from being clipped to pure white, and hoped that the shadows wouldn't be pushed to pure black without detail.

The Histogram

When working with images in Lightroom's Develop module, we can use the Histogram panel to see where the tonal values in the image are and whether the shadows or

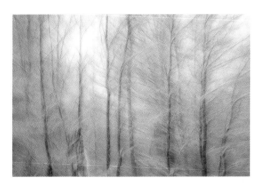

High-key image

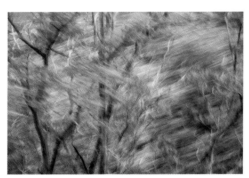

Average image

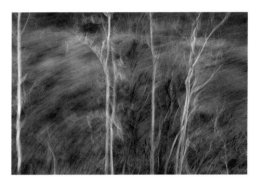

Low-key image

High-key histogram

Average histogram

Low-key histogram

highlights have been pushed to pure black or white. The histogram is a visual representation of all the pixel values in an image, plotted from 0 (black) on the left to 255 (white) on the right; the height of each column shows how many pixels in the image have that value. Lightroom divides the histogram into five areas: blacks, shadows, midtones, highlights, and whites, all of which can be easily manipulated, making areas lighter or darker based on the needs of the photograph.

It's important to know that there is no such thing as a perfectly shaped histogram; each histogram depends on the content of the image. If properly exposed for the true tonality of the scene, when you make a high-key image (white birch trees in the snow, for example), most of the columns in the histogram will fall on the right side. If you have a low-key image (such as the darkening forest at dusk), then most of the columns in the histogram will fall on the left side.

Tip

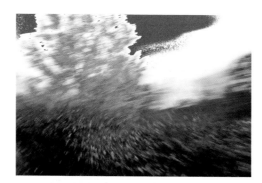

Image with clipping in highlight values (red overlay)

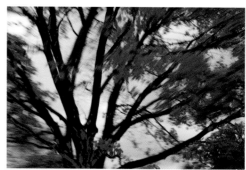

Image with clipping in shadow values (blue overlay)

A word of caution: If you see large spikes at the far left or right edge of the histogram, there are areas in the image that are pure black or pure white, respectively. This means that the highlights are blown out (clipped to pure white) or the shadows are blocked (clipped to pure black) in at least one of the channels, if not all. In either case, there are areas in the image that don't contain any detail. Unfortunately, there isn't any software that can rescue information that's not there—software can adjust, create, or invent information, but it's impossible to recover what wasn't recorded.

To display a preview of any values in the image that are clipped, hover the cursor over the clipping warning icons in the Histogram panel. Shadow areas are displayed in blue, highlights in red. Press J to toggle the clipping warning overlay without having to hover over the icons.

When making tonal changes to my images, (which the following chapters will discuss in more detail), I monitor the Histogram panel,

Exposing the Scene

It's important to remember that when you use the light meter in your camera to make an exposure, the camera is directed to take the values measured and set them in the middle of the histogram. For that reason, if you photograph last year's corn stalks in the snow, those bright, snowy values will be recorded as middle gray. To make the images look like bright clouds or snow, those values will need to be increased in post-processing. Unfortunately, doing this amplifies the noise in the originally underexposed areas of the image as their values are increased. In this case, it's better to manually override the camera during capture if possible (by overexposing the scene) to place the brighter values where they should fall on the histogram—recording the true tonality of the scene at time of capture.

> The world of reality has its limits; the world of imagination is boundless.
>
> —JEAN-JACQUES ROUSSEAU

previewing the clipping warnings as I adjust the tonality in the image. Doing so allows me to extend the image's dynamic range from black to white, while not going so far as to clip important details to black or white without detail.

Fortunately, for the *Passenger Seat* project, I found that even when I needed to underexpose the image (by manually overriding the exposure settings on my camera) in order to capture detail in the highlight areas, with motion-blurred imagery the shadow area often lightened with the blur. Because of this, I ended up capturing images that were flatter than expected—while the highlight area fell nicely within the highlight range, the darkest values were not extending into the deep shadows. To extend the dynamic range of the photograph, I set a new black point using the

Blacks slider in the Basic panel. Generally, darkening the blacks in an image is a better adjustment to have to make than lightening them, because when you lighten the shadow areas in an image you risk the introduction of distracting noise that can degrade the quality of the image.

Of course, the way that you tone your images in Lightroom will depend on the story that you are trying to tell. Setting the dynamic range of an image is an aesthetic choice. A high-key image of a tree in the snow may not contain a deep, rich black, nor is it necessary for a field in the fog to have a strong highlight. Even pushing unimportant or distracting shadow detail to pure black can enhance the composition of the photograph through positive and negative space to add drama and mystery to the image.

CHAPTER 19 **Making Basic Adjustments**

The camera sees more than the eye, so why not make use of it?

—EDWARD WESTON

How you decide to tone an image is one of the most fundamental ways to reinforce visual narrative, create impact, and craft your story. Depending on your project, you may feel that the images require subtler, conservative, traditional edits true to a documentary project, whereas other projects might benefit from more unique, evident creative expression. Regardless of the undertaking, I find that I thoroughly enjoy getting lost in the process of refining images, and the Basic panel in Lightroom is an excellent place to start. When working with my photographs, my goal is to create the highest-quality image using Lightroom's Develop module before ever opening it in Photoshop.

White Balance and Tone

To eliminate unwanted colorcasts in a photograph, the Basic panel's White Balance Selector can be invaluable. If there is an object in the image that you know should be neutral (a gray cement road, gray clouds, or a gray building) but that has an apparent colorcast, select the White Balance Selector tool and click in the area of the image that you want to neutralize. Lightroom will automatically shift the colors in the image to neutralize the color you clicked and dismiss the tool.

A word of caution: It is really rather subjective to select clouds or cement in your image as a definitive neutral tone. They may not be as neutral as you think. For example, the clouds might have been captured at sunset, so they might have a lovely pink glow to them. The cement might have turned yellow over time or have a cyan cast in the shade. In these cases, removing or correcting the color with the White Balance Selector eyedropper may give you undesirable results. In many of the images in the *Passenger Seat* project, not only were there no "neutral" areas, but I also deliberately added colorcasts to images to match the mood that I was feeling at the time the image was captured. For example, I moved the Temperature slider toward yellow to add warmth to fall foliage in some images, while adjusting it toward blue in others to cool the winter shadows.

Tip

If you prefer to retain the White Balance Selector tool in order to experiment by clicking in several areas within the image, simply deselect Auto Dismiss in the toolbar.

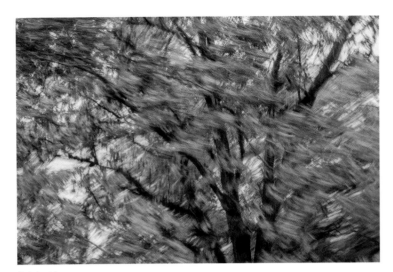

Original image

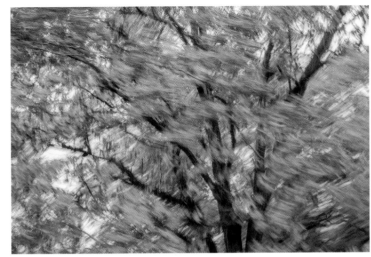

White balance correction applied

If you're not sure what adjustments you want to make to a photograph's tonality, you can use the Auto button in the Tone area of the Basic panel as a starting point. In fact, if selecting Auto gives you the results you want, by all means use it and move on.

I find, however, that I want to have a little more control over my image. I start by Shift-double-clicking the Blacks and Whites sliders to set the black and white points of my image, extending the image's dynamic range from black (0) to white (255). Then, I adjust the Exposure slider to set the midtones of the image to the appropriate range for the subject. Next, I use the Highlights and Shadows sliders to control the amount of detail exposed in the respective areas. Finally,

I increase or decrease the Contrast setting if needed.

Tip

Click-drag left or right in the histogram to increase/decrease the values in any of the five regions without having to adjust each slider (the Contrast slider is not included).

Vibrance, Saturation, and Clarity

You can use the Vibrance or Saturation sliders in the Basic panel to increase (or decrease) the intensity of color throughout the image. The Vibrance slider is a relative

slider and removes or adds saturation based on the original level of saturation in the image. Even if you drag the Vibrance slider to –100, there will still be some color visible in most images. In addition, Vibrance is biased to adjust green, aqua, blue, purple, and magenta more than red, orange, and yellow. This makes it ideal when adding saturation to an image that includes people, as it will add color to the blue sky, green trees, and so on without oversaturating skin tone.

Saturation, on the other hand, is an absolute slider and affects all colors equally. I tend to be a bit reserved with this slider because if there are areas in the image that are similar in saturation to start with, and you push them to be fully saturated, you lose color

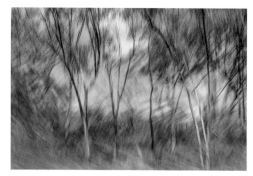

Original image

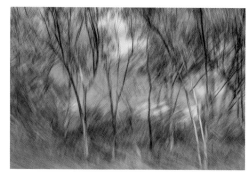

+80 Vibrance adjustment applied

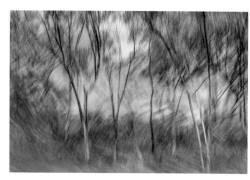

+80 Saturation adjustment applied

differentiation in that area, and the resulting image will appear less detailed. If you move the Saturation slider all the way to the left, you remove all the color from the image. However, if you want to convert an image to black and white, I recommend using the B & W panel instead of the Saturation slider, because it gives you more control over the conversion of specific color ranges to their grayscale counterparts.

Tip

At any time you can reset a slider by double-clicking its name. You can also double-click the name of a set of sliders (such as Tone or Presence) to reset all sliders within that group at once. Or, to reset all changes to the image, click the Reset button.

Adding Clarity helped strengthen images in the *Passenger Seat* project when I wanted to convey a more dramatic sense of motion and gesture by increasing edge contrast (biased toward the image's midtones), resulting in an image that appears sharper, crisper, and more striking. For the softer, more abstract images in this project, I didn't use the Clarity

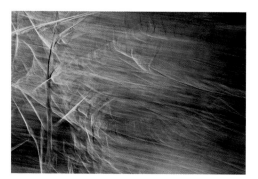

Clarity applied to add edge contrast and reinforce a sense of movement

slider at all, as it would have ruined the calm, tranquil feeling I was trying to convey.

When I'm finished making these adjustments, I double-check the Histogram panel and clipping warnings to make sure I haven't accidentally clipped the highlights or shadows to pure black or white without detail when making other refinements.

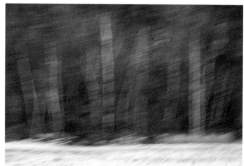

Clarity not applied, to maintain a softer, more abstract look

The Point Curve

Sometimes the sliders in the Basic panel do not provide me with enough control over specific tonal ranges in an image. When this happens, I use the point curve in the Tone Curve panel to make the necessary adjustments. To access the point curve, click the small icon in the lower-right corner of the Tone Curve panel. The curve represents the shadows in the lower left, moving up diagonally through the midtones to the highlights in the upper right. You can add and reposition up to 16 unique points on the curve to subtly increase or decrease specific tonal values (ranges) in an image. As you increase the slope of the curve, you are adding contrast to those values in the image. However, there are a finite number of values that define an image, and increasing the contrast in one area requires that another area be lowered in contrast. Although this cannot be avoided, it's important to pay attention to the entire image in order to avoid inadvertently detracting from one area while enhancing another.

Using the Targeted Adjustment tool is an another easy way to modify the curve: Click the circle icon in the upper left of the Tone Curve panel to select it (or use the shortcut Cmd+Opt+Shift+T or Ctrl+Alt+ Shift+T), and click-drag up or down on the desired tone in the preview area to lighten or darken it, respectively.

If you spend time creating custom tone curves that you will want to reuse, save them using the Point Curve pull-down menu. After you name and save your custom curve, it will appear in the Point Curve pull-down list, ready to be quickly applied to other images.

If I need to make additional tonal changes to select areas in the photograph, I switch to the local adjustment tools. (More about making selective adjustments in Chapter 23.)

Tip

If you prefer, you can use the point curve to extend the dynamic range of an image instead of the Whites and Blacks sliders in the Basic panel. To do so, drag the anchor points at either end of the curve in toward the first column of pixels, using as a guide the histogram in the Tone Curve panel, the shadow/highlight clipping warnings, or the Histogram panel.

If an image doesn't come quietly, it might not want to go where you're trying to take it.

—STU MASCHWITZ

CHAPTER 20 # Comparing Edits

Have no fear of
perfection; you'll
never reach it.

—SALVADOR DALÍ

One of the biggest advantages to using the Develop module in Lightroom is that it's nondestructive. You never actually make changes to the original image data in a RAW file. By default, you are only adding sets of instructions that change the way that Lightroom displays the images. The ability to undo changes and compare different adjustments provides us the flexibility to fearlessly experiment, taking our images in new creative directions.

Tip

Increasing the Camera Raw Cache settings in Preferences > File Handling can improve performance when moving back and forth between images in the Develop module. I have mine set to 20 GB.

Undo and the History Panel

There are a number of different ways to undo changes made to images, depending on how far back in time you want to go. To quickly toggle the effects of the most recent change, select Edit > Undo or use the shortcut Cmd/Ctrl+Z. If you need to go farther back in time, instead of trying to remember which sliders you changed or using File > Undo multiple times, you can use the History panel in the Develop module to quickly undo multiple steps.

The History panel stores every settings change that you make to a specific image, in the order that you make them (in contrast to the Undo command, which actually stores *everything* you change, like switching modules and image selections. When you position your cursor on top of a history state, it will display a preview of that state in the Navigator panel so that you can easily determine what state you want to return to without having to click through each one. The History panel is linear. To understand what this means, suppose you first crop a file, then modify its white balance, and then add contrast. If you want to undo the white balance, you need to click to the crop state in the History panel to return to it, meaning you will also undo the contrast, which was changed after the white balance. (Of course, you can always reset the sliders for a specific option if you simply want to correct that.) You don't have to worry about losing the file's history when closing Lightroom; it remains listed in the History panel until you decide to clear it.

Comparing Versions

Lightroom has two different ways to preview changes made to images in the Develop module. The first is using the Before & After view. Click the Preview icon in the toolbar to display the Before & After, side-by-side view. Click the icon again to cycle through the different side-by-side and split-screen views. Although I find the Before & After view to be very useful when comparing more drastic modifications made to my image, when I make more subtle changes I prefer a different method. I press the \ key to toggle between before and after. This method toggles between the before and after views without having to go to into a split-screen view, thereby displaying a larger preview so

you can more easily see what has changed in the image.

By default, Lightroom displays the original Import state of the image when comparing before and after. Infinitely more useful, however, is the ability to drag and drop the name of any state from the History panel on top of the image in the Before preview area to compare it with the current state.

Tip

To avoid cycling through the different screen views when clicking the Before & After icon, tap the Y key to toggle the view on and off.

There are two additional ways that Lightroom can help when you need to see more

Before & After left/right split view

Before & After left/right view

Tapping the \ key toggles between before and current views while displaying a much larger preview

Current state of image

The illusion of knowledge is more detrimental to growth than ignorance, because once you think you know something, the questioning stops.

—JERRY UELSMANN

than one version of a file: virtual copies and snapshots. When you create a virtual copy (Photo > Create Virtual Copy), Lightroom makes a second (or third or fourth or more) thumbnail of the original image and treats the virtual copy as if it were a unique file (without wasting space by duplicating the original file on the hard drive), making it easy to differentiate between them. This is an excellent method for creating one version of an image in color and another in grayscale, or when you want to experiment with taking a photograph in multiple directions after making basic adjustments to it. Virtual copies enable you to use multiple versions of an image in projects such as slideshows or books, include them in different collections as needed, or print them for side-by-side comparison.

If you decide you prefer the settings applied to a virtual copy over the master version of an image, you can quickly apply the settings from the virtual copy to the master. In the Library module, select the virtual copy and choose Photo > Set Copy as Master. You can then delete the virtual copy if it's no longer needed and you want to decrease the clutter of having more than one version of the file.

Another way that Lightroom allows us to experiment with image processing is by creating snapshots. Snapshots capture and

isolate specific states in history without having to create a virtual copy. I create snapshots when I reach a point in the image that I decide I want to try different effects yet want to be able to efficiently return to a specific point in history. After making all of the modifications that I think I want to make to the image, if I create a snapshot I can then continue freely experimenting, pushing the limits or trying different variations in toning or effects, knowing that I can easily return to that snapshot instead of having to scroll through the long list of changes in the History panel.

Snapshots also provide a considerable benefit when you want to take the image into Photoshop but aren't certain which set of processing adjustments will look better in the layout or composite you're creating. If you hand off the file with multiple snapshots to Photoshop as a Smart Object, you can access those different Snapshots by editing the contents of the Smart Object. (To learn more about working with Photoshop, see Chapter 29.)

Tip

To compare a snapshot and the current state of the photograph, tap T to enter Before & After view, then right-click a snapshot and choose Copy Snapshot Settings to Before.

CHAPTER 21 # Advanced Tonal and Color Adjustments

Clean out a corner of your mind and creativity will instantly fill it.

—DEE HOCK

Although the Vibrance and Saturation options in the Basic panel can help make broad color changes to an image, I prefer to use the HSL panel when making more subtle changes. In the panel, Lightroom provides Hue, Saturation, and Luminance sliders so that each can be manipulated individually, and the color wheel is divided into eight different color ranges with independent controls. This control enables me to, for example, decrease the saturation in only the yellows in an image or darken the reds or shift the greens toward aqua, all independently of the other color ranges in my image. Using a combination of these sliders, I can make subtle yet compelling enhancements, using color to make key elements stand out while secondary subjects recede, coax details to life, and recreate the appearance and emotion I felt when capturing the image.

Targeted Adjustments

At first, I used the color range sliders in the HSL panel to make changes. I quickly realized, however, that the Hue, Saturation, and Luminance Targeted Adjustment tools are actually a much better choice. Click-dragging with the tool in the image automatically selects it's corresponding color range and modifies the range by the direction of the drag—eliminating any guesswork from the process. Although it might seem easy to select the correct color range, when using the Targeted Adjustment tool you'll notice that, more often than not, the "color" you click is actually a combination of different colors, and the tool adjusts them based on the color makeup. The result is that you have more control to refine your image.

Use these shortcuts to move between the Targeted Adjustment tools:

- Cmd+Opt+Shift+H or Ctrl+Alt+Shift+H selects the Targeted Adjustment tool for Hue.

- Cmd+Opt+Shift+S or Control+Alt+Shift+S selects the Targeted Adjustment tool for Saturation.

- Cmd+Opt+Shift+L or Ctrl+Alt+Shift+L selects the Targeted Adjustment tool for Luminance.

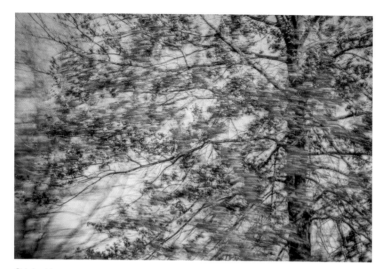

Original image

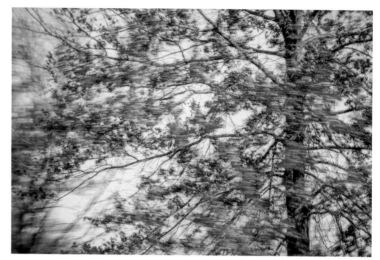

Decreasing the Green, Aqua, and Blue sliders to remove Saturation in the HSL panel.

In the *Passenger Seat* project, I didn't convert any of the images to black and white. If you need to for your project, however, I recommend using the B&W panel, because just as you can control the luminance of a color image, you can use the sliders or the Targeted Adjustment tool to control how the colors in your image are converted to grayscale.

Tip

Cmd+Opt+Shift+G or Control+Alt+Shift+G selects the Targeted Adjustment tool for the B&W panel.

Split Tone and Tone Curve

To add subtle color shifts in an image, I often use the Split Tone panel. Here, I can add color into the shadows, the highlights, or both. For example, I can add a blue color to cool the shadows, creating color contrast between the darker areas of the landscape and the bright, colorful trees. Or I can add a warm gold to my highlights to embellish a sunset.

Opt/Alt-drag the Hue slider in the Shadow or Highlight area of the Split Tone panel to temporarily view the colors at 100% saturation, which makes it easier to choose the desired color/hue. Then release the keyboard modifier and use the Saturation slider to dial in the desired amount of color. You can

choose to add color only in the shadows, only in the highlights, or to both.

If you find that too much or too little color is being added into the midtones of the images when using either the Shadows or Highlights slider, use the Balance slider to modify the tonal range that is being affected. If you're adding color to both the shadows and highlights, the Balance slider determines where the colors cross over from one to another.

For more control, you can switch to the Tone Curve panel. Here you can choose the Red, Green, or Blue channel and add up to 16 different points per curve. This gives far more control than the Split Tone panel and can be very effective when making subtle

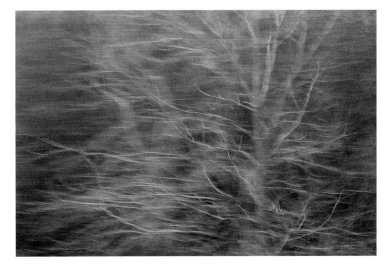

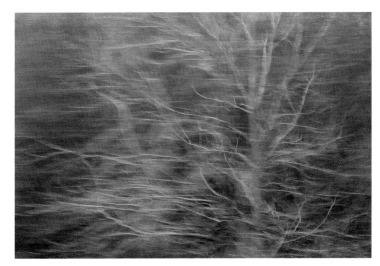

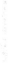

Color added to shadows

Toning constrained to darker shadows by setting the Balance slider to 80

corrections or enhancements. For example, click to add a point on the blue curve and drag up to add a cool blue cast to the midtones. Drag the point down to subtract blue, adding a warm yellow tint instead. (To delete a point, drag it outside the curve area.) To add a blue cast in the shadows, drag the anchor point in the lower left straight up. To warm the shadows, drag the corner point straight to the right. You can also use the Targeted Adjustment tool on a per-channel basis. Select it from the Tone Curve panel, click the desired value in the image, and drag up or down to modify the color.

Although both the HSL and Tone Curve panels can make adjustments to specific tonal and color ranges within an image, they affect those tones and colors throughout the entire photograph. When you need to make a change to a localized area in an image (such as a tree in the foreground, but not those in the background) instead of a certain color or tonal range, you can gain even more control using Lightroom's local adjustment tools. (To learn more about making selective adjustments, see Chapter 23.)

Tip

If you only want to preview the effects of a certain panel, click the toggle switch at the top of the panel to temporarily hide the panel's effects. (This won't work for the Basic panel, because it doesn't have the switch.)

Make visible what, without you, might perhaps never have been seen.

—VIRGINIA WOOLF

Tone Curve Modifications

This image benefited from both composite and component curves adjustments. The composite adjustment improved the overall tonal range of the image; the component adjustments—slight adjustments to the Red and Green channels and a more significant adjustment to the Blue channel— changed the color balance to warm tones in the darker shadows while simultaneously keeping a cooler tone in the highlights.

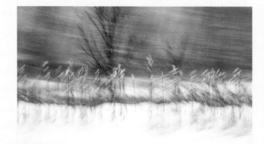

Original image

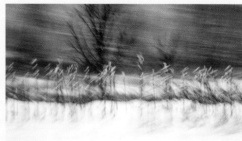

Image adjusted using Tone Curve panel

Composite channel

Red channel

Green channel

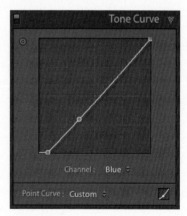

Blue channel

CHAPTER 22 # Removing Dust and Small Imperfections

> Great works are performed not by strength, but by perseverance.
>
> —SAMUEL JOHNSON

Few things are more frustrating than discovering that dust on your camera's sensor produced spots in your images or that your compelling photograph has a small imperfection that you didn't notice while making the image. Thankfully, Lightroom has the Spot Removal tool to help you clean up these modest defects and blemishes. I find this tool invaluable for removing not only dust but also any small, distracting elements in the image.

The Spot Removal Tool

To remove dust spots or other imperfections in an image, select the Spot Removal tool from the tool strip under the Histogram panel. The tool offers two modes: Clone and Heal. Clone creates an exact copy of the sampled area being used to cover the unwanted spot. Heal automatically adjusts the tonality of the sampled area used to cover the spot to help blend the retouched area. To use the tool, click the unwanted area in the image area to set down a spot. The tool automatically selects an area to sample from in order to remove the imperfection.

Tip

Press Q to access the Spot Removal tool. Shift+Q toggles between Clone and Heal modes.

I prefer to use the Heal option when removing dust spots from an image, and I find that using a small feather amount (between 10 and 25) gives me a soft enough edge to blend the sample area without producing mushy edges around the fix. Before using the Spot Removal tool, use the Size slider in the tool options panel or use Opt/Alt+[or] to quickly increase or decrease, respectively, the tool's brush size to match the size of the spot being fixed. Drag the edge of the spot to change its size (the sample spot and the source spot resize in tandem). Drag from within the center of the spot to reposition.

I also find it less distracting to press H to hide the interface when removing spots. As needed, I press the H key again to reveal the interface in order to reposition the sample area or change the size. For more control, Cmd/Ctrl-dragging creates a circle spot and allows you to drag to define the sample spot. If Lightroom wasn't able to automatically

Spotting Spots

Sometimes spots can be difficult to see onscreen, but when you print the file, they become like shining beacons in the sky. To help find these subtle spots so that I can avoid wasting time and resources printing, I enable Visualize Spots (A) in the toolbar. Lightroom displays a black-and-white version of the image, making it much easier to see any spots. Using the Tolerance slider to adjust the threshold can reveal spots that you might have otherwise missed.

Visualize Spots enabled

Removing subtle spots that might otherwise be missed

Original image

Image with dust spots removed

choose a good sample area to repair the problem, press the Forward Slash key (/) to have the Spot Removal tool automatically select a new source for the selected circle or brush spot.

When removing spots from an image, I start by zooming in to 100% and then moving to the upper left of the document, by tapping the Home key. I use the Page Up and Page Down keys to navigate through the entire image (screen by screen) to reduce the possibility of missing spots. When I get to the bottom of the frame, I press Shift+Page Down to move one column to the right. Then I press Page Up until I reach the top of the image and Shift+Page Down to move to the right again. I continue this until I reach the end of my image.

Tip

On a laptop, press the Function key (fn) plus the up/down arrows to move up or down through the image. Press the Function key (fn) plus the left or right arrow to go Home or End.

Retouching Larger Problems

For removing distracting elements and retouching larger areas, you can use the Spot Removal tool like a brush. Paint over the areas to be replaced, and the tool creates an identical shape to select as a new source. To remove an object that's straight (like a distracting snow marker alongside the road), click at one end of the marker to set a spot and then Shift-click at the other end.

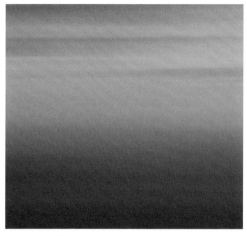

Pressing H hides the Spot Removal interface.

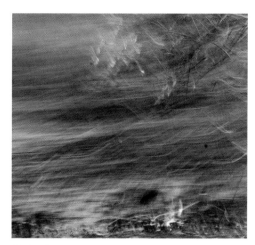

Original image

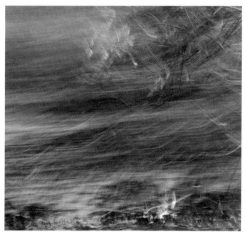

Painting with the Spot Removal tool to replace a distracting spot and area

Lightroom will connect the first spot with the second spot via a straight brush stroke. If the line isn't perfectly straight (like sagging telephone lines), removing it using short, straight sections might be easier than trying to brush freehand along the line.

If you're only trying to suppress an area, such as toning down a specular highlight, try decreasing the opacity of the retouched spot using the Opacity slider in the Spot Removal tool's options to *reduce* a distracting element, not remove it. When the imperfections are too complex to easily remove or if the area that needs adjusting is easier to select in Photoshop, I continue my editing there. To

find out more about removing distracting elements in Photoshop, see Chapter 30.

If dust on your camera sensor leaves spots on a series of images, Lightroom offers an easy solution. Once you remove the dust spots from one image, you can select similar images (similar because they all have the same dust) and use the Sync button to apply the same Spot Removal settings to others. After syncing, you should still check each image to make sure that the clone or heal is seamless, as the photographic content will (most likely) vary from one image to another. (To find out more about automating Lightroom, see Chapter 26.)

Anything worth doing is worth doing to excess.

—EDWIN H. LAND

CHAPTER 23 Making Selective Adjustments

If your project doesn't work, look for the part that you didn't think was important.

—ARTHUR BLOCH

Although it can be very tempting to quickly start making corrections and enhancements to isolated areas of your photograph, it's to your advantage to make global adjustments using the Basic, Tone Curve, and HSL panels before moving to the local adjustment tools. Otherwise, you might waste time adjusting the sky using the Radial Filter and making selective shadow areas lighter using the Adjustment Brush, only to find that you need to go back and refine all of the adjustments after making a global change to the exposure or contrast in your image.

So, assuming that you have already followed the previous chapter's suggestions for making basic, global adjustments, take a look at some of the ways that you can use the local adjustment tools. Using the Graduated Filter, Radial Filter, and Adjustment Brush, among other tools, you can make such corrections as selective lightening and darkening (dodging and burning), color correction, noise removing, sharpening, clarity, and more.

When using the local adjustment tools, pre-load them with the settings that you think they will need. Select the tool, but before applying it to the image, use the sliders to estimate the changes that you want to make. I find that exaggerating the setting can

be helpful. I prefer pushing an edit too far rather than trying to guess whether a small change is enough, and we can always reduce the effect and make other modifications to any of the local adjustment tool's attributes after the fact.

The Graduated Filter

The Graduated Filter tool helps correct imperfections such as uneven lighting and colorcasts, or you can use it for more creative modifications. In the *Passenger Seat* project, I often had to add one graduated filter to the top of an image to darken the sky, while adding another one to the foreground to lighten the shadows. Other images needed color modifications to emphasize one area over another. To set the length of the Graduated Filter, simply click-drag in the image area. Holding down the Shift key constrains the drag to horizontal or vertical. At the start of the gradient, any modifications are 100 percent visible. Over the length of the gradient, the adjustment slowly decreases until at the end of the gradient the modifications are hidden.

You can add as many graduated filters to

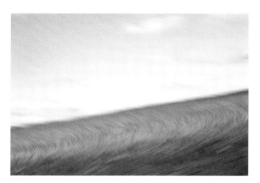

Original image

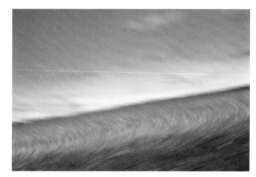

Graduated Filter applied to darken, desaturate, and dehaze around area of primary interest

an image as needed (the same goes for any of the localized adjustments), each with different settings. To modify the Graduated Filter:

- Drag the adjustment's pin to reposition it.
- Drag the end lines to change the length of the gradient.
- Click-drag the center line to rotate the angle of the gradient.
- Press Opt/Alt+' (apostrophe) to reverse the direction of the gradient.

If there is an object in the photograph that the Graduated Filter overlaps but that you don't want to be affected, select the Brush option (in the Gradient Filter options) and paint in the image preview to erase the gradient from the area. To toggle the visibility of the Graduated Filter's mask (and see where you're painting), press O (this shortcut works for all of the local adjustment tools).

The Radial Filter

Many of the images I was working with benefited from darkening the edges to keep the viewer's eye from drifting off the page. I could have added a Post-Crop Vignette, but if the subject was off center or if I wanted to do more than simply darken or lighten the edges (decrease saturation or clarity for example), I used the Radial Filter. By default, the Radial Filter is scaled from the center, so click-drag where you want the middle of the radial to appear. Because you can position the Radial Filter anywhere in the image, it's perfect for an off-center subject. By default, everything that's outside the filter is affected, but clicking the Invert Mask option (or pressing the apostrophe key), flips the adjustments to the inside.

To modify the Radial Filter, you can:

- Shift-drag to constrain the Radial Filter to a circle.
- Drag the adjustment's pin to reposition it.

- Drag the anchor points to change the shape of the Radial Filter. Add the Shift key to constrain the aspect ratio of the already drawn filter.
- Click-drag on the line to rotate the angle of the Radial Filter.
- Cmd/Ctrl-double-click the image to set the bounding box to the image bounds (the Radial Filter will be centered within the image).

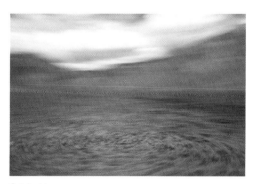

Original image

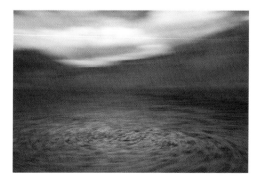

Radial Filter applied to darken, desaturate, and dehaze around area of primary interest

The Adjustment Brush

I often used the Adjustment Brush to enhance local areas of images. With the Adjustment Brush, you can lighten an area to draw the viewer's eye to it, darken an area to make it less noticeable to the viewer, add clarity to make a subject "pop," increase or decrease saturation to help guide the viewer's eye through the image, and much more.

When using the brush, press the left or right bracket keys to decrease or increase the brush size, respectively. Adding Shift to either key press changes the brush Feather setting, which is also referred to as edge hardness. If you paint over an area by

mistake, you can undo the paint stroke or use the Erase option to remove the adjustment. You can add as many different adjustment brushes as needed; each one creates a new adjustment that you can modify independently. Hold the Shift key if you are trying to constrain the brush to a straight line.

When lightening local areas to reveal shadow detail, I increase both the Shadow and Noise sliders (increasing the Noise slider value actually increases *noise reduction*) so that I can suppress the noise in the areas I am lightening. When making adjustments, enable Auto Mask to have Lightroom look for edges. When it finds one, it will not jump over the edge to affect areas that you don't

want affected.

There are a variety of different sliders that control color, including Temperature and Tint, as well as the Color overlay swatch. In addition, the Saturation slider can be used to increase or decrease saturation—even adding saturation that was removed using a global adjustment such as Vibrance, Saturation, or the HSL panel. This is an excellent way to leave some areas of color vivid while muting others. You can adjust a single slider or use a combination of multiple sliders to change color.

If you find yourself making the same types of changes (the Graduated Filter set to –1 stop or the Adjustment Brush with

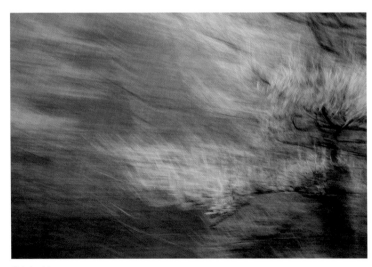

Original image

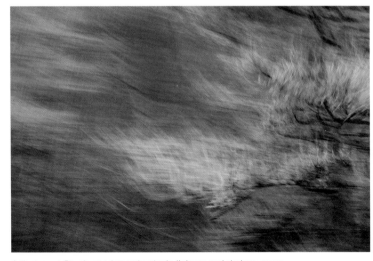

Adjustment Brush used to selectively lighten and darken areas

Shadows set to +35 and Noise Reduction set to +20, for example), save the settings as a tool preset by choosing "Save Current Setting as a New Preset" from the Custom drop-down menu to the right of the word *Effect*. Name and save the preset. The next time you want to use any of the local adjustment tools with those settings, select it from the list of presets.

When the changes that I want to make are too complex, or if the area that needs adjusting is easier to select in Photoshop, I will continue my editing there. To find out more about making selective changes in Photoshop, see Chapter 31.

You will never make a photograph that everyone likes, so make sure that you like every one of your photographs.

—OLIVER GAGLIANI

CHAPTER 24 # Sharpening and Noise Reduction

Art is the most intense mode of individualism that the world has known.

—OSCAR WILDE

The bad news is that regardless of the camera and lens that you are using, some degree of sharpening will be needed to make your images look their best. In addition, if you make photographs in low light (using a high ISO), the camera sensor is susceptible to producing distracting noise in the image. The good news is that Lightroom has simplified these processes for us, providing solutions for sharpening as well as noise reduction in the Details panel.

Sharpening Basics

The Details panel controls the amount of capture sharpening added to a photograph. Capture sharpening should not be confused with *output sharpening*, which is the amount of sharpening added at the end of the work-flow for the specific device that the image will be displayed on. The intent of capture sharpening is to make up for any loss of sharpening that happens as a result of the capture process (this can be due to a variety of reasons, including interpolation of infor-mation by the sensor, anti-aliasing filters on the camera, and lens quality).

Under the hood, Lightroom applies differ-ent amounts of capture sharpening to images made with different cameras. Even though the Sharpening numeric values are set to 25, 1.0, 25, and 0 in the panel for RAW file formats, they are customized for the cam-era that made the image. Sharpening is not applied by default to images captured in the JPEG format because most cameras add cap-ture sharpening when creating the file.

The way that capture sharpening works (and the way that sharpening works in general) is that the software finds and adds contrast to edges in an image in order to trick our eyes into thinking that the image is sharper. In the Details panel, the Amount parameter controls the amount of contrast that is added to the edges, the Radius setting determines how many pixels on either side of the edge are affected, and the Detail and Masking sliders are two different controls for suppressing the addition of any sharpening in areas that have less contrast.

When refining sharpening, view your image at 100% to accurately see the effects. For the images in the *Passenger Seat* project, I rarely had to change the capture sharpen-ing settings, as they worked very well at the defaults. If you increase the Amount and the Radius, be sure to look for halos around edges; they're a dead giveaway that the

image has been oversharpened.

Opt/Alt-dragging any of the sharpening sliders in the Details panel will display a grayscale preview of the slider's effect. Previewing the edges of the masks created with the Detail and Masking sliders can be helpful in determining which of the two options is best for the image that you're working on. As a guideline, the Detail slider works better when suppressing sharpening in landscape images, and the Masking slider works better with portraits.

If you want to selectively apply sharpening (to make one area appear sharper than another or to add a creative effect), use one of the local adjustment tools, such as the Adjustment Brush, to paint sharpening in the areas that need it. The local sharpening slider has limited control and should be considered creative of process sharpening (not capture sharpening).

Tip

To preview two different areas of an image (not visible at the same time when zoomed in to 100%), click the disclosure triangle at the top of the Details panel. Next, click the square icon to pick it up, then click in the image preview area over the area that you would like displayed at 100% in the Details panel. The preview in the Details panel will remain set to that position even if you pan the preview area to a different part of the image.

Noise Reduction Strategies

Camera sensors are not as accurate when capturing information in low light (at high ISO settings), and as a result, these images tend to have increased levels of noise, especially in the shadow areas. The Noise Reduction sliders can help improve the quality of an image by removing this distracting noise. As with sharpening, it's best if you view the image at 100% to accurately see the effects of noise reduction.

Lightroom separates the Luminance and Color values in an image, enabling you to fine-tune each separately. Although I find that I can significantly increase the Color sliders to remove color artifacting in an image, I am more reserved when using the

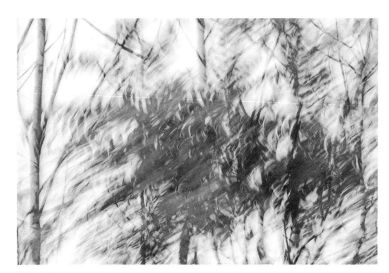

Original image

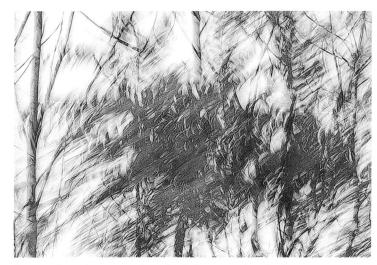

Extreme sharpening creates distracting halos, contrast, and noise.

Inspiration does
exist, but it has to
find you working.

—PABLO PICASSO

Luminance sliders, because they tend to make the image softer and obscure details.

In the *Passenger Seat* project, I seldom captured images with high ISO values (above 600), so I rarely had to increase the Color slider farther than its defaults when working with properly exposed images. However, when images were not properly exposed, and I had to use the Shadows slider in the Basic panel to reveal shadow detail, I found that I did need to increase the Color amount and, if there were still larger areas of color mottling (or splotchiness), I could fix it by increasing the Smoothness slider.

While the RAW files for *Passenger Seat* seldom needed more than +20 Luminance

noise reduction, the JPEG images captured early on with the point-and-shoot camera that was converted to infrared needed a very high value. In fact, I increased the Luminance slider to 100, increased the amount of Detail, and added the maximum amount of Contrast to help keep the details in the image. I am sure that this high a setting would probably lower the quality of most other images, but in this case, it was perfect.

Noise reduction is also available as an option for the local adjustment tools. It can be very powerful when used in combination with the Shadows slider (to simultaneously lighten shadows) without adding an overabundance of additional noise.

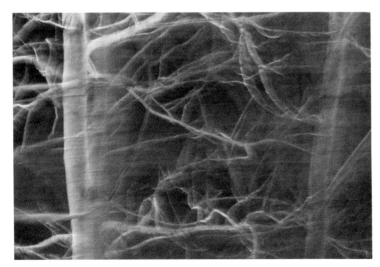

Original image

JPEG artifacting and noise removed

CHAPTER 25 # Special Effects

> Technique is different than style. Techniques are like gloves; anyone can buy and use them. Style is like a fingerprint—unique to the individual.
>
> —GREGORY HEISLER

Vignetting, Grain, and Dehaze are all found under the Effects panel and can all be used to add a range of subtle (or obvious) looks to an image to help reinforce the story that you're telling. For example, vignettes can range from adding a slightly darker or lighter edge effect to solid black or white edges around the frame. Grain can help soften noisy images or create a bolder, more traditional film look. Dehaze can either cut through such atmospheric effects as smog, making an image appear clearer, or help create a soft, ethereal stylistic effect.

Vignette Options

To keep the viewer's eye from drifting off the edge of an image, it can be helpful to add a Post-Crop Vignette using the Effects panel. The benefit is that if you change your crop at any time, the Post-Crop Vignette will automatically update.

When applying a Post-Crop Vignette, I typically set its Style to either Highlight Priority or Color Priority, because these styles work more like a shift in exposure than the Paint Overlay style (which is similar to an overlay of black or white paint). Color Priority is subtler than Highlight Priority but does not recover highlights in an image as well as Highlight Priority. Highlight Priority is more blatant and may have color shifts in the darker values, but has the advantage of recovering highlights more gracefully. You can adjust both styles with the Highlights slider to help reintroduce contrast in the highlights. The effects of the Highlights slider will be most noticeable if the vignetting is applied over bright areas, such as highlights in a sky, and it prevents large areas with little highlight from looking dull and muddy.

After darkening the edges, you can select how far into the frame the vignette affects by using the Midpoint slider. You can change the shape of the vignette by using Roundness and change the softness of its edge by using Feather.

If you find that you're using similar Post-Crop Vignette settings over and over again in a project, I recommend creating a preset (more about automating Lightroom in the next chapter) to quickly apply the basic settings and then refine if necessary. Because I typically darken down the edges, almost all of my presets have a negative Amount; however, you can always set the Amount slider to a positive value to lighten the edge. If I

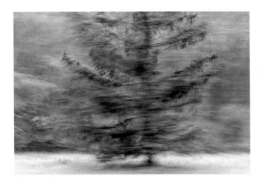

Original image

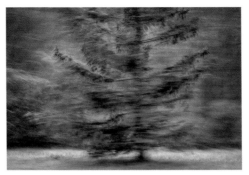

Vignette applied to darken edges

makes the grain more uniform; a positive value makes the noise more uneven.

It is important to note that you will need to do some testing in order to see how the grain that you add will look on your final output. As you can imagine, the amount, size, and roughness of the grain will appear different depending on the size of the original file and how you choose to export it (as it will most likely need to be sampled up or down in the process). When publishing small images (especially for onscreen viewing), it might be helpful to use the zoom values in the Navigator panel to zoom out of the image (1:16, 1:8, and so on).

need the vignette off center, or want to add additional options such as changing clarity or sharpness, then I would use the Radial Filter.

Grain for Effect

Adding grain can help create a more traditional film look, or it can simply help cover noise or other imperfections in the image. Because I needed to use noise reduction

aggressively on a few of the images that were captured in JPEG format, I then introduced some grain in order to make them look at bit more natural as well as to make the grain match what I felt was appropriate for the image and for the series of photographs in the project. Using the Amount slider, I determined how much grain to add, the particle size, and the roughness. Roughness controls the regularity of the grain: A negative value

Removing Haze

The Dehaze slider in the Effects panel can dramatically improve an image by removing haze. The Dehaze technology is based on a physical model of how light is transmitted,

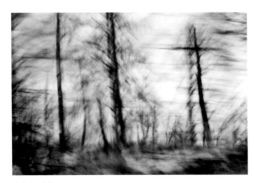

Original image

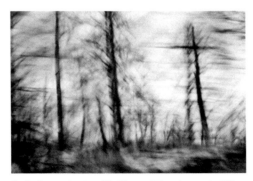

Grain Amount set to 30, Size and Roughness to 100

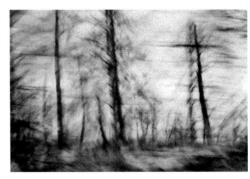

Grain Amount set to 100, Size and Roughness to 20

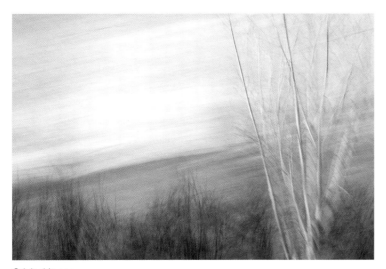

Original image

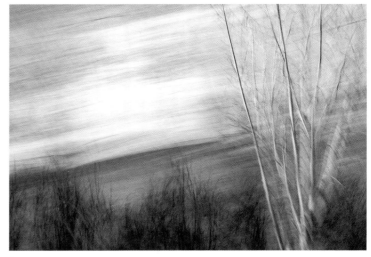

Dehaze applied

and it tries to estimate light that is lost due to absorption and scattering through the atmosphere. Move the slider to the right to easily remove the haze from the original scene. Move the slider to the left to add a creative haze effect. You can choose to make very subtle to very significant adjustments.

When moving the slider to the right, you'll see very little change in the highlight area, which is on the right side of the histogram, while the shadows and lower portion of the histogram are clearly being changed. If you are concerned that the darker values in the image are being clipped to pure black, Opt/Alt-drag the slider to see the black point clipping visualization. When you see black areas appear in the image, you know that

you're starting to clip to pure black and you can back off.

If you're pushing the slider to the extreme, you might want to return to the Basic panel to refine the image (increasing the shadow detail or refining the Vibrance slider) in order to achieve the exact look that you're after. Dehaze is also available when using any of the local adjustment tools if you need to apply it selectively to an image.

Tip

For the best results, set the white balance for the image before using Dehaze.

It goes without saying that creativity and rule breaking go hand in hand. To invent the new, you have to challenge the old. If you just follow conventional thinking, all you'll ever be is conventional.

—CHRIS ARNOLD

CHAPTER 26 # Automating Changes

Everything you've ever wanted is on the other side of fear.

—GEORGE ADDAIR

You can automate Lightroom in a variety of ways to make image editing more efficient and productive. Even when images aren't very similar to begin with, I'm amazed at how applying a basic set of corrections and enhancements can streamline the refinement process. Methods to do so include applying the previous image's settings, copying and pasting settings, syncing multiple files, creating and applying presets, and Quick Develop.

Previous, Paste, and Sync

If after making changes to one image, you select the next image and find that you want to apply the same setting as the previous image, use the Previous button. Clicking Previous applies the changes from the previous image to the currently selected one. The previous file doesn't literally have to be before the image in the order of the filmstrip, just the image that you had previously selected. The Previous feature is a quick way to apply the same changes to another image, but is limited in that you can't choose a subset of the changes that you made. Everything that was changed in the previous image will be changed in the currently selected one.

If you want to apply subset of the same changes (for example, changes made to the Basic panel but not the changes made with the Crop tool), the Copy and Paste commands are a good solution. With the corrected image selected, choose Copy and select the desired attributes in the Copy Settings dialog. Then, select the next image and choose Paste. This method takes longer because there are more steps, but it also gives you added control over exactly what settings you want to apply.

If you constantly add a certain adjustment (like a vignette, for example), you might find it helpful to copy those changes using the Copy Settings option. Press the Mac shortcut Cmd+C or the Windows shortcut Ctrl+Shift+C to open the Copy Settings dialog and choose the desired settings. Now, as you move through your images, you can quickly paste the settings that you copied to Lightroom's clipboard using Cmd+V or Ctrl+Shift+V, pasting the vignette to images when you feel it's appropriate.

The Sync feature also provides the option of applying all changes or a subset of the changes that you've made. Start by making the desired changes to one image, then select

the other images using the filmstrip and choose Sync. You can choose exactly what to sync and then apply those changes to all of the selected files. If you prefer to select multiple images using the filmstrip and want the changes that you make to apply to all of the selected images, flip on the Auto Sync switch on the Sync button. As long as Auto Sync is enabled, all selected images will have the changes applied as you make them. Just don't forget to turn off Auto Sync when you no longer want to affect all of the images you have selected.

Presets

In the *Passenger Seat* project, creating and applying presets was a valuable automation tool. As I moved through the images in the Develop module, I found that I was consistently decreasing the Highlights slider, increasing the Shadows slider, and adding contrast, clarity, and vibrance. Instead of having to change these five sliders on each image, I made the changes to one image and then clicked the plus icon on the Preset panel to create a preset that captured these settings. It's not that all of my images needed the exact same adjustment, but I did find this to be a better starting point for this body of work.

Usually, I create two types of presets: single-item and all-in-one. Although the example above changes more than one slider,

Making Relative Versus Absolute Adjustments to Images

If you have already refined your images only to discover the next day that you made them all too dark or too light, too saturated or too muted, too warm or too cool, instead of refining each image individually, it can be to your advantage to use the Quick Develop panel in the Library module to make the change to all of them at once.

When you automate changes to multiple images in the Develop module, the changes are *absolute*, meaning all of the sliders are set to a specific value regardless of what the current setting was. For example, you might have three images all with different slider values set for Vibrance. Syncing or copying and pasting settings using the Develop module would set them all to the same absolute numeric value.

On the other hand, Quick Develop adds (or subtracts) any adjustment to the image's previous settings. For example, if you have three images all with different slider values set for Vibrance and click the double arrow icon in Quick Develop, each file would have +20 Vibrance *added* to its slider value regardless of its starting value.

Therefore, if I have multiple images that I previously made adjustments to and want to add (or subtract) vibrance, exposure, or other adjustments, I will do it using Quick Develop, instead of having to adjust each one separately in the Develop module.

I would still consider it a single-item preset, because it does one thing: sets a better starting place for the Basic panel. Similarly, if I create a preset for a Post-Crop Vignette, that would be a single-item preset (even though it actually records multiple sliders). Other times, when I know that I'm going to want to use the same combination of changes together on multiple images, I'll create a preset that makes all of the changes in an "all-in-one" click. For example, for another project, I created a preset that converts a photo to

grayscale, adds a sepia tone using the Split Tone panel, and applies a Post-Crop Vignette. This ensured that the sepia tone and vignettes were identical across the body of work, and I only had to refine the grayscale conversion based on my preferences for the content of each individual photograph.

As you create and save your own presets you'll find the way that works for you. I imagine that it will be by using a combination of the two types of presets, discussed above. Even though you can preview any

The quality of a person's life is in direct proportion to their commitment to excellence, regardless of their chosen field of endeavor.

—VINCE LOMBARDI

preset in the Navigator panel, I suggest that you organize them using folders and name them descriptively to make them easy to find.

Depending on your workflow, you may apply presets on an as-needed basis; when you find an image that would benefit from the preset, you simply click to apply it. However, if you know that you want to apply the preset to 100 images, you might want to select the images in the filmstrip, click the switch icon on the Sync button to invoke AutoSync, and apply the preset. When finished, click the switch on the AutoSync button to toggle it off. Any Develop preset

can also be applied in the Library module (to a single image or to all selected images) using the Saved Preset drop-down list in Quick Develop. Presets are also available on import under Apply During Import > Develop Settings.

Tip

To rename or change the settings saved in a preset, right-click the name of the preset and choose Rename or Update with Current Settings.

CHAPTER 27 # Converting to DNG and Saving Changes

> When you are a
> photographer, you
> work all the time,
> because your eye is
> the first camera.

—PATRICK DEMARCHELIER

The term *RAW file* is loosely used in the photo industry today to refer to the file format that a digital camera captures. However, not all RAW files are the same, so even though a Nikon shooter captures in "RAW" and a Canon shooter captures in "RAW," those file formats are different.

Why DNG?

Because almost all camera manufacturer's RAW formats are proprietary, I prefer to convert my images into the Digital Negative (DNG) format because it is openly documented and openly licensed and I believe it will have a better chance of longevity in the industry. In addition, DNG files are typically smaller then RAW files yet still retain all of the original, proprietary file format's information; nothing is deleted in the conversion.

When working with RAW, DNG, JPEG, TIFF, and PSD files, the changes that you make in Lightroom are stored in the catalog by default, but can also be saved to the image(s) by choosing Metadata > Save Metadata to file (in the Library module). If you're working with proprietary RAW files,

then Lightroom saves the information in an XMP sidecar file. Because RAW files are written differently by each manufacturer, writing information into these RAW files carries with it the risk of "breaking" the file. As a result, many manufacturers choose not to do so.

Even though the DNG file format is a RAW format, because it specifies how a file should be written, it has no need for a sidecar file. Even better, Lightroom can validate a DNG file created in Lightroom to confirm that the "source image data" has not changed (which is helpful when you want to check to make sure that files haven't been corrupted after copying them from one drive to another), independently of the other information in the file (which may have changed in order to add metadata and enhance the image).

The reason that I choose to convert my RAW files to DNG *after* I finish editing my images is because I often throw away a large number of photographs from a shoot. Especially for the *Passenger Seat* project, it didn't make sense to waste time converting files that I was going to turn around and delete. In the Library module, with the images

The best time to plant a tree was 20 years ago. The second best time is now.

—CHINESE PROVERB

selected, I choose Library > Convert Photos to DNG. I enable "Only convert the RAW files" and "Delete originals after successful conversion" and leave the other settings at their defaults. By making the conversion to DNG the last step, I know that I have finished editing the shoot if the files are in the DNG format. Of course, I can continue to make changes to the files even after they have been converted to DNG but converting the files lets me know that I've completed all of the essential steps in my work flow.

Note

One disclaimer: If you do convert your images to DNG, you might not be able to open the files in the camera manufacturer's software.

Saving Changes

One of the welcome features of Lightroom is its ability to automatically save changes as you make them. By default, these changes are stored in the catalog, but I also choose to save them in the individual files whenever possible. To do this, I enable the option "Automatically write changes into XMP" in Catalog Settings > Metadata. This tells Lightroom to save the changes to the catalog and also push the metadata changes made to images (such as star ratings, keywords, copyright information, and image enhancements) from the catalog into individual files. This has helped me in the past when I accidentally deleted my catalog. Fortunately, when I imported all my images into a new catalog, they still had the metadata and image enhancements. I did lose my collections and virtual copies when I deleted the catalog; sometimes it takes the loss of significant data to make you get serious about backing up your information!

Converting my images to DNG and saving the metadata within the file is a personal choice—one that I make in hopes that I will be able to continue working with my photographs far into the future.

CHAPTER 28 Exporting Images from Lightroom

You are not here merely to make a living. You are here in order to enable the world to live more amply, with greater vision, with a finer spirit of hope and achievement. You are here to enrich the world, and you impoverish yourself if you forget the errand.

—WOODROW WILSON

One of the benefits of capturing RAW files and processing them in Lightroom is that you can easily create derivatives of those files as needed. For example, if I need to send files to a publication as PSD files or post images to my blog as JPEG files, I can quickly batch export the images from Lightroom. As soon as those files have been received (or posted or whatever), I can then throw away the exported derivatives because I have the original RAW files to return to and can therefore quickly export any additional images as necessary. Of course, this workflow might not work for everyone, but I find it convenient that I no longer need to keep track of as many secondary files. One word of caution, however: If you export a file and then do additional work (retouch the files in Photoshop, for example), I *would* keep the retouched files as well as the original RAW files.

Lightroom makes it easy, whether you're trying to export a single image or a thousand images: Select the images and choose Export. The Export dialog has all the options to customize the images for your needs. For example, you can choose an appropriate folder location, as well as decide whether you want the exported files added to the catalog. If I were exporting files to work on further in Photoshop, then I might want to automatically import them into the catalog so that I can keep track of them. On the other hand, if I'm exporting JPEG files to post online, then I'm not going to clutter my catalog with them.

Export Settings

Depending on your workflow, you might want to rename the files. I would suggest that you simply append the files with pertinent information—such as "_lr" for low res or "4x6in" for sending to the lab—rather than changing their names entirely. If you change the name completely and then someone has a question about a file seen online, for example, it might take extra effort to figure out which file the person is referring to. To create your custom file renaming template, enable Rename To and choose Edit from the pulldown menu to access the Filename template Editor. Insert Filename, type in whatever you want to append the file with, and save a new preset.

The file type that you choose depends on how you're going to use the photos. If you're trying to reduce the file size because you

want to post the images online or send them via email, I would save as a JPEG. However, the JPEG file format automatically discards thousands of colors and uses lossy compression in order to reduce the file size. When saving as a JPEG, it's always a balance between image quality and file size. Often, lowering the quality from 100 to 90 will decrease the file size significantly without a visible loss of quality. Lowering the quality to 80 takes the file size down even farther, but you need to be the judge of the quality. Some images will hold up better than others; at lower quality settings, beautiful, subtle color gradations in skies, for example, might not hold up as well as a high-frequency motion-blurred image. Although you can save a JPEG file in a color space other than sRGB, if you're going to be displaying your image onscreen (in a blog post on a portfolio site, for example), then I would stick with sRGB because even though sRGB is a smaller color space, it's the color space that browsers use. Of course, we don't live in a world of perfectly calibrated screen devices, but at least staying in the sRGB color space lessens the chance of huge discrepancies in color between you and your viewer.

If you are going to take the images into Photoshop for additional editing and refining, then I would save them as PSD or TIFF files. These file formats do not use lossy compression. If you have large edits to make, then I would export in 16 bit because you will have more information per pixel to adjust in

Photoshop. If you only have slight changes, you might consider 8 bit, but I prefer to have as much information as possible and work with the highest-quality image (even though the 16-bit image will be larger than the 8-bit). I also choose to work in Adobe RGB because it is a larger color space.

If I need to resize the images, I like to use the Long Edge option in the "Resize to Fit" pull-down menu. Designating the size of the longest side allows me to export images with different aspect ratios and orientations (horizontal and vertical) at one time. For images that will be displayed onscreen, I find it easier to export a specific number of pixels; whereas for print, it is necessary to enter the long dimension in the correct unit of measurement as well as the resolution.

If you're going to continue to work in Photoshop, then don't add output device–specific sharpening at this point. Wait until the final image is saved from Photoshop. If the exported image is the final version, then choose the appropriate output device and dial in the desired amount. Lightroom automatically adjusts the amount of sharpening when exporting based on the size of the original and the size of the exported image. Select the Amount setting (Low, Standard, or High) based on the content of the image as well as personal preference. I would suggest that you print a small number of "typical" images on the paper stocks that you use most frequently to see what amount you prefer.

Of course, if you want more control, you can always open your image into Photoshop to apply sharpening using any of the many different sharpening filters.

To embed copyright and contact information, be sure to choose to include it in the Metadata options.

Reusing Settings

Once you've completed setting up the output options, if you think you might want to use them again, click the Add button in the Export dialog and save the preset. The next time you need it, it will be available under the Preset list on the left of the Export dialog.

If you ever need to export additional files with the same settings that you just used, select the file(s) and choose File > Export with Previous. This exports the files with the previous settings while bypassing the Export dialog.

Finally, if you need to export files in multiple formats, you can also start one set of images exporting (Lightroom will start processing the files as a background task) and then start another one to process simultaneously using different settings.

You can't use up creativity. The more you use, the more you have.

—MAYA ANGELOU

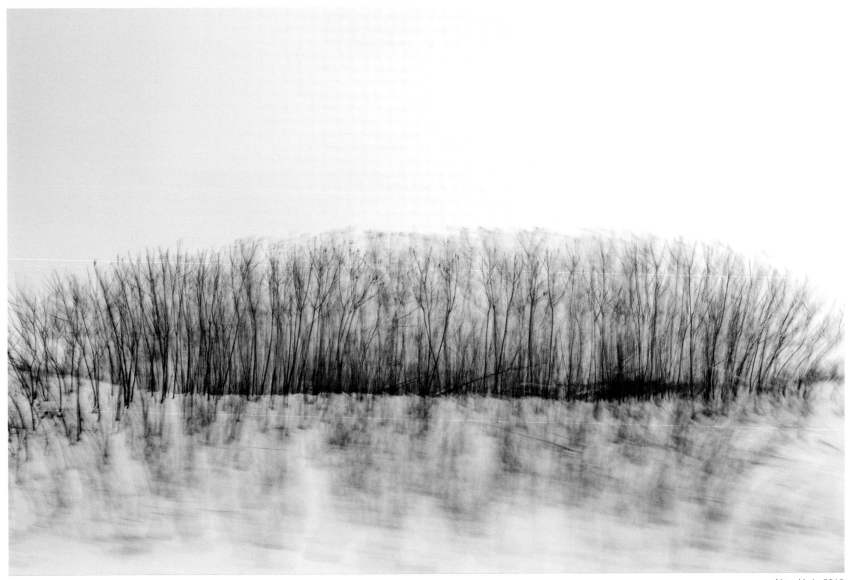

New York, 2012

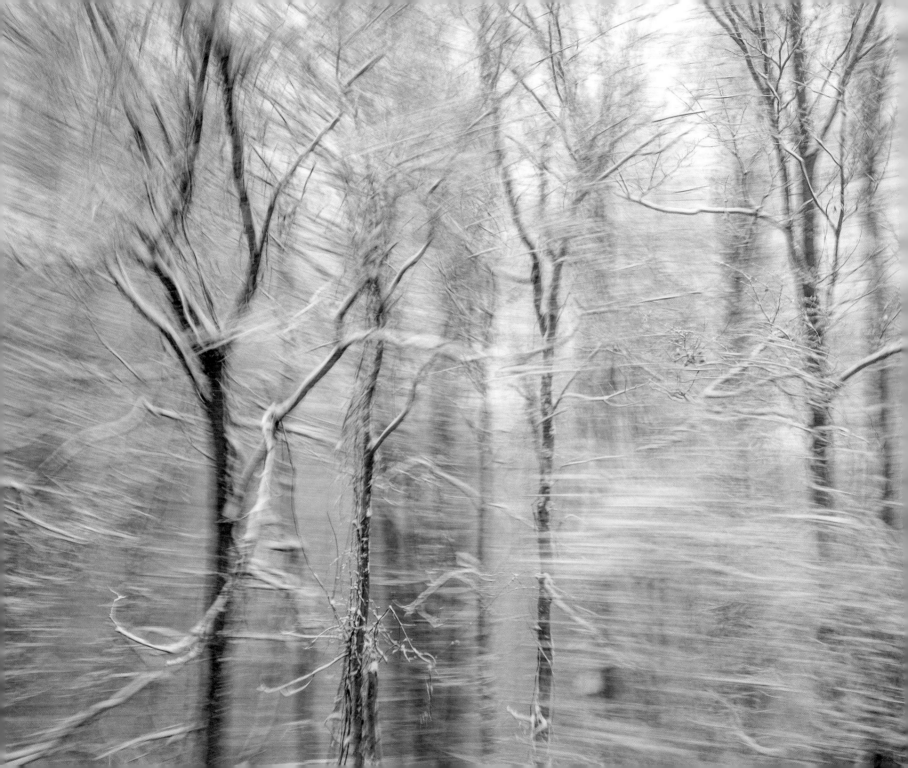

PHASE V

Post-Processing with Photoshop

Pennsylvania, 2012

CHAPTER 29 # Opening Files into Photoshop

Beauty, like truth, is relative to the time when one lives and to the individual who can grasp it.

—GUSTAVE COURBET

Adobe Photoshop is incredibly powerful image editing software that excels at a vast number of post-processing tasks, including retouching, image transformations, multi-image compositing, masking, typography, painting, vector shapes, even 3D texture mapping. A few years ago, I would have started in Adobe Bridge to organize my images, made changes to RAW files in Adobe Camera Raw (ACR), and then progressed into Photoshop to make use of its extended toolkit. In fact, for certain design projects, I still do use the Bridge to ACR to Photoshop workflow when I need to work with additional file types such as video, audio, Illustrator artwork, page layouts, and more.

The Passenger Seat Plan

For the *Passenger Seat* project, however, Lightroom was definitely the best tool to start with, not only for organizing my image library, adding metadata, and culling images, but also for making global and simple, local edits to my photographs. Yet some of my images needed more precise adjustments on selected areas that were far easier to make by using Photoshop tools than by trying to brush in the adjustment in Lightroom. Other images needed heavier retouching to remove larger distracting elements—another job for Photoshop with its advanced Content-Aware technology. Finally, a handful of images needed more complex manipulations that could be accomplished only by using adjustment layers and masking.

Tip

Lightroom has a parametric image editing model, meaning changes are made as sets of instructions to be applied to the file to make it appear lighter or darker, warmer or cooler, and the like. When you open photographs in Photoshop, Lightroom applies the set of instructions to the RAW file and opens a document that is pixel based. Working with pixels provides some advantages when retouching and editing images, but the file sizes do become larger.

Prior to opening my photographs in Photoshop, I set Lightroom's External Editing preferences (Preferences > External Editing) to hand off (render) files using the PSD file format, Adobe RGB (1998) color space (the space in which I characteristically work), 16-bit color, and a resolution of 300ppi. I prefer to deselect Lightroom's "Stack with Original" feature to more easily see the

original and edited file side by side in the grid view. Finally, I create a new Filename Preset using the Filenaming Template Editor, choosing to keep the base name the same (by inserting the original filename) and adding _ME (for master edited) to the files that I open and save from Photoshop.

Handing Off Files to Photoshop

In Lightroom, selecting Photo > Edit In > Photoshop will apply any changes made to the image, including adjustments made in the Develop module, and open the selected file into Photoshop at the native capture size. If you have cropped the image in Lightroom, it will hand off the area within the crop only. The file size that you need to work with will depend on the output device. If you know that you'll need to work with an image larger than the native capture size, you can either use Lightroom's Export options to resize the file or use the Edit In command to open the file at its native size and then resize the image in Photoshop. When I know that I will need to enlarge an image, I typically use Lightroom's Export options to create the larger file because Lightroom interpolates the raw data, which has the potential to render a higher-quality result than interpolating a file that has already been opened in Photoshop as a pixel-based file. I suggest that you do a test with your own images to find your preference.

The External Editing preferences

Tip

If you need Lightroom to hand off files to Photoshop with different attributes on a regular basis (such as bit depth and color space), use the Additional External Editor section of the External Editing preference to create presets for your different needs. The presets will appear under Photo > Edit In.

Smart Objects

Smart Objects are an extremely powerful feature in Photoshop. They allow you to open one or more RAW files as one or more layers in Photoshop without converting the RAW data to pixels. For the *Passenger Seat* project, however, I chose not to open my files as Smart Objects for several reasons. First, opening the photos as regular, pixel-based images simplified the workflow, as many of the retouching tools in Photoshop that I planned to use (such as the Healing Brush or Clone Stamp tool) can't be applied directly to a Smart Object and therefore would require the addition of multiple layers to retouch. In addition, bypassing Smart Objects kept my file sizes down. And because I wasn't doing any multi-image compositing, I knew I wouldn't need the flexibility to resize layers multiple times within the image to make the relationship between elements believable.

When I *am* working on complex compositing and design work where flexibility is paramount, I will use Smart Objects, as they allow me to resize, reprocess, and refine the original data in the RAW file. This can be extremely useful when I'm blending together multiple layers (adding a texture overlay on top of a layered composite file, for example) and I need to lighten or darken the underlying layers as a result.

Opening RAW files from Lightroom as Smart Objects also allows you to access the snapshots created in Lightroom. Let's say you've created a *Color* snapshot and *Black and White* snapshot in Lightroom. You open the file from Lightroom (in color) as a Smart Object in Photoshop to include in your design. After a day of working on the design (adding multiple layers, transforming and masking them, and more), you decide that the photo would look better in black and white. Selecting Layers > Smart Objects > Edit Contents displays the Camera Raw dialog. Select the Snapshot tab and click the *Black and White* snapshot. Camera Raw reprocesses the high-quality RAW data and updates the Smart Object in the Photoshop document.

When handing off JPEG files from Lightroom to Photoshop, you will see one additional dialog. From the three options, select "Edit a Copy with Lightroom Adjustments" to have Lightroom to apply edits made in the Develop module to the file.

When working with a large number of images, it might be easier to export them all at once as PSD files using Lightroom's Export settings. In the Export Location options, enabling Add to the Catalog will automatically add the newly created files to the Lightroom catalog, making it easy to manage the files. (See Chapter 28 for more information on exporting from Lightroom.)

Tip

If you want to open more than one image into a single Photoshop document, in Lightroom select Photo > Edit In > Open as Layers in Photoshop.

If the wind will not serve, take to the oars.

—LATIN PROVERB

CHAPTER 30 Removing Imperfections in Photoshop

All photographs are accurate. None of them is the truth.

—RICHARD AVEDON

Although Lightroom can remove small imperfections such as dust spots and other distracting elements using the Spot Removal tool, Photoshop has additional tools and technologies better suited for more complex retouching and image manipulation. For example, the Spot Healing Brush in Photoshop can create texture and blend colors with potentially better results than are currently possible in Lightroom. Retouching imperfections is the first task that I do when I open my photo in Photoshop.

My tools of choice for removing imperfections are the Spot Healing Brush, Healing Brush, Patch, Content-Aware Move, and Clone Stamp tools. When I'm ready to work on removing any distracting elements in the image, I double-click the Zoom tool to zoom to 100% so that I can see every pixel in the image and be as accurate as possible. You can retouch on a separate layer or on the Background. When I'm confident that a fix will be easy, I retouch on the Background. For more challenging retouching tasks, such as removing glare from car windows, I retouch on a blank layer so that if I make a mistake

I can delete it (or a part of it) and try again, change opacity, mask the area, or change blend modes in order to achieve more realistic results.

Choosing the Proper Tool

When you paint with the Spot Healing Brush, it automatically selects the "good" area in the image to replace the unwanted area. Selecting Content-Aware in the options bar blends both color and texture and most often provides the best results. When I want to control the sample area, I switch to the Healing Brush. Opt/Alt-click with the brush to set the point from which to copy (a "good" area of the image), then release the key, move the cursor to the problem area, and paint over the imperfections. Choose Aligned to keep the sample and source points aligned as you move throughout the image; disable it to keep the sample spot in the same location until you redefine it. The Healing Brush can produce stellar results even though it does not use the Content-Aware technology. If you notice soft areas around the edges of the

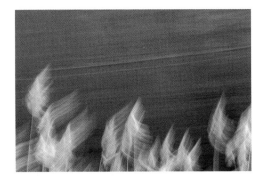

Original image

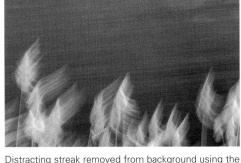

Distracting streak removed from background using the Healing Brush

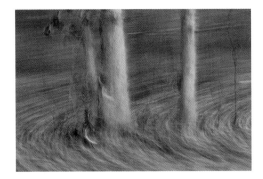

Original image

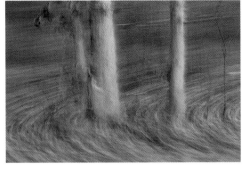

Red bag removed from image using the Patch tool

after selecting and repositioning the area, transform the object as necessary to better match the object's scale within the scene. After transforming but before deselecting, use the Structure and Color options to refine the edge blending. To better see the blend, you can press H to toggle the visibility of the selection marquee. After using this technique, I often used the Healing Brush or Patch tool to refine the edges of the extended area.

Tip

With a painting tool selected on the Mac, you can use the shortcuts of Control+Opt-dragging left or right to decrease or increase brush size, respectively, and Control+Opt-dragging up or down to decrease or increase brush hardness, respectively. On Windows, use Alt+Right Mouse while dragging to do the same.

The Clone Stamp tool makes an exact duplicate of the area, which is perfect for duplicating a fence or any patterned area. The Clone Stamp panel provides options for offsetting, flipping, and changing the angle while painting with the tool. It's extremely powerful; however, if the image color and tones change over the area being retouched, the retouched area may not blend well with its surroundings.

For more flexibility when retouching, the Spot Healing Brush, Healing Brush, Content-Aware Move, and Clone Stamp tools can

retouched areas, try using a harder-edged brush.

For larger areas, I find it easier to use the Patch tool set to Content-Aware. Make a selection around the area to be fixed (with the Patch or any other tool), then drag the selection marquee over a "good" area in the image for Photoshop to use as a "patch" for the imperfection. After Photoshop patches the

area but before deselecting, use the Structure and Color options to refine the content.

To move or extend an object in the image, use the Content-Aware Move tool. Although I didn't use the tool to move objects, several times during the *Passenger Seat* project I wanted to extend a patch of grass or tree limb to improve the overall composition of the photograph. With the Extend option selected,

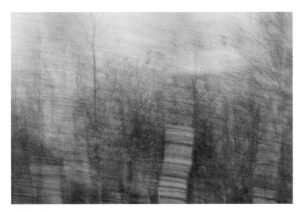

Original image

Reflection removed by painting with a soft-edge, low-opacity black brush on a layer set to Soft Light blend mode

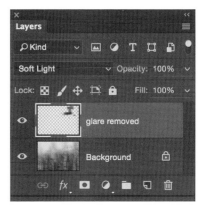

The Layers panel

all sample information from multiple layers and place the retouched "fix" on its own layer. Select Layer > New > Layer to create a new, blank layer, enable the option to Sample: All layers, and retouch on the blank layer. The Spot Healing Brush, Healing Brush, and Content-Aware Move tools have one interesting exception: If there are adjustment layers above the layer being retouched upon, their adjustments will not be included in the retouching. Ignoring the adjustment layers can be an advantage, as they can be changed later without wrecking the retouching. When the Clone Stamp tool is set to Sample: All Layers, it includes adjustment layers. If you have layers that you want the Clone Stamp tool to ignore, temporarily toggle off the layer's visibility using the Layers panel.

Removing Reflections

Several images that I really wanted to include in the *Passenger Seat* project had reflections from the windows or lens flares from shooting into the sun. The methods I used to correct this type of problem depended on the complexity of the reflection. If the area was simple, such as a reflection in the sky, I removed it with the Healing Brush or the Patch tool. If the reflection was over a detailed part of the image, I created a new layer and set the layer's blend mode to Soft Light. Depending on where the reflection was in the image, I selected black or white for my foreground color (white to lighten an area, black to darken). Using the Paint Brush with a soft-edged brush and very low opacity

(3%), I painted to lighten or darken (dodge or burn) the reflected area to match its surroundings. Where the values were uneven, I painted repeatedly, varying the brush size as necessary, slowly darkening (or lightening) the reflected area until it blended into its surroundings. If I needed to dramatically alter the tonal values, I made a selection and then used an adjustment layer with a mask to adjust the tonal values of the reflected areas to match. For more information on adjustment layers and masking, see Chapter 31.

I would rather die of passion than of boredom.

—VINCENT VAN GOGH

CHAPTER 31 # Making Selective Changes in Photoshop

No great artist ever sees things as they really are. If he did, he would cease to be an artist.

—OSCAR WILDE

Photoshop can be intimidating when you first start to explore the multitude of options available to enhance your images. But I bet that if you remember back to the first time you picked up your camera, you might have felt the same sense of apprehension about all of the dials and menus that you had to choose from. It might have taken a little practice for you to master f-stop, shutter speed, and ISO, but you did it, knowing that mastering those variables would enable you to capture the images that you see.

Photoshop has a similar powerful combination: selections, adjustment layers, and masking. They all work together. The doors to Photoshop open once you discover how these three variables are interconnected.

Selections

The Marquee tools are the most basic and can be quite useful when selecting ovals or rectangles. Holding down the Shift key while dragging with a Marquee tool constrains the selection to a perfect square or circle. Often it's a combination of the tools (an oval combined with a rectangle to select an archway in a building, for example) that will create the selection that you are looking for. Once you create your first selection, with these and other tools, use the icons in the options bar to add to, subtract from, and find the intersection of multiple selections. The Lasso tools allow for free-form, hand-drawn selections as well as those made by drawing straight lines between mouse clicks and were the tools that I used most often when selecting trees and other areas in images for the *Passenger Seat* project. The Quick Select and Magic Wand tools make selections based on sampled colors.

Tip

Pressing and holding the Spacebar and mouse button while dragging to make a selection lets you reposition the point of origin. Let go of the Spacebar to continue making the selection.

For more complex, hard-edged selections, I switch to the Pen tool, which offers vector and free-form options (including Bezier

curves), which you can draw and then edit point by point. I often used the Pen tool to select harder-edged objects (such as a window in a barn) and enhance them separately from the rest of the image. To use the Pen tool, select it and then create a work path around the area you want to select. You can then add or subtract points along the path and reposition them to make the path remarkably accurate. When you're satisfied with the path, save it (choose Save Path in the Paths palette pull-down menu), as you may decide you want to edit or use it again later. To create a selection from a path, choose Make Selection from the Paths palette pull-down menu to convert it into an active selection.

Color Range and Focus Area (under the Select menu) are two additional methods for selecting specific areas of an image.

Focus Area automatically selects the areas of the image that are in focus. You can customize the In-Focus Range, although I find the Auto option does a better job than I can on most images. Selecting the areas in focus and then making slight color and tonal adjustments or changes to sharpness and contrast can help separate one area of an image from another.

Color Range selects pixels based on color. You can specify a predetermined range (such as reds or yellows) or use the eyedroppers to sample colors in the image. The Localized

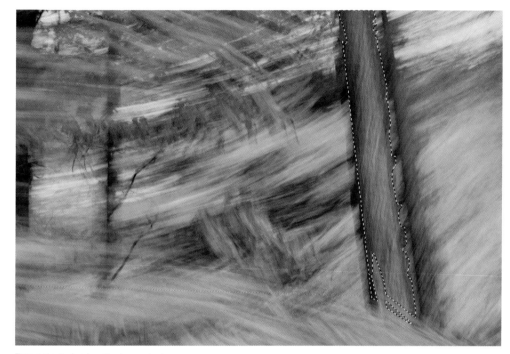

Tree selected using the Lasso tool

Color Clusters option restricts Color Range from selecting any color or tone that is discontiguous from the area sampled. The Fuzziness slider adjusts the tolerance level; higher values capture a wider range of colors. Color Range also offers the unique ability to select highlight, midtone, or shadow areas in the image. Once you select a range, it can be narrowed or broadened using the triangles.

Although you can make adjustments to color ranges in Lightroom, one advantage

of using Photoshop is that you can select only part of the photograph and then use Color Range to create a selection within that specific area of the image. In addition, you can easily invert the selection to make additional changes as needed. In the *Passenger Seat* project, I found that using Color Range I could make a selection of the leaves on one tree and increase their saturation and shift their hue in one direction, while then selecting the surrounding areas and adjusting

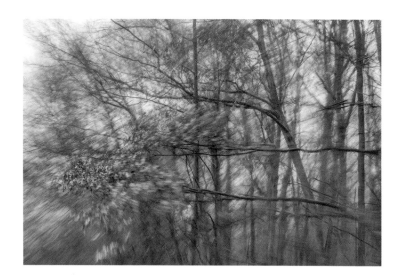

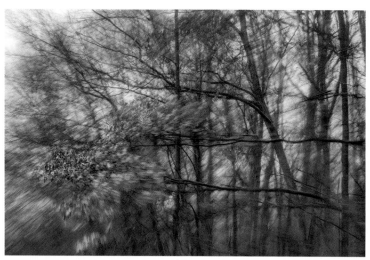

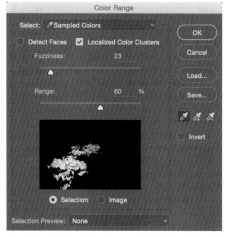

Color Range was used to select the leaves in the original image.

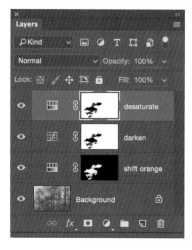

Shifting the hue and saturating the tree leaves while simultaneously darkening and desaturating the background

them in another direction (desaturating and darkening) to add color contrast between the trees, elevating the importance of the primary subject.

In the example on the left, I used the Lasso tool to make a rough selection around the tree and leaves that I wanted to change. Next, I chose Select > Color Range and set Select to Sampled Colors. Using the eyedropper, I clicked in the tree leaves to sample the brown colors, adjusting the Fuzziness and Range sliders to refine the adjustment, and clicked OK. Adding a Hue/Sat adjustment layer with the selection active automatically created a mask based on the selection. Shifting the Hue slider toward red and increasing the Saturation slider added emphasis to the leaves.

Cmd/Ctrl-clicking the Hue/Sat adjustment layer's mask in the Layers panel loaded the mask as a selection so that when I added the Curves and Hue/Sat adjustment layers, they had the same mask. Using the Properties panel to invert the mask, I could then modify the background separately from the leaves. Adding a slight feather to each of the adjustment layers removes any edge artifacting that might arise from using the same mask (or an inverted mask) multiple times.

After a selection is created (regardless of the tool used), its edges may need to be feathered (or softened) to blend it into the rest of the image. Photoshop has several ways of defining the amount of feathering and adjusting selection edges. I find the following approaches to be most useful:

- If the entire selection requires a softer edge uniformly, after creating the selection choose Select > Modify > Feather and enter a pixel value. The higher the value, the softer the edge.

- After the initial selection is created, choose Select > Refine Edge. Use the Adjust controls to soften, smooth, add contrast, and shift the edge. The Edge Detection and Radius can help with objects, like blurred grasses or tree leaves, where variable edge softening is needed.

There are additional methods for adjusting the edge of a selection, but first you need to learn about adjustment layers and masking.

Adjustment Layers

Although adjustments can be made directly to the image using the Image > Adjustments menu, adjustment layers are more flexible (Layer > New Adjustment Layer). The primary benefits of using adjustment layers are:

- Adjustment layers don't make permanent changes to the original image until they are merged.

- You can add as many adjustment layers as needed.

- Adjustment layers can be adjusted, readjusted, used in conjunction with each other, blended, added, or deleted at any time.

- Adjustment layers, as well as their masks, can be applied to entire images to make global corrections or applied selectively for local adjustments.

The only real disadvantage to using adjustment layers is that they increase file size and may limit the number of file formats to which that file can be saved while retaining its adjustments in individual layers. Despite their impact on file size, I recommend using adjustment layers wherever possible to maintain flexibility as you work.

When making adjustments to isolated areas in an image, most people make them in one of two ways:

- Make a selection, add an adjustment layer, and then refine the visibility of the adjustment layer by editing the layer mask as necessary.

- Add an adjustment layer (without first making a selection), and then paint the adjustment layer's mask to hide and reveal the adjustment in specific areas.

Both methods can yield comparable results, so it's really just a matter of personal choice which technique you use. If the selection is easier to make based on the specific contents of the image, such as color or tone, I tend to make the selection first, then add the adjustment layer.

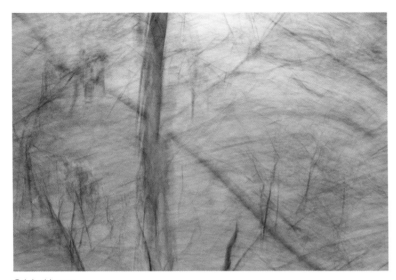

Original image

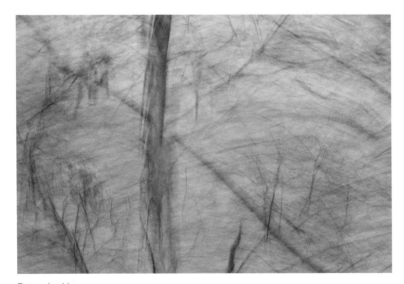

Layers panel with selective adjustments added to darken sky area and remove yellow color casts in trees

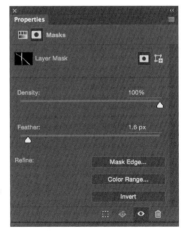

Properties panel with Feather set to 1.6 px to soften edges of layer mask

Retouched image

Masking

In Photoshop, layer masks work the same regardless of the type of layer to which they're applied. Where a layer mask is white, you can see the content or effect of the layer; where a layer mask is black, the layer's content or effect is hidden. Painting varying levels of gray on a layer mask will show or hide varying degrees of the content of the layer.

When adding an adjustment layer to an image without first making a selection, paint with black on the adjustment layer's layer mask to selectively remove the adjustment. Paint with white to reveal the adjustment if you inadvertently hide too much. Using a large, soft brush at low opacity on an adjustment layer's mask (for example, when using a Curves or Levels adjustment layer) can achieve subtle dodging or burning effects by selectively hiding and revealing the effects of the adjustment layer.

You can also use the Gradient tool to create subtle transitions in layer masks. Where the gradient is white, the content or effect is visible (unmasked); as the gradient becomes darker, the content or effect gradually becomes more and more hidden from view. There are a number of gradient styles from which to choose, including linear and radial gradients—and different styles can create significantly different effects.

If you create your selection first and then add the adjustment layer, Photoshop will create the mask based on the selection. I suggest that when using adjustment layers you don't add a feather to your selection. Instead, to soften the edge of the selection, use the Properties panel to adjust the mask's Feather slider. This method is more flexible because the Feather slider is nondestructive and can be modified at any time (even after the file is saved, closed, and reopened).

If an edge needs to be modified unevenly (soft in one area, hard in another), modify the adjustment layer's mask directly with a painting tool such as the Brush, Dodge, Burn, or Smudge tool to selectively soften the edges as needed.

If the adjustment is too strong, you can decrease the opacity of the layer (this might be easier than adjusting several sliders that make up the adjustment). Use the Density slider on the Properties panel to lessen the effect of the mask. Decreasing the Density slider lightens the values in the mask, revealing more of the adjustment (click the mask icon to reveal the Density slider). Similar to the Feather slider, the Density slider is nondestructive and can be edited even after the file is saved, closed, and reopened.

You can also use layer blend mode settings to change the way the content or effect of one layer is applied to the layers below. For example, if you add a Curves adjustment layer to an image and want only the tonal values to change (not the colors), set the adjustment layer's blend mode to Luminosity. This prevents any color shifts in the image.

In the Layers panel, click the layer mask's thumbnail to select it. To view a mask, Opt/Alt-click the mask icon. To display the composite image again, click the eye icon. To temporarily disable a mask, Shift-click the mask icon.

Don't think about making art, just get it done. Let everyone else decide if it's good or bad, whether they love it or hate it. While they are deciding, make even more art.

—ANDY WARHOL

Replacing Large Areas of an Image

When trying to replace a large portion of an image, I find that instead of using the retouching tools, I can make use of other areas in the image to cover up larger undesirable areas.

Here's how: Using any of the selection tools, make a selection around a good area of the image; make it significantly larger than the area that you want to cover. Use Cmd/Ctrl+J to copy this good information to its own layer, and reposition it so that it hides the unwanted area. Opt/Alt-click the Add Layer Mask icon in the Layers panel to add a black mask (to hide the layer). Using a brush set to a low opacity and the foreground color set to white, paint in the mask to slowly reveal the good information on the layer. If the new content doesn't align correctly, in the Layers panel click the link icon between the layer and the layer and, with the thumbnail for the layer selected, reposition, scale, and rotate until the top layer blends into the photograph.

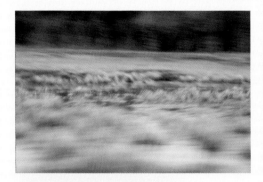

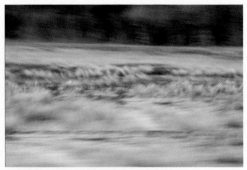

Original image

Copy of grass and water, transformed to extend across entire width of photo

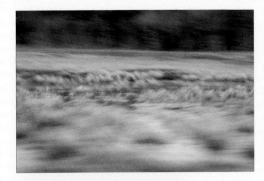

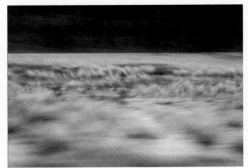

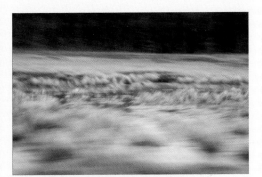

Layer mask added to selectively reveal new grass and water in foreground

Trees copied and transformed to extend across entire width of photo

Layer mask added to selectively reveal new trees in darker areas

CHAPTER 32 # Saving Files in Photoshop

An artist is not
paid for his labor
but for his vision.

—JAMES WHISTLER

After you finish all of your image editing, you need to save and manage your files in a manner that will help you find, and possibly edit, them at a later date. When I finish editing the photograph and choose to save the retouched image (File > Save), Photoshop automatically saves it as a PSD file (based on my External Editing Preferences in Lightroom. See chapter 28 for more information). Saving as a PSD (or as a TIFF, if you prefer) ensures that all layers, masks, paths, ICC color profiles, and channels are retained. I also set Photoshop's File Handling preference "Maximize PSD and PSB File Compatibility" to Always. Although this preference increases file size, it enables me to work with the file in Lightroom and other software applications.

One of the benefits of using the Edit In command in Lightroom to open my RAW file into Photoshop is that when I'm finished and I select Save and Close, Photoshop saves the file to the same location as the original RAW file, appends the file extension (based on my Lightroom preferences for External Editing), and automatically imports the newly created PSD file into the Lightroom catalog. For the most part, I leave the edited PSD file in the same folder as the original, but there are times when I use Lightroom's Folder panel

to move the PSD files to a different folder. It simply depends on the project.

I do not use the Develop module to make additional edits to my multi-layered PSD files in Lightroom. Instead, I use Lightroom to manage and keep track of the finished photographs.

If I need to make additional modifications to the layered PSD file, I choose Photo > Edit In > Photoshop and select Edit Original in order to maintain separate layers in the Photoshop file. If I need to create derivatives of the retouched PSD file, I choose Save As and append the file name using a sequence:

JKOST_2015_00001_ME.psd
JKOST_2015_00001_ME01.psd
JKOST_2015_00001_ME02.psd

Although this might seem mundane, it's far better than ending up with three copies of an image named:

JKOST_2015_00001_MEBest.psd
JKOST_2015_00001_MEDone.psd
JKOST_2015_00001_MEFinal.psd

If I named files this way, I would never remember which one was really the completed photograph and would waste time opening them all to see which one was actually the finished file.

There are a variety of file formats to which you can save, but be careful because not all of them support the extensive features in Photoshop. Files that have multiple layers should be saved as PSD or TIFF files, and when saving files over 2 GB you will need to save as either PSB or TIFF. Other file formats, such as JPEG, will flatten the file, eliminating layers and the ability to modify them at a later date. JPEG also is a compressed format—in order to decrease a photograph's file size, the format selectively discards data, lowering the quality. PNG is a popular file format for posting images online because it supports transparency (although not multiple layers). You might also save to PNG if your logo has transparency and you want to use it as a watermark over a photograph in Lightroom.

If I need to send someone a copy of the finished file and if size is a concern, such as when emailing, I would save the layered, retouched document as a PSD file (which would automatically import it into my Lightroom catalog). Then, in Lightroom, I would select the PSD file and export a JPEG for sending.

When everything seems to be going against you, remember that the airplane takes off against the wind, not with it.

—HENRY FORD

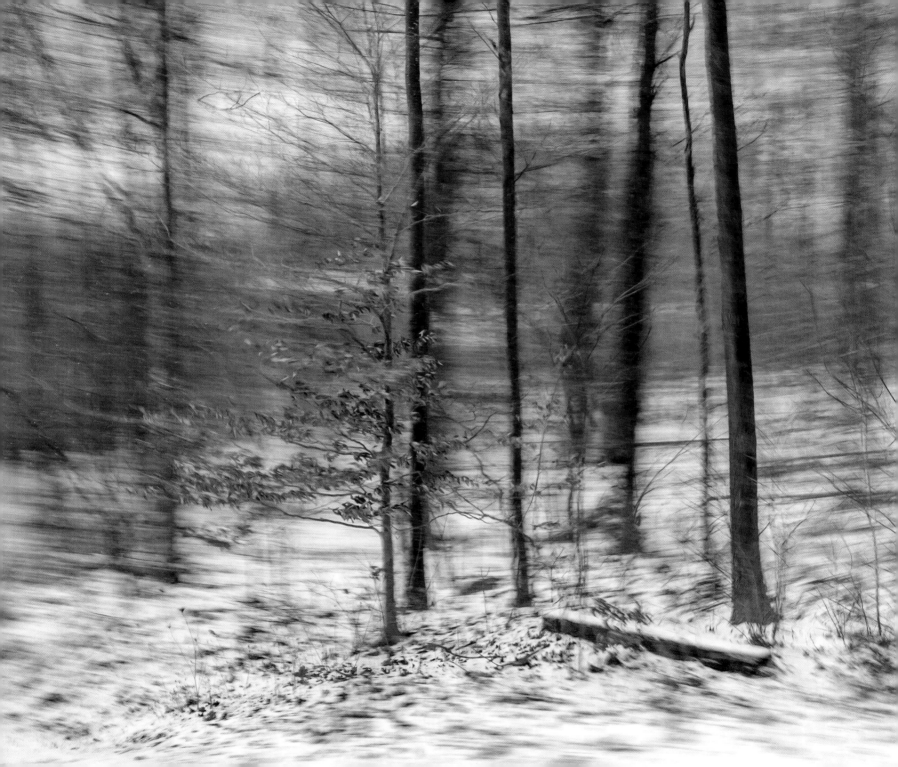

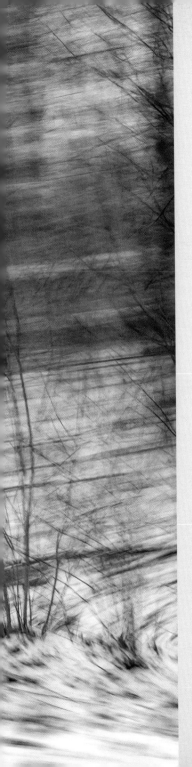

PHASE VI

Presenting Your Project

Vermont, 2012

CHAPTER 33 **Constructive Criticism**

As to what the picture represents, that depends upon who looks at it.

—JAMES WHISTLER

The more images you make, the more chances you have to discover your voice and improve the stories that you are telling. Throughout a project, it's important to take time to take a step back from the technical details of producing your images to constructively critique them—both the good and the bad, the successes and the failures. When you do, you will learn what works and what doesn't, which will, in turn, help you refine your imagery and define your style.

Every time you make an image you have the opportunity to improve your skill. There is never anything wrong with making mistakes as long as you learn from them. The only failure is when we don't try to understand what didn't work and find a way to prevent it from happening again.

It's easy to go through your images and choose the ones that you like, but I learn far more from asking what works and what doesn't work in both the successful *and* the less successful images. More often than not, it's the less successful images which provide valuable insight. When critiquing my work, I think about technique, composition, and concept.

Technique

When I look at technique, I ask myself questions with regard to capture as well as post-processing. Are the camera settings correct for the effect that I was after? Was the shutter speed too fast or two slow, resulting in too much motion or not enough? Does the depth of field isolate the subject or is too much or too little in focus? Is there too much camera movement in the image or too little? Would it have been better if it had been shot at a different angle or with a different lens? Is there detail in the highlights and shadows?

Is the lighting correct and does backlight/front-light work better? Does the direction and quality of light match the emotion within the frame? Was the photograph taken at the right time, at the right place, from the right angle, and with the correct subject distance? Does the color palette support the mood in the image?

After processing the images, I want to make sure that I haven't gone too far and pushed the image somewhere that it doesn't want to go. Is there a good reason for every change that I made to the image, and do

the edits reinforce the story? Is the image believable; not that it has to be realistic, but will the viewers suspend their disbelief and accept the enhancements? Was the technical execution seamless, or can the viewer tell where areas have been poorly retouched, clumsily masked, or oversharpened?

Composition

When critiquing image composition, I look at the rules of design and then, if the rules are broken, ask if it's still a successful image. The frame is a stage, where we are the directors that get to assemble everything within that space. Everything that you place on that stage should have a meaning—every element should be there for a reason. The more things that have to come together in a single moment to create your stage, the more unique your photograph will be. The camera captures the photograph of the landscape, but you arrange the elements so that the landscape tells the story.

Placing the subject in the center of the frame can create a balanced composition, but it will more than likely be static. That's not to say it won't work, but an asymmetrical subject supported by other meaningful elements that reinforce the story can add depth to the photograph. Would cropping the image make it more dynamic? Should everything needed to tell the story be included within the crop, or is the viewer intrigued by what is outside the frame?

Does the image take advantage of design principles to emphasize certain elements? As the stage director, you have the power to place the subject and then add supporting elements to draw the viewer's eye around the image. Can you use leading lines to elevate key elements in the image and keep the viewer's eye within the frame, or do the lines move the eye out of the photograph? Where is the brightest spot in the image? Does your eye go there first and get stuck? Should the subject stand out from the background? Would making it more vibrant or desaturated, or lighter or darker, help elevate its importance?

Is there too much chaos in the image? To eliminate clutter and give the eye a place to rest, should you try to reduce your subject to the barest forms of shape, shadow, color, and composition? Are there distracting and unnecessary elements that should be removed to help focus the viewer's attention on the subject of the story? Can you use positive and negative space to make the image more visually interesting? If you have a number of elements in your image, is there a distinct hierarchy? If not, do you want to change the rhythm of the image so that one subject takes the leading role? Do all of your elements line up in the image or are they split apart to add visual interest? Would having an odd number of items be more engaging?

Vertical lines convey strength, diagonal lines add movement, and horizontal lines tend to imply stability and tranquility—can you use them to reinforce the subject of the photograph? Do the images pair the right motion (in direction and amount) with the color and tones in the image: sweeping vertical motion with vivid colors can create energy; long, soft horizontal lines in muted tones can project tranquility; and sharp, diagonal branches can cause anxiety.

Have you included objects in the foreground and background for a sense of depth and scale? Or would omitting a sense of scale strengthen the image through abstraction? Would a different viewpoint or perspective help the image? For this project, being at the level of the passenger seat (without any significant way to change my elevation in relationship to the scenery), many of the images I favored were taken looking up a hillside, simply because of the unique perspective.

Concept

The technique and composition must also reinforce the concept, meaning, or visual narrative of the image. How powerful are

[He] escaped all censure
and unkind criticism
by doing nothing,
saying nothing, and
being nothing.

—ELBERT HUBBARD

the stories that you are telling? Will the image grab the viewer's attention? Is it strong enough to hold their attention? And is the imagery compelling enough to get the viewer involved on both an intellectual and emotional level? Are you creating an aesthetically redeeming or socially useful picture?

For the photographer, it can be difficult to separate the making of the photograph from the photograph itself. Is the photo bringing your unique personal vision to your subject in order to tell the story, or is it only about you? Does the image simply represent or document a subject (a tree, for example), or does it also provide information and a story about the object (the tree as it represents a broadening of personal vision by capturing a moment seen only through the eyes of technology)?

Asking ourselves these questions can help us discover what we might do differently the next time we make images in order to more successfully accomplish our vision. Mistakes can also lead us down paths that we didn't know existed or weren't conscious of. If we pay attention to our images, they can provide us with insights into our state of mind when the photograph was taken. They can tell us a lot about ourselves when we take the time to look.

CHAPTER 34 # Sharing Work with Others

The only way to find your voice is to use it.

—AUSTIN KLEON

As an image-maker who puts care and passion into your work, you naturally become disappointed when hearing nearly anything short of a glowing acceptance for something you have created. But constructive criticism and advice from someone who is unbiased is more valuable than a short-term ego boost. For this reason and more, sharing your work with other people is important.

Putting your work out there takes guts, but no one will know that your work exists unless you take that risk of making it public. Don't be held back by the fear of how other people will react to you. Make sure that you aren't giving away your power to people who don't care about the work as much as you do. Ask yourself whether they are invested in your story. Stay away from those that can't offer constructive criticism. This isn't to say that other people's opinions shouldn't matter, only that it's important to realize whose opinion matters to you.

Share and Collaborate

If you're really serious about getting feedback on your work, I would suggest that you share your work while it's in progress so that you are able to make adjustments in the roadmap early on. Sharing your finished projects is also important, but I often realize that if I had received the feedback earlier in the process, I could have saved myself a lot of time and effort and told a more effective story.

Tap in to your communities and collaborate with others to share thoughts, ideas, information, concepts, and so on. Someone might offer a brilliant addition or subtle change that could really benefit the project in a way that you hadn't thought of. You might be too close to the project to be able to see it as clearly as an outsider. Or maybe you're not ready to see themes or stories within the story, as others might be able to do. People extract different meanings from images at different times in their lives, and even we as the creators often make photographs that we understand only long after they are made.

I find it extremely beneficial to take the time to talk about the work. Sometimes I just need a sounding board, someone to converse with about a project in order to clarify its direction. I'm fairly confident that just talking to myself would help, but articulating the idea out loud to another person helps me focus what I'm trying to say, makes it that

Never leave that till tomorrow which you can do today.

—BENJAMIN FRANKLIN

much more "real," and helps me continue a project—especially when I'm in a rut. The more you talk about your work, the more you can learn from it.

Don't confuse support of your work with praise of your work. Not everyone is going to like your work, but they can still support you. Everyone has different life experience and brings with them their own perception of the world. You can't control how other people react to your work. Keep an open mind, and realize that being uncomfortable with feedback is OK. Some criticism you have to take to heart; some you should take with a grain of salt. You are the only one that can ultimately decide if you are going to continue to move forward with a project. Making art that is compelling is very difficult. Don't stop if you think the project is valuable.

Ask Questions

Most people love to talk about what they know, so if you're with someone more experienced, ask them questions. It's been my experience that people achieving their personal goals tend to share information to help other people achieve their goals. Work with people who aren't afraid to help someone else get better. Join a like-minded organization, take a class, visit a meet-up group, or participate in a photo walk or online community to give you an excuse to go on a field trip or share information.

Everyone has something to bring to a conversation if you are willing to open your mind and listen. The more you can open yourself up to feedback from others, the more you may be able to learn. But you have to really open yourself up, try to absorb their point of view, and understand their thoughts—without trying to form a response before they are finished—to hear what they have to say. And don't forget to ask the quiet people that don't typically blurt out information in a group setting. Take turns contributing, or propose that everyone write down their comments and share them as the imagery is discussed.

When you compare your work to others (because we all do at some point), do it with the intention of where you want your work to be, what you want to accomplish, and how you are going to get there. Don't compare your work to make yourself feel better than (or worse than) someone else. Compare to bring the level of your work up—compete with yourself—and try not to bring emotion to it. And remember that every photo you take doesn't have to be great, but when you do show your work, only show the great ones!

Write About It

If you are uncomfortable talking about your work, write about your work. If you can't talk about it to other people, at least have a conversation with yourself: Write down titles or caption the images. Do they reinforce the story that you are trying to tell? Print a contact sheet of your images and write below each image what works and what doesn't. Taking the time to write things down helps me see things in context, as well as see the relationship between the photographs that I capture.

If the thought of sharing your work will stop you from creating the work, then go ahead and keep it private. Make the work, and perhaps sometime on down the road you will choose to share it with a larger audience. When you do, choose the venue that's most comfortable to you. For example, I prefer to share my work in a controlled environment; that's why I prefer a website or portfolio over posting to a social media site where the clutter on the page takes away from the photographs and the images are lost in the stream after a week or even a day.

Printing the Perfect Image

Creativity is allowing yourself to make mistakes. Art is knowing which ones to keep.

—SCOTT ADAMS

I still find that printing a photograph is one of my favorite ways to share my images. For me, printing is an integral part of my creative process. I enjoy taking the images out of the computer and into the world, where I'm no longer dependent on the size or quality of the screen to view them. I control the size and quality of the print and determine what paper it should be printed on, as well as how the photograph is displayed.

Once printed, the photographs become tactile and gain a new sense of permanence. We can hold them, move them around, and quickly reorder them to determine how the story progresses. They become a part of the environment and allow me to change my perspective in order to look at them with fresh eyes. I can look at a large number of photographs at once (significantly bigger than the thumbnails onscreen) and see how they relate to one another. A well-printed portfolio is your commitment to the importance of the body of work, and it is evidence that you care about the presentation and that you are willing to put time and effort into the work.

When working on the *Passenger Seat* project, I printed all of the images once and most of the images several times. To evaluate their quality when enlarged as well as the visual impact of different sizes, I selected several of the images and printed them at a range of sizes (4x6, 8x12, 16x24, and 20x30). I printed more than 500 images at a smaller size (4x6) in order to cull and sequence. I quickly had an important realization: Many images in the project wouldn't be as successful when printed small, because they would lose important details such as swirling snow-flakes, suspended leaves, and frozen grasses. This helped me make the right decisions when selecting images for the *Passenger Seat* book. Over the years, it has become clear to me that some images are bold and want to be printed large and have the audience stand back to take in the entire view, whereas others are quiet and want to be printed small, creating a more intimate relationship with the viewer as they walk into their space. Most of the images in this project fall under the former category.

For the 4x6 images that I would use to cull and sequence, in order to keep costs down and increase my productivity I chose to batch export and send to a color lab to make quick proofs. For the other images (including the images for the exhibition), I

printed directly from Lightroom to my inkjet printer using the Print module.

The Print Module

In the Print module, start by defining the print options and page setup for the printer, including the paper size, color settings, and other printer-specific options. Clicking the Page Setup and Print Settings options exits Lightroom and enters the printer driver. Each printer manufacturer provides slightly different options, but I make sure to turn off the color management features in the printer driver, choosing instead to use Lightroom's

Printing to JPEG

Although the default setting in the Print module is to print to a printer, you can also choose to print to a JPEG file (using the Print Job panel). I find this indispensable when "printing" multiple images to one file (such as diptychs) to post on my blog or other social media sites. It's also a great way to create an image with a border or to add a watermark, filename, copyright, or other information to send to a color lab or service bureau for printing.

color engine to convert my images to the color space of the printer (in the Print Job panel). If you do not turn off the printer's color management features in the printer driver, the file will be converted twice, which almost guarantees that you will not get the results you want. Make sure that you designate other important information, such as paper size, paper type, and inks, in the printer driver as well.

Use the Layout Style panel to print a single image or contact sheet and the Layout panel to set margins and cell size, as well as page grid and cell spacing. If you're printing more than one image on a page, use Image Settings to rotate images to better fit on the paper. If the image's aspect ratio doesn't match that of the size that you want to print, use "Zoom to Fill" to temporarily trim the edges of the image in order to fill the desired cell size. When "Zoom to Fill" is enabled and the image's aspect ratio is different from the cell size, drag to reposition the image within the cell. For more control over the crop, use the Develop module. The "Repeat One Photo per Page" setting is a great way to print multiple copies of an image on the same piece of paper.

Use the Page panel to add helpful information such as filename, copyright information, page numbers, and page info (sharpening amount, printer profile, and printer). Use the Identity Plate and Watermarking options to

Single image

overlay your logo or copyright on the page or on each image. In the Print Job panel, disable Draft Mode Printing (it will print lower quality) and Print Resolution (unless you have a specific reason to disable the print driver's resampling and image interpolation features). To sharpen for your specific output device, choose your Media Type and Print Sharpening amount. Since you cannot preview the sharpening amount, you will need to do some test prints on images that are typical of what you will be printing. If your printer and operating system support printing in 16 bit, enable the checkbox 16 Bit Output.

In the Color Management area (still in the Print Job panel), click the drop-down menu to the right of Profile (it will say "Managed by Printer" by default). Choose Other to access all installed ICC profiles, and check the profiles that you use most often for your printer, paper, and ink to have them appear

Contact sheet

Custom package

on the list. Select the correct printer profile and rendering intent for your printer.

Click the Print button to print the selected image, or select multiple images (using the filmstrip) and choose Print to batch print all selected images. To print the same images with the same settings in the future, choose Print > Create Saved Print. The saved print project becomes available in the Collection panel. To save all the settings to use with *any* group of images in the future, save a template using the Template Browser.

To control the placement of two or more images on the same page, change the Layout Style setting to Custom Package. Use the Cells panel to add specific sizes to the package. Clicking a cell size button will add additional cells to the layout. Then adjust the cell size, and even rotate the cell, by using the Cells panel or by dragging and repositioning in the preview area. Add your photos

by dragging and dropping images from the filmstrip into the individual cells.

RGB or CMYK

For output to an inkjet printer, RGB files are preferred, but if you're going to be sending your files to a commercial printer for process-color printing, your files will need to be converted to CMYK in an application such as Photoshop. Due to the multiple variables involved in offset printing (resolution, dot gain, paper, inks, type of press, and so on), consult with your printer before converting your files to CMYK. If the color is absolutely critical, you may want to hire an expert to do the conversions for you and supply you with color proofs before the job is printed. In any case, do all of your color correction and retouching first and save the file. Next, flatten the file, convert to CMYK,

Soft Proofing

Enabling Lightroom's Soft Proof feature in the toolbar in the Develop module allows you to use an ICC profile to simulate onscreen what the image will look like on a given output device. You can choose to soft proof for a desktop printer, a CMYK device, or a specific color space (such as sRGB for screen display), as well as preview what the image will look like as a result of choosing different rendering intents. Based on the soft proof, you can make modifications to the image using any of the options in the Develop module. For example, the HSL panel can help selectively desaturate or shift a color's hue to better align it with the gamut of the output device. When a change is made, Lightroom asks if you want to create a virtual copy for soft proofing. Choosing Create Proof Copy makes it easy to identify and keep track of the original image as well as the copy that now has custom modifications for the specific printer, ink, and paper type.

save the file as PSD or TIFF, and be sure to include "cmyk" in the filename so that you'll know which file is which. When your files are converted to CMYK, you'll notice that the colors may shift slightly. That is to compensate for the more limited range of colors

To change who you
are, change who
you think you are.

—J. L. HUIE

(called the "gamut") that can actually be reproduced on press. In the example with the trees in fall, you can see that the histograms of the two versions of the image are significantly different.

Of course you don't have to make a choice between print and screen; today most of us will choose to publish our work to multiple channels based on the project. Images have very different audiences when shown in a gallery, hung on someone's wall, printed in a book, or posted online. It's your story, and you will decide where your images are best displayed.

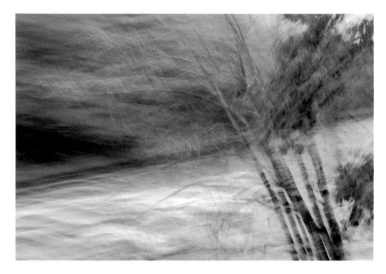

RGB image (simulated) with histogram

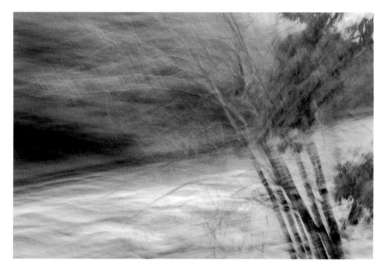

CMYK image (actual) with histogram

Making Books in Lightroom

Don't ask yourself what the world needs. Ask yourself what makes you come alive, and go do that, because what the world needs is people who have come alive.

—GIL BAILE

Lightroom's Book module is an excellent way to assemble and publish a book to share with the world. Books allow you to control the sequence in which you would like the viewer to experience your images. Start by choosing the book type: Blurb, PDF, or JPEG. Use Blurb to self publish a physical or electronic book, select PDF to create an electronic book, or choose JPEG to create individual files that can you can print or send to a color lab for printing. When publishing a Blurb book, you can sell and distribute it through the Blurb site (www.blurb.com). I strongly encourage you to create a book for your personal project. Your photography is worth it, and it can be very satisfying seeing your body of work to completion.

Before moving to the Book module, I prepare my images as much as possible by creating a collection, sequencing the images, and making color and tonal corrections. To add titles or captions to the images, use the Library module to ensure that the metadata is available not only in the Book module but in all of Lightroom's output modules. When choosing a book size, think about how the image (or multiple images) will best fit within the dimensions of the page. When creating the sequence, think about the pace

of the book, how many images you will want to place on a page, and whether you will print photos on both the front and back of each page. Slightly altering the layout, size, and positioning of images on the page can help set the pace and rhythm of the book and add visual interest to keep the viewer's attention. You can still make image enhancements, add or subtract images, and adjust the sequence after the book process is started; I just find it easier to do as much planning as possible before starting the process.

Book Module Basics

Using the Book settings in the Book module, choose the type of book and options such as size and paper type. I chose to create a Blurb book for the images in the *Passenger Seat* project to make a coffeetable book for my friends and family. I used the Standard Landscape size (because most of my images were horizontal), a Hardcover Image Wrap (because I wanted a hardcover book), and Proline Pearl photo paper (because of its higher quality, heavier paper weight, and semigloss finish). The Book module is based on templates. For some, these constraints might seem prohibitive, but for others, the

ease of use outweighs the lack of complete control over the layout.

Before laying out the book, in book preferences in the Book module (Book > Book Preferences), I set Default Photo Zoom to "Zoom to Fit" to avoid cropping images that were at a different aspect ratio than the cell size, and I set "Fill text boxes with" to "Title metadata" because I knew that I wanted to use the metadata from each image to fill in titles under each image.

Although you can choose to create your book one page at a time using the Page panel, I prefer to use the Auto Layout panel to have Lightroom automatically fill the pages of the book as my starting point. Each page's template can be changed at any time for very flexible book editing, so you don't have to worry if you want to modify the page templates later in the process. Selecting the Auto Layout panel's Preset menu, I chose the "One Photo per Page" template, then customized it by selecting Edit Auto Layout Preset from its drop-down menu. In the Auto Layout Preset Editor, I clicked to turn on Photo Text to allow for titles to appear under each image. After saving the new custom template and clicking Auto Layout, I was ready to start customizing my book.

When working on the book, you will move back and fourth between the three viewing options: Multi Page view (Cmd/Ctrl+E), Spread view (Cmd/Ctrl+R), and

Single Page view (Cmd/Ctrl+T). You can toggle between these views with their keyboard shortcuts and use the plus and minus keys to increase and decrease the size of the thumbnails in Multi Page view. The left and right arrow keys move from one spread to the next (or page, depending on view), or you can use the navigation icons in the toolbar. Double-clicking views a single page.

If you choose a book style that includes a cover, select the front or back cover pages and use the triangle in the yellow highlight surrounding the page to choose a template. There are a number of different templates (designed specifically for covers), ranging from a single image to multiple images with text. To change the cover photograph, drag and drop the desired image from the filmstrip into the empty cell. If your image is not at the same aspect ratio as the cell and you want to fill the cell, right-click and choose "Zoom Photo to Fit Cell" from the resulting menu. Drag in the image cell to reposition the image within the cell (or use the Crop tool in the Develop module for more control).

To reposition the image within the cell, use the Cell panel and adjust the cell padding options (unlink them by clicking off the Link All option to move each option independently of one another). Although the templates might not seem flexible in the beginning, once you discover that you can select a template that has a single image on

Multi Page view

Spread view

Single Page view

a page and use the cell padding to reposition the image anywhere within that page, they become much more interesting. Using the cell padding is much more exact than trying to align images in adjacent cells by dragging to reposition the photo in the cell.

If you have chosen a cover page with text cells, click in the cell, add the desired text, and format it using the Type panel. Once you select the font, size, opacity, color, and any additional settings in the Type panel, use the Text Style Preset option to save them as a preset to reuse. Use the Cell panel's padding options to customize the position of the type within the cell.

To change the sequence of the pages in the book, click the page number under the page to select it. Drag to reorder. You can even select multiple pages and move them all at once. Enable Page Numbers in the Page panel to display page numbers within the book. Right-click a page to hide a page number from a specific page.

Modifying the Layout

You can reorder images on a page by dragging from one cell to another. Dragging to an empty cell moves the image; dragging to a cell with an image swaps the photos. Replace an image by dragging from the filmstrip. Change the page template using the Page panel, or select a page and use the triangle

in the yellow highlight area to select a new template. Select multiple pages and change their template at one time. Add additional pages using the Page panel, or right-click a page to add (or delete) a page. If you find yourself adding the same page over and over again, choose it as a favorite by hovering over the individual page layout in the list and clicking its "pearl" or by right-clicking it and choosing Add to Layout Favorites so that it appears under the Favorites in the Template preset picker.

If you customize the page (changing the cell padding, for example), right-click the page to save the custom template. To apply the custom layout to another page, select the page and use the triangle in the yellow highlight area to select Custom Pages and then choose the template. (Custom pages can also be selected from the Page panel.) Custom pages are based on book size, so if you create a custom page while working on a Standard Landscape book, it will not be available when working on a book in Standard Portrait size, for example.

To add text on a page, select a template with text areas or enable the Page Text option in the Text panel. The type cell will grow when adding large amounts of text. Reposition the type on the page using the Offset options. With large blocks of text, use the cell padding to reposition the text within the cell. Use the Type panel to change columns,

gutter and text alignment, and justification. Any text entered in the Page Text is specific to the book.

Change the background color of a page or add a background image using the Background panel. Selecting a background image and then lowering the opacity is a creative way to embellish a type-heavy page while leaving the type legible.

To save the book, choose Create Saved Book. Once you save the book, it's visible in the Collections panel, and any updates to the book after its initial creation will automatically be saved. To add additional images to the saved book, add them to the saved book project in the Collections panel.

Once you are finished creating the book, you can use the Export to PDF option to create a PDF, which is great for proofing, or send the book to Blurb.

Perseverance is not a long race; it is many short races one after the other.

—WALTER ELLIOT

CHAPTER 37 **Making a Slideshow in Lightroom**

There is nothing worse than a brilliant image of a fuzzy concept.

—ANSEL ADAMS

Slideshows are a great way to present your photographs to music. You don't have to add music to a slideshow, but if you are going to, it will be helpful to choose the song or songs before you get started creating the sequence of images. If you know the length of the audio track, you can figure out how many images you will need based on the amount of time you want each image to be displayed. The order of images might also change based on the content of the music, with muted colors for slow, soft portions of the song and strong, bold colors for the crescendo, for example.

When creating a slideshow for the *Passenger Seat* project, because of the movement in the images I chose a fast-paced, high-energy piece of music that would show each image for a little longer than two seconds. I decided not to add crossfades between the images because I felt the subject matter would benefit from the quick cuts from one image to the next.

Because I find it easier to sequence images in the Library module, I started there, made a collection of images, and sequenced them in the order that I wanted them to appear in the slideshow.

Slideshow Templates and Settings

Moving to the Slideshow module, I used the Template Browser to choose the Simple template as my starting point.

In the Options panel, I disabled all of the options: I made very deliberate crop choices and did not want the Slideshow to zoom the images based on the frame. I did not want a stroke around the border of the images, and because my background would be black, there was no reason to enable Cast Shadow.

Using the Layout panel, I entered a slight padding of 50 pixels to ensure that the images were surrounded by black and would not bleed to the edge of the screen when displayed. If you are planning on adding text like copyright or image captions, unlink the Guides to offset the image and allow for the type. Use the Aspect Preview to preview what the slideshow will look like on the current screen, 16:9 or 4:3 aspect ratio.

Depending on the final destination of the slideshow, you can choose to overlay a watermark on the images or add an identity plate (such as your logo). When adding an identity plate, drag to change the position,

anchoring it to the side of the slide (it will remain in the same location regardless of the photograph that is displayed) or to the image (it will move based on the position of the photo within the slide). Watermarks can be graphical or text-based and appear over the top of the image. You can control Image and Text options (including size, opacity, and the watermark's position) in the Watermark Editor.

Enable Text Overlays and enter text in the toolbar to add the same text to each image, or use the Custom Text drop-down menu to add metadata from the image, such as title, caption, or copyright. Use the anchor points to resize and reposition the text. You can add as many Text Overlays fields as needed, using the Overlays panel to control font, size, opacity, color, and drop shadow options.

Although I prefer to use black as the background color, you can not only change the color but also add a color wash (gradient) using the Backdrop panel. I have seen examples of inserting a background image such as a logo or subtle texture, but be careful that you aren't distracting from your photographs with these options. Titles can be added at the beginning, the end, or both to introduce the body of work and tell viewers about what they are going to see, and you can add a closing statement, music credits, or a call to action at the end (like a link to your blog or contact information).

Add Audio, Adjust, and Save

Add audio tracks using the plus icon in the Music panel. When you add more than one, the panel displays the total duration of the audio. In the Playback panel, set the cross-fade duration (if desired) and choose "Fit to Music." Lightroom automatically calculates the duration for each image based on the length of the song. Or, choose "Sync Slides to Music" to have Lightroom switch the images in time with the music.

Drag in the filmstrip to reorder the image sequence if necessary. To save slideshow settings with the images to use again in the future, click Create Saved Slideshow. The saved slideshow becomes available in the Collection panel. To save all of settings to use with *any* group of images in the future, save a template using the Template Browser.

You can preview or play the slideshow or, when finished, render a video using the Export Video options and choose the preset for your desired destination.

If you prefer to control the timing of the slideshow (because you want to tell your audience about the images, for example), switch the slideshow mode to Manual in the Playback panel. This disables the audio but will allow you to easily move through the images using the arrow keys. You can also choose to export to PDF or to JPEG, neither of which will export the audio.

Productivity is never an accident. It is always the result of a commitment to excellence, intelligent planning, and focused effort.

—PAUL J. MEYER

CHAPTER 38 # Backing Up Your Photography

Commitment is an
act, not a word.

—JEAN-PAUL SARTRE

I think we have all heard someone say that you shouldn't ask yourself *if* your hard drive will fail, but instead, *when* your hard will drive fail. I know from first-hand experience that it can be extremely unpleasant when a hard drive crashes and you haven't been diligent about creating backups of your photographs. After losing a significant number of images early on due to drive failure, I decided that it was going to be a lot less work (and a lot less stress in the long run) if I committed to a timely and consistent backup strategy.

Backing Up Images

How you choose to back up your files depends a lot on your hardware configuration. Lightroom is primarily used in two common scenarios: The first is by a photographer who has one computer with everything stored on it, and the second is by a photographer who has so many photographs that they need to store the images on external drives.

If you have only one internal drive, then backing up your work is fairly simple. You just need to back up that drive. You can use Time Machine or Windows Backup and back up everything on the internal drive to a secondary "backup" drive, which will include your Lightroom catalog, catalog backups, your Lightroom preferences, presets, and your photographs.

But once you start working with multiple drives, then it can become a bit trickier to keep track of where things are. I have a Mac with a fast solid-state internal drive. But this drive isn't nearly large enough to store all of my photographs. Instead, I save my photographs on external drives. The internal drive is reserved for the operating system and applications like Lightroom and Photoshop (and their supporting files, like presets and preferences). I also store my Lightroom catalog on this internal drive because it is so fast. I use backup software to regularly back up the entire internal drive as a bootable hard drive so that if the drive fails, I can get up and running again quickly.

I use backup software to back up all of my photographs (and everything else that I store) on my external drives using the software that came with the drives. Although you can manage this process manually, I find that software such as Intego Backup Manager Pro (www.lacie.com) saves me time by automatically running a script at the end of the day and backing up only files that

have changed. I back up the files to one set of drives and keep them at home, and back those up to a secondary set of drives and store that information offsite. I know that this redundancy comes at an additional price, but I believe it's less than the cost of losing the information.

Tip

Some photographers keep their smaller active projects on their internal drives for speed, and then move them to their external drives when finished with the project. If you choose this workflow, just be sure that you are backing up those files on your internal drive as you work through the project.

Lightroom's Backup Catalog Setting

Lightroom offers another method for backing up the catalog (not your photos, just the catalog). When you quit (or exit) Lightroom, Lightroom asks *how often* and *where* you want to back up the catalog. (If you don't see this dialog, change the frequency of the backup in the Catalog settings.) Set the frequency to a schedule that you're comfortable with; I have mine set to "Once a week, when exiting Lightroom."

Lightroom's backup saves a copy of the catalog in its current state. However, the next time you open your catalog and make changes to your images, the "backup" catalog

becomes out of date. Why would you bother using this option if you are already backing up your catalog when you back up the rest of your files? Because an older version of the catalog may come in handy in case of emergency—for example, your working catalog becomes corrupted or you accidentally throw it away.

By default, Lightroom's backup catalogs are saved in the same folder as your current catalog. I suggest that you change this location if you can. Because I have additional drives, I have Lightroom create the catalog backups on an external drive. Otherwise, if the drive fails that has both your working catalog and the backups, you would lose both if you haven't backed up that drive.

Periodically, you will need to manually delete the older backup catalogs (I set a monthly calendar event to remind me.) The backups can get large, but fortunately Lightroom backs up only the catalog, not the image previews (which can be huge).

Tip

If you don't know where your catalogs are, while the catalog is open, choose Lightroom > Catalog Settings on a Mac (or under the Edit menu on Windows). Click the General tab and click the show button to the location of the catalog, or use the operating system to search for the string ".lrcat" to find all of your catalogs (including the backups).

Using Lightroom on Location

When I'm on the road with a laptop computer (which isn't my primary computer, where I have my master Lightroom catalog), I create a new folder on the desktop called NewPhotosNewYork (or wherever I am). Inside of that folder I create two folders, one for new photographs and one for a new Lightroom catalog. After making photographs all day, I download them into the Photos folder (creating any subfolders as necessary) as well as to a secondary drive. In fact, if I'm traveling with another person, we carry each other's backup drives so that if I mislay my computer bag I won't lose both copies of my photos (and likewise for my companion).

After downloading my photographs, I launch Lightroom, select File > New Catalog, and add the new photographs to this catalog (for the rest of the trip, I continue to add my photographs to this catalog). While on location I can work with those files, adding metadata, ratings and Develop module edits, creating collections, making virtual copies, and so on. When I get home, I copy the entire NewPhotosNewYork folder to the external drive where I store my images, launch my master catalog, choose Import from Another Catalog, and select the New York catalog. Lightroom merges that on-location catalog with the master catalog so that I don't lose any of the edits that I made on the road. After merging the catalogs and backing up the new photos on my external drives, I can delete the on-location catalog from my external drive as well as the catalog and photos from my laptop.

CHAPTER 39 # Parting Thoughts

It's perverse, but the more you fear missing out, the more you actually miss out. Then you are peripherally participating in a bunch of things and have no meaningful engagement in anything.

—ADAM GRANT

Slow down, and practice seeing.

Today, I don't believe that it's the technical aspect of photography that is difficult for most people to learn in order to achieve the results that they want. There is an enormous amount of information easily accessible via educational institutions, books, training videos, and the web, covering everything from shutter speed and f-stop to imaging techniques and photo manipulation. With practice and experimentation, I believe we can all discover how digital capture and post-processing works today and master the technologies.

It's learning to see that is much more difficult.

Although we live in a rapidly evolving and constantly changing world where it seems as though not even instant messaging disseminates information fast enough, the art of seeing, just like any art, takes time to really master. It takes concentration and patience see past the first image that you come across in order to capture something a little bit different, unique, and more interesting.

Personal projects take time. We need to fight that urge for instant gratification and allow our projects to evolve, develop, and mature. I try to take as much time as I can to nourish them. I don't like being that pebble when it's skipping wildly over the water, just ricocheting from one surface to another and barely touching down before being thrown forward again. I want to be the pebble as it slows down, stopping in one place and taking the time to go through the layers of the water to see what lies in the depths below.

But taking the time in order to see more than just what's on the surface can be difficult. After all, we have deadlines, and we're always striving to be more efficient and more productive. Yet slowing down might just enable you to make that body of work, those meaningful images that you aspire to create. "Seeing" parallels "creative problem solving." If you are brainstorming and just go with the first solution that someone comes up with, think of everything else that you might be missing. Make yourself slow down; stop the distractions, multi-tasking, hyperactivity, and overstimulation. Take a deep breath, and look for new and interesting approaches to express and communicate the ways in which you see the world.

Commit to making work that matters. We can only make an image that is as deep

as we think. Decide what is important to you and then only chase the things that are worth chasing. Make images of what you see and what you want others to see. Be open-minded. Enjoy the process. Who you are will come out in your work. It's your vision, your voice, and your eye that set you apart from other photographers. If your work comes from the heart, it will touch someone else.

Your actions define you—so go out there and finish your project. See it to its completion. Create something; your capacity for greatness is immeasurable. Do something noble; your life is worth it.

> We do not see things as they are. We see things as we are.
>
> — ANONYMOUS

Index

Improve your photography skills
Manage your photo collections
+ Express your creative vision

= Adobe Press + Adobe Creative Cloud Photography Plan

Adobe**Press** + Adobe Creative Cloud Photography plan

Adobe Press and Adobe invite you to become a Creative Cloud Photography plan member today and **SAVE UP TO 20%** on your first year!

Visit **adobepress.com/register** and follow the instructions to receive this offer!

AUTHORIZED
Affinity Partner